Utopic Impulses:

Contemporary Ceramics Practice

UTOPIC
IMPULSES

CONTEMPORARY
CERAMICS PRACTICE

EDITED BY RUTH CHAMBERS,

AMY GOGARTY & MIREILLE PERRON

RONSDALE PRESS

UTOPIC IMPULSES: CONTEMPORARY CERAMICS PRACTICE

RONSDALE PRESS
3350 West 21st Avenue
Vancouver, B.C., Canada V6S 1G7
www.ronsdalepress.com

Typesetting: Julie Cochrane, in Berkeley 11.5 pt on 18
Cover Design: Julie Cochrane
Cover Image: Sin-Ying Ho. *Music*. 2004. High-fire porcelain, hand-painted cobalt blue, computer decal transfer, terra sigillata. 40 x 20 x 20 cm.
Back Cover Images: *Bowls*, Paul Mathieu.
 White Matrix: Tea Party. 2000. Penelope Kokkinos.
 Curb Works. 2003–in progress. Rory MacDonald.

Ronsdale Press wishes to thank the following for their support of its publishing program: the Canada Council for the Arts, the Government of Canada through the Book Publishing Industry Development Program (BPIDP), and the Province of British Columbia through the Book Publishing Tax Credit program and the British Columbia Arts Council.

Library and Archives Canada Cataloguing in Publication

Utopic impulses: contemporary ceramics practice / Ruth Chambers,
Amy Gogarty & Mireille Perron, editors.

Includes bibliographical references and index.
ISBN 978-1-55380-052-1

1. Pottery craft — Social aspects. 2. Pottery craft — Political aspects.
3. Utopias in art. I. Chambers, Ruth, 1960– II. Gogarty, Amy, 1953–
III. Perron, Mireille, 1957–

TT920.U86 2007 738 C2007-902389-4

Printed and bound in China

Contents

ARTIST PROJECTS

Acknowledgements

A number people and organizations assisted us in the preparation of *Utopic Impulses: Contemporary Ceramics Practice*. We respectfully acknowledge and thank the Saskatchewan Arts Board for their early support for our project. As well, we wish to thank the Project Assistance to Visual Arts and Fine Craft Organizations section of the Canada Council for the Arts for their support in developing our manuscript, and the Writing and Publishing Section of the Canada Council for the Arts for their grant to help with the production costs of our anthology. We would also like to acknowledge the support of our institutions, The University of Regina in Regina, Saskatchewan and The Alberta College of Art & Design in Calgary, Alberta.

We were inspired and encouraged throughout by the remarkable enthusiasm, patience and creativity displayed by our fellow artists, colleagues

and contributors, without whom this project could not have taken shape. We can only hope that this manifestation of their "utopic impulses" bears fruit in the form of additional projects and contributions to making a better world. Our publisher, Ron Hatch, was of invaluable help throughout with his sage advice and commitment to our project. Our designer, Julie Cochrane, has enriched our presentation with her sensitive and elegant design. Finally, we would like to acknowledge Paula Gustafson, whose pioneering work in the field of craft discourse through her many presentations, mentorship and publications was so sadly cut short before she could see the publishing of this manuscript. Her influence and tireless efforts on behalf of craft are sorely missed.

Introduction

The spirit of this anthology derives from the editors' shared belief that craft practices — in this case, ceramics — contribute to the development, support and diffusion of speculative models and creative endeavours that envision a better world. By framing particular ceramic practices as "utopic impulses," we hope to foster new and stimulating conceptions of their contribution to the social and political fabric of their time. Utopias have long inspired artists; depictions of ideal cities or imaginary social orders promoting socially responsible roles for creative work are legion. More specific to ceramic practices in their broad context are two inspiring case studies noted here: Cedric Price's unbuilt project, "The Potteries Think-belt" (1964–65), and "The Medalta Potteries Project," ongoing and located in Medicine Hat, Alberta, Canada.

Cedric Price (1934–2003) was a visionary British architect. His reputation rests as much on the radicalism of his un-built ideas — of which "The Potteries Thinkbelt" is a magnificent example — as on his built projects such as "The London Zoo Aviary" (1960–1963). Price grew up in the "Potteries." His mother was a direct descendant of Enoch Wood (1759–1840), who, with Josiah Wedgwood (1730–1795) and others, established the famous "Manufactories" in the eighteenth century. The North Staffordshire Potteries remained at the centre of the English ceramic industry for over two and one-half centuries. After the devastation of the Second World War and the shift to post-industrial economies, the Potteries declined, businesses closed and workers lost their jobs. Of interest to Price was that, at their peak, the Potteries were a centre for cutting-edge science, technology and design. For example, Joseph Priestley held the first thermodynamics experiments in the Potteries. One of the first steam engines, designed by James Watt (1736–1819), and "The Rocket," the first "modern" steam engine developed in 1829 by George Stephenson (1781–1848), were used to circulate materials, crush and mix clay and turn potters' wheels. As noted by Stanley Mathews, an extensive and innovative web of railways connected towns and factories, and these supported the industrial sites ("Cedric Price").

What Price retained from this history was the notion that advanced science and technology involved a careful balance of pure and applied research. Highly critical of the British university system, Price proposed converting the declining English Potteries into a comprehensive, high-tech, hands-on think tank, a visionary model for learning, living and working in a post-industrial society. His "Potteries ThinkBelt" encompassed a mobile learning resource for 22,000 students, utilizing the existing infrastructure of railway tracks to transform the derelict Staffordshire potteries into a positive vision of a future Britain. He imagined a utopian landscape, a vast project that recycled and redeployed obsolete industrial detritus. As Mathews comments:

The "PtB," as it became known, was not a "building" and perhaps not even "architecture" as it was understood at the time. Price proposed using the derelict railway network of the vast Potteries District as the basic infrastructure for a new technical "school." Mobile classroom, laboratory and residential modules would be placed on the disused railway lines and shunted around the region, to be grouped and assembled as required by current needs, and then moved and regrouped as those needs changed. Modular housing and administrative units would be assembled at various fixed points along the rail lines ("Potteries Thinkbelt").

From seminar coaches to laboratory and lecture-demonstration units to "capsule housing," everything could be moved and ordered to suit the needs of users over time. As underlined by Mathews, the plans are impressive in their detail and precision, and, as an experiment, "The Potteries Thinkbelt" navigated "uncharted territory."

In Medicine Hat, Alberta, "The Medalta Potteries Project" shares the same spirit. It similarly recycles and redeploys the apparatus of a bygone industrial era, making it available to the public in the form of "The Medicine Hat Clay Industries National Historic District" and "The Medalta International Artists-in-Residence Program" (MIAIR). Consequently, this ambitious project provides the rural region with new cultural economies while offering professional visiting artists a unique opportunity for advanced research.[1]

Drawing from these two inspiring models — one that remained on paper and one that is close to completion — we invite our readers to travel with us into new regions. Imagine boarding one of Price's mobile learning units or exploring The Medicine Hat Historic Clay District, where the remains of "industry as museum site" cohabit with a state-of-the-art contemporary ceramics studio and learning/research facilities. Such a frame of mind would be most appropriate for engaging with this anthology.

The first part of *Utopic Impulses* consists of critical essays, with three major "transfer points" identified to facilitate mobility: Explicating His-

tories, Generating Theories, and Performing Activism. What these essays all have in common is that their authors are artists who believe that their histories, theories and activities are too important to be left only to other specialists to record. Consequently, the authors advance a range of unique interpretations based on rigorous primary research conducted in new terrain. They explicate (from *explicare*, "unfold, unravel, explain") histories that have been overlooked, unacknowledged or misconstrued; they generate theoretical paradigms for situating craft practice in a contemporary world, and they perform activism through identifying and endorsing responsible material practice. Arguing from personal experience, the authors shape discourse and offer aesthetic models for ethical reflection. As primary research, the essays examine specific case studies and provide description, analysis and, where appropriate and feasible, images of selected examples. As a group, these essays "make a case" for the importance and value of craft as — or in — practice in the public sphere.

The second part of this anthology documents artist projects that exhibit commitment to values of community, social responsibility and craft practice. The renowned cultural critic and theorist Peter Dormer (1949–1996) argued passionately for the value of craft practice as a living archive of tacit knowledge. Dormer distinguished tacit knowledge, acquired through the hands-on experience of doing things, from explicit knowledge, which allows one to talk and write about those things (147). Tacit knowledge not only preserves the "workmanship of risk," itself a utopic quality fostering discovery and innovation, it "keeps alive" essential cultural knowledge and experience that disappear with the loss of those individuals and makers who know how to do certain things. Through their insistence on tacit knowledge, these artist projects preserve cultural knowledge, contribute to the overall diversity of contemporary practice and exemplify ethical and socially based approaches to making art.

The artist projects in *Utopic Impulses* reflect influences and contexts arising from numerous local and global concerns. Our selection draws from a full spectrum of practices and includes functional wares, design for

industry, community-based projects and large-scale installations. Six sub-headings suggesting common themes and interests organize and introduce the individual projects, each of which consists of visual documentation supported by an artist statement.

Presenting research as utopic impulses in the form of critical essays and artist projects advocates for the value of an inclusive and nuanced field in which ceramics research and practice participate in the creation of a better world. The French curator Nicolas Bourriaud argues that all works of art produce "models of sociability." Those works exhibiting relational aesthetics invite viewers to dialogue with the work in order to "learn to inhabit the world in a better way" (13). While encouraging participation, a number of these essays and projects advance pressing agendas and political perspectives, challenging stereotypical notions that craft should comfort or placate. Following Ernesto Laclau and Chantal Mouffe, Claire Bishop insists that

> a democratic society is one in which relations of conflict are *sustained*, not erased. Without antagonism there is only the imposed consensus of authoritarian order — a total suppression of debate and discussion, which is inimical to democracy. It is important to stress right away that the idea of antagonism . . . does not signal "the expulsion of utopia from the field of the political." On the contrary, they [Laclau and Mouffe] maintain that without the concept of utopia there is no possibility of a radical imaginary (66).

Other projects offer more open "models of sociability," seeking harmonious inter-subjective relations and amenable encounters with viewers and objects. For these works, elements of beauty, compassion, self-reflexivity and collective memory signal utopic desires.

The essays and projects in *Utopic Impulses* participate in a wider critique of aesthetic, political, ethical and social impulses worldwide. Echoing Jacques Rancière, they call for new forms of participation and spectatorship modelled on viewers who are active interpreters, who "link what they see with what they have seen and told, done and dreamt." Rancière calls for "spectators who are active as interpreters, who try to invent their own

translation in order to appropriate the story for themselves and make their own story out of it." *Utopic Impulses* aims to foster and contribute to what Rancière calls "an emancipated community . . . a community of storytellers and translators."

While the majority of essays and projects are Canadian in origin, we include "fellow travellers" from Ireland, Great Britain and Australia to indicate these "impulses" are shared internationally. We offer these examples as "snapshots" of practice as we find it today in the hope that they will inspire others to recognize the utopic potential of socially responsible craft practices and creative endeavours. As editors, we invite readers to explore possibilities opened up by the creative interplay of culture, theory, history, science, technology, material, process, tradition and innovation, which together contribute to defining contemporary ceramics practice.

The Editors

Ruth Chambers, Amy Gogarty, Mireille Perron

NOTE:

1. See projects by Les Manning and Mireille Perron in the artist project section of this anthology. Additional information on the international residency program is available on the Medalta website at www.medalta.org/air.shtml.

WORKS CITED

Bishop, Claire. "Antagonism and Relational Aesthetics." *October* 110 (Fall 2004): 51–79.

Bourriaud, Nicolas. *Relational Aesthetics*. 1998. Trans. Simon Pleasance and Fronza Woods. Dijon: Les presses du réel, 2002.

Dormer, Peter, ed. *The Culture of Craft: Status and Future*. Manchester: Manchester University Press, 1997.

Mathews, Stanley. "Cedric Price's Potteries Thinkbelt as Utopic Landscape." Presentation, 31st Congress of the Comité international d'histoire de l'art, Montréal, Québec, Canada, 23–27 August 2004.

——. "Potteries Thinkbelt: an architecture of calculated uncertainty." Hobart & William Smith Colleges. September 2000. 7 January 2005. http://people.hws.edu/mathews/potteries_thinkbelt.htm.

Rancière, Jacques. "The Emancipated Spectator." Keynote address, 5th International Summer Academy, Frankfurt, 20 August 2004. Online. 30 March 2007. www.v2v.cc/node/75.

CRITICAL ESSAYS

Explicating
Histories

"Explicating Histories" presents five different historical interpretations of activity in the field of ceramics. Drawing on existing histories and historical models, the authors of these essays expand their research into new areas. Three of these essays examine examples from the Canadian context, the fourth explores studio ceramics in Ireland and the fifth revisits assumptions regarding the ceramic work of an internationally famous artist, Pablo Picasso. As artists, the authors bring their intimate understanding of the material and milieu to their research. It is by means of their tacit knowledge that each is able to re-articulate familiar or mainstream historical narratives to produce new readings of selected events.

Naomi Clement's "Function, Form and Process: Walter Ostrom and the Female Potters of NSCAD" looks at gender in relation to objects and legacies left by women who trained at Nova Scotia College of Art and Design under the auspices of Walter Ostrom, as did Clement herself. Her essay calls attention to the role of this important mentor, who revived the status of decorative, functional pottery in the construction of the broader Canadian ceramics and educational matrix.

Susan Surette, in "Invoking the Land: The Evocative Vessel," examines definitions of professionalism within ceramics communities in light of dominant and official discourses linking Canadian national identity to landscape. She traces the formation of public collections and their contribution to the shaping of a very specific Canadian national identity.

Paul Mathieu uses the occasion of a recent exhibition of 1970s Vancouver studio pottery at a university art gallery to examine both the radically utopic impulse that motivated the making of those pots and the degree to which they challenged assumptions about avant-garde practices

from that time period. "The Brown Pot and the White Cube" also critiques aspects of display in relationship to the exhibition of multi-sensory craft objects.

Michael Moore's essay "Irish Studio Ceramics of the Twentieth Century: an Outline of its Origins and Evolution" traces the development of studio ceramics in Ireland since the 1950s, a subject largely unexplored by scholars to date. Ascribing the lack of an indigenous Irish pottery tradition to the legacy of colonial domination and imported aesthetic, Moore's research opens a new field of inquiry, providing intriguing insights into a complex cultural and political history. Moore's text serves as an able complement to Paul Mathieu's, as each considers unexpected and often overlooked implications of Bernard Leach's influence as experienced in smaller centres well-away from the British mainstream.

Léopold Foulem contributes an edited version of a slide lecture he presented on Picasso's ceramics, "Archetypes, Prototypes, and Artefacts: Formal and Conceptual Connections Relevant to the Ceramics of Pablo Picasso." This essay benefits from being read in conjunction with *Picasso and Ceramics*, the extensively illustrated catalogue that accompanied the recent major travelling exhibition of the same name. Cross-references between this essay and images in that catalogue are provided in the text. Foulem was one of the curators of *Picasso and Ceramics*, and his reputation as a leading analyst of conceptual complexities relevant to Picasso's vast body of ceramic work is borne out by the primary research and insight he demonstrates here.

Function, Form and Process: Walter Ostrom and the Female Potters of NSCAD

Naomi Clement

 In 1896, the Victoria School of Art and Design, now NSCAD University,[1] held its first china painting course taught by then-principal, Katherine Evans (Soucy and Pearse 38). From that moment, women have been intricately (if sometimes peripherally) involved in the growth and establishment of the NSCAD ceramic program and style. The most widely acknowledged names within the internationally recognized ceramics department at NSCAD have often belonged to men, such as Homer Lord and Walter Ostrom, yet the women who have both studied and taught at the college have had a resounding and lasting influence on the work of subsequent generations of NSCAD students. While the ceramics produced by these women are both varied and unique, it is impossible to miss the common thread found throughout the work of the female

potters of NSCAD — the importance of functionality, a use of the "cut and paste" technique and a sensuality of form and colour.

As a recent graduate of the NSCAD ceramics department who is trying to find a place for myself and my work, I find that I realize only in hindsight the value of my time at NSCAD. I regret I did not appreciate it more at the time. Inevitably, with these ponderings on the department of which I was a part for three years, I am drawn back to a certain conversation between John Gill and Walter Ostrom. The conversation in question took place in my final year at NSCAD, in 2002, when the ceramics department was lucky enough to have Gill as a visiting artist. During one of his lively demonstrations, he and Ostrom discussed the department at NSCAD and its alumni. At one point Gill said something to the effect of, "You know Walter, there sure have been a lot of spunky, talented women who have come through this department." While I had never thought about it before, one has only to start listing the names of these women (Joan Bruneau, Katrina Chaytor, Sarah Coote, Julia Galloway, Linda Sikora, and Friederike Rahn) to realize how accurate this statement is. In thinking about these women and their work, it struck me what an interesting dichotomy it was that so many successful women have come from a program where the majority of full-time faculty and department heads have been male. During my time in the ceramics department at NSCAD, women were always the majority of students, yet I never had a female ceramics instructor.

When I first approached this subject in my naivety and inexperience, I did not understand that it was perhaps less an issue of the gender of the faculty than the creative environment which they in turn fostered. As both Julia Galloway and Linda Sikora suggested to me, the lack of gender balance found in teaching positions is perhaps not so much an issue of gender itself, as it is a combination of the generation and permanence of tenured teaching positions (Galloway, Sikora). Furthermore, as senior faculty retire, things are slowly becoming more balanced. For example, Galloway is the first woman to be hired full-time at the Rochester Institute of Technology (Galloway interview). During our conversations, both Galloway and Sikora

noted that, in general, women outnumber men in undergraduate ceramic programs. Sikora believed this was especially true regarding functional work, with these ratios varying according to the school.

Invariably, any discussion about the NSCAD ceramics department and its faculty centres on Walter Ostrom, who has been teaching ceramics at the college since 1969. It is by examining different aspects of Ostrom's work and his development of the ceramic department at NSCAD that one begins to understand the connection between the high ratio of male teachers to female students at NSCAD. During a phone interview in March 2003, Sikora suggested to me that one of the factors contributing to the higher population of female students in the ceramics department at NSCAD was Ostrom's focus on the domestic, or, in Ann Gabhart's words, his "emphasis on function, on pots which are completed when filled with food or flowers" (Gabhart 18–19). Sikora logically suggested that Ostrom's interest and dedication to pots that exist for, and are about domestic spaces attracts students who are also interested in domestic settings and functional work. She pointed out that gender is one thing, but masculinity and femininity are quite another (Sikora).

In any literature written about Ostrom, from show catalogues to magazine articles and interviews, function as physical attribute and philosophy is an ever-present leitmotif in both his life and work. To Ostrom,

> A pot should never stop working. In use, it should function to contain, present and enhance both its content and its context. A pot comes with all sorts of cultural information, social, economic, aesthetic, etc. I try to keep in mind both the utilitarian and informational role (Clark 51).

In a time when many ceramics departments were interested in more conceptual ceramic practices, Ostrom encouraged and supported functional work. This is particularly important as it relates to NSCAD. According to Andrea Gill:

> In a school that has a reputation for radical thinking, Ostrom took the position that pottery, beautifully made and highly decorated, had significance and conceptual weight in the context of the avant-garde (West 32).

This was fundamental not only in the development of Ostrom's own work, but also in terms of supporting and validating his students' own efforts in the realm of functional ceramics.

During a phone interview, Julia Galloway, who had come to NSCAD as a visiting scholar in 1994, spoke to me about the differences she experienced between the University of Colorado (where she received her Master of Fine Arts) and NSCAD. As a maker of functional pots at the University of Colorado, Galloway was constantly being interrogated on why she was making functional work. However, when she came to NSCAD, the functionality of her work was not even an issue. Rather than being asked why she was making pots, she would be asked, "What is your work about?" (Galloway interview). This concentration on the work itself rather than on current trends favouring conceptual art created an atmosphere in which students could explore their own ideas about ceramics without constantly being on the defensive. According to John Gutteridge, who graduated from NSCAD in 1984, "The impact of Walter's belief in the value of function and the decorative surface made me more confident that these were realistic ways to transmit my own feelings" ("The Continuum" 43).

Furthermore, as suggested by Gabhart,

> [Ostrom's] whole-hearted and radical embrace of earthenware in 1975 had its political as well as artistic implications. As an anarchist, he championed pottery in part because it was at the bottom of the hierarchy of art practice. Now he chose earthenware, at the bottom of the hierarchy of clays (20).

Galloway suggests that by actively choosing to work in earthenware, Ostrom was in many ways the underdog in the ceramics world, a position to which women are often relegated when working in a male-dominated field (Galloway interview). He had to deal with comments from influential people such as Michael Cardew, who said, "My God, man, why would *anyone* work in an *inferior material*" (Gabhart 20). Perhaps by having this early experience of discrimination, Ostrom more thoroughly understood and was sympathetic to the difficulties and prejudices that others might face. In a

newspaper article on Ostrom from 1972, he discussed his frustration with male chauvinism:

> We had an excellent pottery student, and, when she graduated, she was all set to make and market her pottery. But she had to scrap the whole idea because her husband said he needed her to work in the store. Now that just wouldn't have happened if she were a man. Women should not have to put aside their talents to suit a man's interest (Press Clippings Book, NSCAD Archives, Box #23).

As suggested by Joan Bruneau, who graduated with a BFA from NSCAD in 1988, when you were a student of Ostrom's, as long as you were dedicated to your work and excited about it, he would be supportive of you (Bruneau).

Intrinsic to Ostrom's advocacy of ceramics and his belief that one can "change the world with the breakfast cereal bowl" (West 33) is the philosophy that pottery and craft are not just a way to make a living. Rather, they are a way *of* living. According to former student Peter Bustin,

Joan Bruneau.
Tea for Two.
Earthenware and
polychrome glazes.
23 x 18 x 18 cm.

Walter was one of the few instructors who saw that art is about being human; about life and living. You put your art where you live, and if you are lucky enough to make beautiful pottery, you can use your art ("The Continuum" 41).

Early in Ostrom's own art education, he became aware of this connection between art and life while visiting the home of his art history professor, Gary Schwindler, where "he saw for the first time original works of art in a domestic setting; that they were used as an element of daily living made a deep impression on him" (Gabhart 14).When Ostrom himself became a teacher, he realized the importance of exposing his students to similar experiences. According to Bruneau, who currently teaches at NSCAD:

Walter really works at creating a strong community in the Ceramics Department. Often students are invited to his home for parties, and potlucks and festivities are organized among students and classes ("The Continuum" 41).

Clearly, Ostrom understands and wishes to convey to his students that, as Janet Koplos says:

Perhaps the whole way that a maker lives and deals with material goods should always be a part of the discussion. Perhaps the object is just the physicalization of a philosophy that shapes a lifestyle (qtd. in Johnson 3).

Inherently linked to this craft lifestyle is the principle that one uses and lives with beautiful objects, objects to which one is connected, and objects whose stories are interwoven with the fabric of one's everyday life. Ostrom understands that functional craft is all about community, an exchange between the maker, the pot and the user. According to him, "[T]he essence of utility is collaboration" (Gabhart 19). In Ostrom's own work and life, collaboration has played a pivotal role; throughout over thirty years of marriage, his wife, Elaine Dacey Ostrom, has worked alongside Ostrom to help him better understand his work. In filling the pots that Ostrom made, either with flowers from their garden, or food for their family, Elaine helped to complete the work, providing a connection between what

Ostrom was making in the studio and the daily events in their own home. In a recent video made by the Museum of Civilization to commemorate Ostrom's winning of the 27th annual Saidye Bronfman Award, Ostrom stated that, contrary to popular belief, he does not make vases and flower bricks because he is a gardener, but rather because his wife loves to arrange flowers.

By demonstrating to his students how craft was part of a lifestyle, inviting them into his home and encouraging potlucks and other ceramic department events, Ostrom nurtured a sense of community within the department. Whether consciously or not, he demonstrated to students his belief that "there's more to a pot than just making it" (Gabhart 21). From very early on, Ostrom understood that, as Koplos suggests, "The crafts world is a small town, a community, although it's geographically dispersed" (qtd. in Johnson 87). Much of the strength and vitality of this "small town" lies within craft colleges and departments such as his own. As a student at NSCAD, Bruneau valued this emphasis on community, saying that it "gives the individual strength. Then they do not have to make apologies for creating with clay in the institution. . . . This allegiance with others then continues when you leave the school" ("The Continuum" 41). This "allegiance with others" certainly extends beyond each individual graduating class; by inviting past students to give workshops, as well as promoting their work in his class slide lectures, Ostrom has allowed the work of previous students to have an impact on current ones, engendering an interplay of ideas and techniques as well as a knowledge that one belongs to a larger continuum.

Over the years, through his teaching, influence and support of his students, not only has Ostrom managed to contribute greatly to the field of ceramics, but, by encouraging a strong sense of community within his own department, he has fostered the growth and dissemination of a NSCAD style. There certainly is a NSCAD vocabulary of form, technique and colour, as has been pointed out by many people. Paul Mathieu discusses this in terms of Julia Galloway's work:

> [It is] situated within the relatively recent tradition, actually a revival and renewal of the old technique of cut and paste, where thrown or hand-built forms are altered and reorganized by subtraction and addition. . . . This tradition can be traced, through various historical precedents, to the maiolica work coming out of NSCAD in Halifax under Walter Ostrom.

Former student Friederike Rahn also believes that the work of NSCAD potters has a characteristic feeling, stating:

> I think a certain aesthetic was promoted there. That is, a kind of softness or casualness about the form, a heavily potted look, a juicy quality to the surface, an actively decorated surface. . . . The aesthetic is a starting point, which leads off in many directions ("The Continuum" 44).

While this style has many characteristics attributable to Ostrom's own influence, such as the use of earthenware clay, references to historical pottery and vibrant surface decoration, his students have also played an important role in the development of this aesthetic, developing their own styles within it. Although there are exceptions to every rule, in looking at the ceramics of many of the prominent NSCAD graduates, I have observed that the work of many of the female graduates has a distinct style. This style is one that centres on functional vessels made on the wheel, with forms that accentuate the gestural qualities of wheel-thrown objects — vessels that reinforce the connection to the maker's hand, with soft, organic shapes whose volume and sense of movement are enhanced by colourful decoration. This is in contrast to the work of several of the male graduates, such as Bruce Cochrane, whose work is generally more architectural. In work by men, there is less of an emphasis on the hand of the maker and the process involved; throwing lines are often erased, and decoration is used to adorn the surface or accentuate structural aspects rather than to enhance the sense of volume in the work.

While Ostrom's work, particularly his use of bright colours and historical references, has influenced the women discussed so far, the work of Sarah Coote, who graduated from NSCAD in 1983, and who taught at

Bruce Cochrane.
Flower Brick. 1999.
Porcelain, carved,
high-fire reduction.
12.7 x 17.8 x 30.5 cm.

NSCAD from 1987–1990, was pivotal in the development of this style both among her female students and subsequent generations of women. To Coote, the idea of using the wheel as a tool rather then as an end in itself is primary. During a workshop at the college in 2000, she demonstrated how she forms various parts on the wheel, manipulates them when still wet, and later pastes them together. She developed this style largely through working with John Gill at Kent State University in 1984, learning from him the way to hand-build various parts and paste them together to form a piece (Coote). By combining the techniques she learned from Gill with her own knowledge of the wheel-thrown form, learned through working with Ostrom, Coote was able to create new shapes and vessels. While teaching at NSCAD, Coote demonstrated her working techniques and consequently influenced another generation of potters including Bruneau and Sikora, who themselves have gone on to teach.

It is through understanding Ostrom's work, with his dedication to function and love of colourfully decorated surfaces, and Coote's approach to form and surface, that we may come to understand the roots of the style that has developed among several generations of NSCAD female potters. In looking at the work of four of the more prominent women to have studied

Sarah Coote.
Soy Ewer. 1989.
Porcelain, cone 9
soda fired. 17.8 cm.

at NSCAD, Joan Bruneau, Sarah Coote, Julia Galloway and Linda Sikora, one can see many parallels. These include a dedication to function, a similar style of making that involves manipulating wheel-thrown forms and a general sense of volume created through this method of making.

As with Ostrom, in all four of these women's work, function serves not only as a direction for their pots, but also as a guiding principle and philosophy. When I asked Coote what the driving factor or goal was when making her work, she stated that for her, it was important that the pieces not only function sufficiently, but excellently. Similarly, when making functional work, Sikora strives for a sense of the human hand in the piece, a connection between the maker, the pot and the user. She states, "When it is used, an overall feeling will complete the mere pragmatic aspects of its function and inspire the person using it" ("Northern Stars" 37). Bruneau feels that it is important when teaching her students to stress that "function is not a limitation, but another vehicle for expression" (Bruneau). On her personal website, Galloway makes clear the role function plays in her work, stating:

> I am a maker of useful objects. I understand the world through making, studying and using domestic objects. Pottery presents our values, aesthetics and beliefs back to us ourselves.

Galloway suggests that in order to make successful functional work, "a useful potter has to be in tune with physical aspects and details" (Interview). As a potter, she is "most curious when [her] pots support our most intimate rituals of nourishment and celebration" (*A Potter's Body*). Function is also essential in the work of Sikora, who states:

> The function of the pot itself has come to be of primary inspiration and motivation as I acquire and use more and more pots. Along with function, a specific solution to a form and surface may arise in response to an artefact from a culture or tradition past . . . or because of a process that has unfolded

while handling the clay, glaze and fire . . . or because of a utilitarian need I discover or an aesthetic question I have in my life. Within the solutions of function, form and surface, there always seems to exist a play between the elemental and the intellectual, the pragmatic and the ideal ("Northern Stars" 37).

It is clear that the functional pot fits within these makers' practices on a deeper level than physical function alone; as with Ostrom's, the work of these women embodies their way of living, their way of viewing the world around them. Function has become not only a narrative between the maker and the piece, but a narrative that permeates the life and lifestyle of each individual.

While function is the guiding philosophy behind the work, the ceramic practices of Bruneau, Coote, Galloway and Sikora are also connected on the level of process. All four of these women approach the making process through the potter's wheel, using the wheel to throw different forms, which they then manipulate and piece together in various ways. In speaking to Coote, I found that she stressed her desire to work through process and retain the form in her own practice, while at the same time altering it. Within her work, Coote strives for movement and for forms that are strong, yet informal, and not "dumpy or soulless." Coote has said about her own work, "When I make functional pottery, I search for a gesture and try to animate the pot" ("Northern Stars" 37). She hopes that the surface decoration will become part of the form in the finished piece, and she tries to make both glaze and work support each other (Coote). Bruneau, a student of Coote's, also discusses this idea of gesture and movement:

Julia Galloway.
Vase with Saucer.
Porcelain, cone 6.
25.4 x 15 x 17.8 cm.

> My pots are thrown and altered by way of cutting and pasting, sometimes using simple molds. The finely textured earthenware is treated as an organic membrane, stretched and shaped, with throwing lines intact, to evoke the fluid gestures of material process and growth ("Northern Stars" 36).

With the merging of these two commonalities of function and wheel-based processes, the resulting forms are inevitably ones that contain: they are forms of volume. While volume is a word that has several definitions, it is commonly understood in terms of ceramics to mean "space occupied by a gas or liquid." To say that a pot has volume is to suggest that it has the capacity to hold something, to contain, that it is something that forms a barrier or membrane between one space and another. Does a pot indeed become a layer of skin or a point of contact separating inside from outside, which we understand in terms of its relationship to ourselves?

If so, how does this relate to women who make functional pots? Is it, as Ostrom says, because pottery "is the only thing that the human makes and cognates in terms of his or her own physical self (foot, belly, neck, lip)" (West 35). Or, as Julia Galloway suggests, "When you tuck and dart and you start to get good at it, you inevitably create volume, and women's bodies tend to be about volume; they are more about interiors than exteriors" (Interview). The women discussed in this text make work and forms that suggest the space within, the volume contained by the pot. The surface decoration often serves to accentuate these forms.

The more I think about the history of the NSCAD ceramics department and the role played within it by cut and paste ceramics, the more I question and contemplate my own place within this continuity. I have never had any of these women as teachers, yet I have been influenced by their work and methods of making. I have come to realize that this way of working reminds me of what drew me to ceramics and clay in the first place: the sensuality and sheer physicality of it. When making vessels by tucking and darting, cutting and pasting, there is a sense of excitement which parallels the excitement and wonder that I felt the first time I sat down at the potter's wheel. Forming vessels in this manner becomes a constant dance between one's skill and the forms one envisions: the tension and exhilaration of cutting into a wheel-thrown pot — will I take it too far, not far enough . . . does it matter? It is a method of making that harkens back to the wheel itself — the battle between one's desire to

centre everything and the wheel's tendency to pull everything off centre.

The sheer act of making objects in clay will forever be entwined with our own ideas of creation and identity. As Ostrom suggests, "Pots are a metaphor for use, offering a vehicle for coming to understand the world; a meeting place" (West 35). How this individual identity exists in the larger continuity of life, the world and our processes of self-actualization, will forever change. Yet, as Gabhart suggests, "Much of the history of ceramics is the story of the movements of peoples with their pots, the impact of objects transported by exploration and trade" (12).

The transportation and impact our pots have within the world will keep building, coil upon coil, forming a vessel that becomes re-invented with each new addition. The development of the ceramics program at NSCAD with its characteristic style has been integral to the development of many people's sense of place within this larger continuity. Despite the fact that the faculty of the NSCAD ceramics department is and has been predominantly male,[2] the department has managed to create a dynamic learning environment in which women flourish and continue to forge paths of their own. Currently, NSCAD is poised on the edge of a new stage in its development. Its former president, Paul Greenhalgh (2001–2006), initiated plans to increase and diversify the institution's student, faculty and campus base. As NSCAD University evolves, it will be interesting to see whether it chooses to acknowledge and accommodate the interests of its current student population, of which more than half are women,[3] and recognize the success of past students by respecting their legacy in hiring future faculty.

Daunting as it is to realize that I, too, am now among the ranks of alumni, it is also to some extent heartening. Through the process of re-searching this paper, the women I contacted have all been very generous with their time and help. No matter how many years may have passed since they studied at the college, I share this experience with them. It is an experience to which we can all relate, remember and be proud, dispersed though we may be. If one thing contributed to the characteristic style and spirit of the NSCAD ceramics department, it is the migration of individuals

with their pots and their ideas of pots. As Paul Mathieu writes, "Pots, by nature, have no real locality. They are essentially mobile and can fit in numerous contexts." It is this mobility and versatility that has been — and continues to be — essential to the female potters of NSCAD.

NOTES:
1. In 1969, the school was renamed Nova Scotia College of Art and Design, and, in 2003, renamed again NSCAD University.
2. Currently in the ceramics department at NSCAD both full-time faculty are men, as is the ceramics technician.
3. According to Tara Wong, the registration database systems manager at NSCAD, during the 2003 school year, there were 2.4 women to every man at NSCAD.

WORKS CITED:
Bruneau, Joan. Personal Interview. 3 February 2003.
Clark, Phyllis Blair. "Walter Ostrom." *Ceramics Monthly* 51.4 (2003): 50–58.
"The Continuum." Statements by former students of Walter Ostrom. Gabhart, Higby, West et al. 40–46.
Coote, Sarah. Telephone Interview. 18 March 2003.
Cosgrove, Barbara. "Sexual Discrimination in Ceramics." *Ceramics Monthly* 36 (1988): 23, 52.
Dean's Office. Crafts Division Administrative Correspondence 1976–1985. Public Archives of Nova Scotia, NSCAD Archives, Box 8.
Elwood, Marie. *Potters of Our Past: A Brief History of Making in Nova Scotia until 1970.* Halifax: Art Gallery of Nova Scotia, 1996.
Gabhart, Ann. "Cosmic Turtle." Gabhart, Higby, West et al. 12–23.
Gabhart, Ann, Wayne Higby, Anne West et al. *Walter Ostrom: The Advocacy of Pottery.* Halifax: Art Gallery of Nova Scotia, 1996.
Galloway, Julia. *A Potter's Body of Work.* 15 February 2005. www.juliagalloway.com.
—. Telephone Interview. 24 March 2003.
Gill, John. Visiting Artist. Nova Scotia College of Art and Design, Halifax. December 2002.
Gustafson, Paula. "Canadian Craft Museum: Contemporary Crafts in Canada." *Ceramic Review* 142 (1993): 36–37.
Johnson, Jean, ed. *Exploring Contemporary Craft: History, Theory and Critical Writing.* Toronto: Coach House Books and Harbourfront Centre, 2002.
Mathieu, Paul. "The Pottery of Extremes: The Work of Julia Galloway" [online] *Ceramics Art and Perception* 42 (2000): 3–7. 15 February 2005. www.juliagalloway. com/articleextremes.html.

Metcalfe, Robin. "The Halifax Clay Wars." *Border Crossings: a Magazine of the Arts* 15.3 (1996): 66–68.

Nova Scotia College of Art and Design. *Annual Reports*, 1992/1993–2001/2002. Halifax, Nova Scotia.

"Northern Stars: Women Potters from Canada and Minnesota." *Ceramics Monthly* 44 (1996): 36–37.

Press Clippings Book. January 1972–May 1972. Public Archives of Nova Scotia, NSCAD Archives, Box 23.

Sikora, Linda. Telephone Interview. 27 March 2003.

Soucy, Donald, and Harold Pearse. *The First Hundred Years: A History of the Nova Scotia College of Art and Design*. Fredericton: University of New Brunswick Faculty of Education and the Nova Scotia College of Art and Design, 1993.

Walter Ostrom: The Virtue of Necessity. Videotape. Dir: Lori J. Schroeder. Canadian Museum of Civilization (27th Annual Saidye Bronfman Award), 2003.

West, Anne. "Curator's Statement." Gabhart, Higby, West et al. 26–36.

Wong, Tara. Registration Database Systems Manager, NSCAD. Email to author. 14 and 21 June 2004.

Invoking the Land:
The Evocative Vessel

Susan Surette

 The British art critic Herbert Read described pottery as "at once the most simple and the most difficult of all art." He continues, "It is the simplest because it is the most abstract . . . the art is so fundamental, so bound up with the elementary need of civilization, that a national ethos must find expression in this medium" (42–43). Canada's national ethos is bound up with its sense of itself as a vast terrain, a perception that is neither neutral nor innocent. As Gillian Rose suggests, "landscape's meanings draw on the cultural codes of the society for which it was made. These codes are embedded in social power structures . . . the material and symbolic dimensions of the production and reproduction of society [are] inextricably intertwined" (89). This essay examines the interconnected relationships among Canadian ceramic

vessels, Canadian landscape imagery, definitions of "professional" within the ceramic community and Canadian national identity during the later years of the twentieth century. The origins of this inquiry are rooted in my personal experience as a professional ceramist, which itself fuelled my interest in and commitment to the development of ceramic theory.

The inclusion of contemporary ceramics in the Canadian Museum of Civilization (CMC) through the collections associated with the Bronfman Award and the Massey Foundation has opened a space within the Canadian national museum system to honour contemporary ceramics, underscoring the performative power of the private collector to contest the pedagogical within the national system.[1] The interrelationships among the ceramics, the collections and the national museum system are played out within a dynamic whereby identity politics affect not only the viewer, but also the collector (Bal 105). The action of collecting inserts the objects into the narrative perspective whereby "their status is turned from objective to semiotic, from thing to sign" (111).

When the written and visual language surrounding the Bronfman awardees and their works is examined, a recurring theme becomes evident, the connection between the makers and their ceramics to the land. This association is made both by writers championing the works and by the artists themselves. Within the framework of the collections, this trend can be seen from the 1970s through the 1990s; within the Bronfman collection, it encompasses the works of recipients Robin Hopper (1977), Satoshi Saito and Louise Doucet Saito (1980), Wayne Ngan (1983), Harlan House (1989) and Walter Dexter (1992). These artists are also linked by and celebrated for their mastery of Korean, Chinese and Japanese ceramic techniques expressed within a contemporary North American visual language. Several of these ceramists were also included in the Massey Collection, which, through photographic presentation in Hart Massey's *The Craftsman's Way* commemorating the 1981 transference of the collection to the Canadian government, highlighted the bond between the ceramists, their functional works and idyllic rural settings. Writers for

ceramic and craft journals and magazines, catalogue essays, and CMC publications *Masters of the Crafts* and *Transformations* have regularly linked these ceramic productions to the land.

Robin Hopper has acknowledged that many of his works capitalizing on glaze manipulation to create visual landscapes were inspired by northern Ontario and western Canadian landscapes. He has also stressed the links between the geological origins of the raw materials of the ceramic vessel, their expression in the vessel and a relationship with the land (Bovey 15). Hopper's enhancement of surface textures through clay and glaze additives and sandblasting extended the appreciation of his vessels from the purely scopic to the tactile. The tactile is also evident in the work of Wayne Ngan, who uses natural raw materials found around his Pacific seacoast home to add to his clay, glazes and firings, creating effects firmly nuanced to place. Ngan's artist statement underlines that his search for an organic relationship between himself, the environment

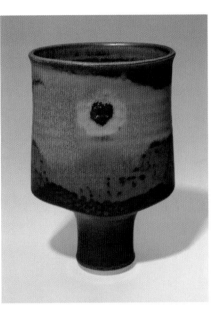

Robin Hopper. *Landscape Vase*, Olympic Series. 1978–1980. Porcelain, multiple glaze application on composite form. 20 x 13 x 7.6 cm. Winnipeg Art Gallery G-93-271. Photo: Ernest Mayer.

and his art led him to construct his home and studio from local raw materials and to create his own tools from natural available materials. His use of *hakeme* brushwork on his pot surfaces was inspired by his body's interaction with the rhythms of the natural world (Shadbolt 97). Doucet-Saito's exploitation of Canadian clay has been celebrated by D.G. Jones in his essay for the exhibition catalogue *Momentum in Clay*, where he links the thickly glazed angular vessels to geological features of the land, such as scoured glacial rocks.[2] Jones points out that Louise Doucet Saito had been an advocate for ceramic work to express the strength of Canadian space since she had been a student of Gaetan Beaudin in the 1960s, himself a champion of the creation of *"une céramique propre au Québec, fabriquée avec la terre d'ici, teintée d'oxydes de la région"* (Lemay 40–42). According to Gloria Hickey, the magnificence of the land has also been integral to the ceramic production of Harlan House. Hickey sees within House's work a

concern for the ability of man to cope with the land, which has led him to an expression of landscape through his teapot handles fashioned from local apple and lilac wood, as well as his carving of local flowers into his vases (9–13). Walter Dexter's abstract expressionist brushwork and warm colours on his raku-fired vessels have been associated with the paradisiacal Pacific coast landscape where he lives and works (Wright 6). His colours and textures have been linked to the "roughness of the Canadian environment — its geography and weather . . . [and] the fragility of the landscape" (Elder 28–29). Notably, these connections between landscape and ceramics were made in the catalogues accompanying the requisite exhibitions of the Bronfman awardees, in magazine articles celebrating awardees or in CMC catalogues.

The representation of landscape has been a recurrent theme within the continuing transformation of Canadian ceramic styles, manifested for over 150 years in a variety of aesthetic languages and within differing social, economic, political and cultural contexts. The recurrence of this theme must be analyzed in order to recognize its inscription and re-inscription within these changing contexts at various historical junctures. This semiotic approach underscores the interdependence of text and context, wherein both the ceramic object and its accompanying critique can function as either text or context. The meanings of ceramic vessels can thus change due to "different conditions of reception, as different viewers and generations of viewers bring to bear on the artwork the discourses, visual and verbal that construct their spectatorship" (Bal and Bryson 179).

Nationalism can also be read semiotically. According to Stuart Hall, "nationalism is capable of being inflected to very different political positions, at different historical moments, and its character depends very much on the different traditions, discourses, and forces with which it is articulated" (355). This observation is fundamental to my discussion of the interpretation in ceramics of Canadian landscape imagery. The influence of Canada's colonial status vis-à-vis Britain and the United States[3] has profound ramifications for the production and reception (commercial and

critical) as well as the (re)readings of the ceramic objects. The examination of national identity within this production embraces the twin concepts of *Gemeinschaft* and *Gesellschaft* communities.[4] The local, homogenized craft community, as envisaged by the Arts and Crafts movement and the fundamental concept of the inhabited landscape have been integrated into the abstraction of the nation-state through consciously nurturing the shared symbolic construct of the importance of the landscape to reinforce the sense of membership within the nation (Osborne 230). The use of landscape to create Canadian national identity makes it dependent upon semiotic readings of an ever-shifting "ideal" of the land, contingent upon economic, social and political considerations.

Benedict Anderson's definition of the nation as an "imagined political community" demands that we examine by whom it is imagined and what exactly constitutes a community (6). I would extend Anderson's proposition regarding the importance of print-languages to the formation of a national consciousness to include visual/decorative art languages, testified to by the anxiety within the Canadian political, cultural and intellectual fields since Confederation regarding the search for a "Canadian" expression.[5] As part of the larger cultural and intellectual community, Canadian ceramists and writers about Canadian ceramics have participated vigorously in this debate. Integral to this is the question regarding the ability of a colonized country to speak for itself.[6] Its very existence in the shadow of Britain and the United States challenged the twentieth-century Canadian ceramic community's ability to develop its own voice while relying upon American and British teachers to refine its technical and aesthetic programs. As a former British colony, Canada is by no means unique in its search for a means to represent itself in the ceramic world. The United States, relieved of its colonial status in the eighteenth century, had definitively established a national ceramic identity by the early twentieth century,[7] whereas Australia, as a more recent colonial nation, is still seeking to define indigenous idioms that would indicate the metamorphosis of European styles into an Australian ceramic language (Pascoe 49).

Any examination of the representation of landscape, recognized as culturally inscribed and contingent upon semiotic reading, must acknowledge that the landscapes themselves are also "system[s] of signification, expressive of authority," constantly modified by ideological impulses (Baker 5). Landscape, as currently examined within the discipline of cultural studies, cannot be seen as the objectification of a bounded, distant environment, dominated by a scopic impulse (Berleant 5), but as constitutive of places where social groups belong, in which they interact and from which a shared group identity and meaning can arise (Groth 1). Within the framework of Raymond Williams' *The Country and the City*, "country" landscape is revealed as a utopian ideal, constructed in contrast to urban centres, bound up with the capitalist system in an industrialized society and tied to the imperial gaze. Coterminous with the myth-making of the utopian countryside is the social and artistic idealism of William Morris and John Ruskin. Under the aegis of the Arts and Crafts movement, these philosophers championed the return to a socially homogenized community, in which producers of arts and crafts would exist in a rural Eden. By bringing morality and beauty to a polluted, industrialized world, they would thereby uplift the moral tone of the nation. The influence of the Arts and Crafts philosophy was woven into the social and cultural fabric of Canada in the early years after Confederation, and, over the next one hundred years, this philosophy came to permeate the ideology of the nation.

The writings of W.J.T. Mitchell and Anne Bermingham offer a means of reconciling the discourses of landscape and represented landscape. Mitchell points out that sub-categories of landscape genres such as the pastoral, beautiful, picturesque and sublime are actually distinctions of spaces themselves. He links real estate value to ideal estate value, a viewpoint with which I concur. The more the Canadian land became a monetary commodity, the more it was also seen as a source of "pure inexhaustible, spiritual value" (14–16), a value eventually read into Canadian ceramic art production. Like clay and glaze, aesthetic codes and subjects

of representation form an amalgam with capitalist land interests. Ann Bermingham suggests that systems of representation and aesthetic languages employed by artists and understood by consumers are contingent upon class relationships to the means of production (3). When potters such as Robin Hopper, Harlan House and Walter Dexter exploit clay and glaze effects to represent the land, they do so within an historical ceramic precedent that is dependent upon the visual languages of their own time. Their bodies of work can be connected to Modernist abstract expressionist vocabulary, which reinforces their canonical status.

In this examination of the prevalence of references to the land in contemporary Canadian ceramics, I would like to return to an historical antecedent, nineteenth-century ceramic production by potters in Canada and by British potters. An examination of this production is articulated upon a mid-twentieth-century interest in antique ceramics (Collard *Canadiana* 10), and fuelled by factors such as the Massey Commission's pronouncement on Canada's official national culture policy, post-WWII affluence and Canada's 1967 centennial of Confederation. This last event catalyzed the publication of a plethora of magazine articles and books on historical Canadian ceramics between the mid-1960s and mid-1980s.[8] These publications served the important function of writing into history an almost neglected subject,[9] thereby both revealing and creating a Canadian history for the burgeoning studio pottery movement, creating a context within which it could flourish. Ceramics, which had been valued by consumers in the previous century but neglected in the first half of the twentieth century, were re-inscribed within Canadian ceramic history, contributing in a new sense to the formation of the national ethos.

The historical ceramics studied by Collard included Enoch Wood's table service that incorporated representations of popular tourist destinations in British North America, c.1830: "Table Rock," "Quebec" and "Montmorency Falls." The patterns were based on drawings executed in the sublime style earlier in the century (Collard *Potters' View* 4, 20). A decade later, British-produced transfer-printed wares inspired by drawings

executed by William Bartlett for Willis' *Canadian Scenery*, rendered within the rustic landscape tradition and celebrating the Canadian land as picturesque, were designed specifically for marketing to colonies in British America. These included Podmore, Walker & Co.'s "British America" patterns and Francis Morley's "Lake" pattern (Collard *Potters' View* 44–55). An unknown Staffordshire potter commemorated Britain's exploratory expeditions of 1819–20 and 1821–23 into the Arctic with "Arctic Scenery" based on sketches from Edward Parry's two books publicizing the voyages (Collard *Potters' View* 40–41). These patterns were collected by prominent Canadian households such as that of Sir William Dawson, who became principal of McGill University in 1855 (Collard *Nineteenth-Century* 210), and that of the Ewings, Montreal merchants, who both purchased "Lake." A prominent family connected with fur-traders acquired "Arctic Scenery" (Collard *Potters' View* 58, 43). The consumption of these patterns by the business, social and educational elite, and their current presence in the CMC, underscores, according to Pierre Bourdieu, the role of cultural taste in creating and maintaining class structure, and, reciprocally, the role of class in consecrating taste (1–2).

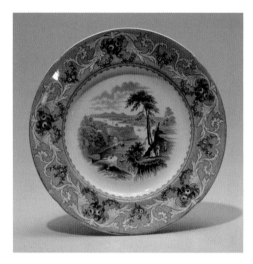

Francis Morley & Co.
Plate. 1845–1858.
Earthenware.
23.3 x 3.1 cm.
Winnipeg Art Gallery
G-81-150.
Photo: Ernest Mayer.

The creation and consumption of these landscape patterns coincided with specific political and commercial events involving the opening up of the Canadian land within the first half of the century to exploration, trade and settlement, including the establishment of the canal systems (Morton 221–222). As well, they were collected in the context of manoeuvrings between the reformists who were agitating for self-government and the on-going need for British protection from American imperialist designs (233–269). As these patterns were based on images executed by tourists to British North America and manufactured in England, it is tempting to read these productions as imperialist tools. However, in light of Mitchell's contention that the representation of landscape must be examined in a

more complex fashion to see if it reveals "both utopian fantasies of the perfected imperial prospect and fractured images of unresolved ambivalence and unsuppressed resistance" (10), it becomes evident that these patterns also coincided with (and perhaps honoured) the growing political independence of British North America from British control, which culminated in the 1867 Confederation. Following Confederation, a bilingual pattern, "Quebec Views," was created by Britannia Pottery in Glasgow, Scotland, based on Canadian etchings and executed in 1888 from photographs of tourist highlights taken by the Quebec photographer, Louis Prudent Vallée (Collard *Potters' View* 75–80). The appearance of this pattern, which emphasized the peaceful pastoral nature of the city and environs, masked the French Canadian nationalist discontent after the capture and execution of Louis Riel in 1885, as well as the hardships resulting from the economic depression that drove many French Canadians to emigrate to the United States in search of work (Morton 371–373). It should be added, however, that both English and French Canadians alike collected this pattern, including the parents of the famed Canadian/Quebec ethnographer, Marius Barbeau (Barbeau 127).

Books on nineteenth-century pioneer pottery and industrial pottery trace the history of Canadian potters from the most rural localized expressions of the craft to the burgeoning industrial potteries of the second half of the century. Within the production of the rural potteries, an emphasis on their use of local clays, and, where possible, glaze materials, as well as their ingenious construction of buildings, kilns, machinery and tools from local materials is celebrated. The association of the ceramic product with indigenous materials is the key that links this pioneer production with the ideological program of the mid-twentieth-century ceramic community, which was still in thrall to the Arts and Crafts movement and inspired by *A Potter's Book* (Leach). Wayne Ngan's use of homemade tools and local materials, self-built studio and home, discussed earlier, are certainly reminiscent of the strategies of the pioneer potters. However, Ngan's approach, as he has stated, is couched within an ideology based upon Korean Yi

dynasty works that emphasize the use of natural materials derived from the local environment, rather than pioneer necessity (artist statement). While the mid-twentieth-century's stress on the importance of indigenous materials in creating a ceramic art of national character contributed to the pioneer potter's reinsertion into the history of Canadian ceramics, the use of the molded, stamped and drawn maple leaf and beavers on nineteenth-century industrial earthenware and salt-glazed stoneware had come, by the mid-1950s, to be associated with tourist wares. These nineteenth-century Canadian ceramic productions were also the site of a contested professionalism, where recognition was essential to secure the home market for Canadian potters in the face of stiff American and British competition. As recorded in *The Story of Ontario Agricultural Fairs and Exhibitions 1792–1967*, productions were exhibited and prizes competed for at regional fairs, as well as at international exhibitions in the United States, Britain and Europe (Collard *Nineteenth-Century* 258–266). This concern still existed in 1934 for the founder of the Canadian Handicraft Guild, who wrote, "When the arts and crafts of a country gain recognition, that country takes a new position in the respect of the world" (Flood 64). In 1947, poor Canadian craft was seen as "badly representing us in other countries" (Pfeiffer 27). Today, the requisite level of professionalism for a Bronfman awardee is to have represented Canada internationally in exhibitions and lectures.

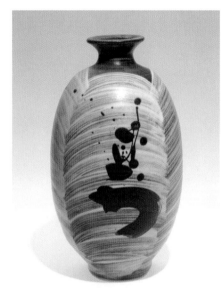

Wayne Ngan. *Vase.* 1991. Stoneware, *hakeme* and cobalt brushwork, applewood ash glaze. 32.2 x 18.7 cm. Winnipeg Art Gallery G-92-10. Photo: Ernest Mayer.

Elizabeth Collard observed that there was not much interest in collecting nineteenth-century ceramics in Canada until after WWII (*Canadiana* 10). The post-WWII interest in this body of work coincides with the growth of the studio pottery movement and with the 1951 report of the Royal Commission on the National Development of the Arts, Letters and Sciences (the Massey Commission), which "operated on the premise that their enterprise deserved the support of all patriotic citizens because culture was what bound Canadians together and distinguished them from

other nationalities" (Litt 4). According to Maria Tippett in *Making Culture: English-Canadian Institutions and the Arts Before the Massey Commission*, this belief was already entrenched in the early decades of the century. In her examination of the interplay between Canadian government policy, the practice of art and philanthropic Canadian and American organizations linked with the search for national identity, she documents how the foundation was laid for a "mature" cultural life, which "dictat[ed] an increasing concern with professional standards, on the one hand, and a 'national' culture, nationally organized, on the other" (x–xi). These concerns were a direct result of the growth of the nation's population, the stabilization of its political boundaries, the emergence of its economic strength and the sophistication of its ideological precepts. As Canada grew by immigration, the multi-ethnic reality of the nation continued to be subsumed under the myth of a national identity that accessed a "pure mythic time," in this case, the mythological uninhabited landscape, a strategy that could erase the social violence leading to nationhood (Hall 356). This social violence embraced imperialistic and genocidal policies towards Canada's First Nations, a colonial control exercised on French Canadians,[10] national immigration policies limiting and ghettoizing Chinese immigrants at the turn of the last century and the disenfranchisement and property appropriation of the Japanese-Canadians during WWII. This mythic time is echoed in Stewart W. Wallace's 1927 writing: "In the beginning was geography. The influence of geography on Canadian history . . . has been at all stages profound, but in no way more so than in stimulating the growth of Canadian national feeling" (9). But, Tippett observed that, in the 1920s,

> [w]illingness on the part of the ethno-cultural groups to operate within the parameters established by the "dominant culture" did . . . pay certain dividends. It represented a move away from the kind of rigorously assimilationist, melting pot approach. . . . It could also prompt abandonment of the worst of the old stereotypes. And, from the point of view of the "dominant" group, it certainly played a part in the nation-consolidating enterprise then very much underway (117).

The highlighting of the mastery of Asian ceramic practices in the Bronfman collection and the inclusion of the Chinese-Canadian Wayne Ngan, the Japanese-Canadian Satoshi Saito and the French-Canadian Louise Doucet Saito must be considered within the layers of social/political histories: is this an inflexion towards an erasure of violence or an opportunity for dialogue? Towards cultural appropriation or cultural inclusion? Surely, the viewers who bring to bear their own histories to the evaluation of the CMC collection decide this.

Tippett documents how, during the first fifty years of the twentieth century, in part due to the Arts and Crafts ideology, culture functioned on local levels, embracing amateur expression while encouraging professional development and integrating the European immigrant into a middle-class Anglo-Saxon Canada. Craft was extolled as essential to the construction of a civilized nation by writers and community leaders such as William Carless, professor of Architecture at McGill University, Arthur Lismer, member of the Group of Seven and educator, and M.A. Peck, president of the Canadian Handicraft Guild (Flood 64–65). The appeal of Canadian pottery lay in the fact that it *was* produced from the land, and, in line with the Arts and Crafts movement, the values of folk, local materials, inspiration from nature and the handmade appealed to both the maker and the consumer. These qualities were capitalized on in the productions of potters such as Emily Carr (Blanchard 161), Alice Hagan (Elwood 4), and Nunzia D'Angelo (Crawford 44), as well as Axel Ebring (Kingsmill 3), Peter Rupchan (Silverthorne 14–38) and Kjeld and Erika Deichmann (CMC *The Turning Point* 17). They were also invoked in the later part of the century when praising the ceramics of Wayne Ngan and Doucet-Saito.

Of the earlier potters, it was the Deichmanns who were seen to pull Canadian pottery clearly into the aesthetic of Modernism. Carless argued that the international Modernist movement, with its lack of decoration or relation to locale, was an impediment to the creation of a national craft aesthetic (4–5). However, international Modernism's de-emphasis on decorative programs for ceramic vessels was eventually reconciled with the

Arts and Crafts ideological need to link ceramic production with national ethos by invoking landscape through forms, textures, colours and the inclusion of local materials. Abstract landscapes of New Brunswick were evoked through the Deichmann use of glaze colours fused to Maritime clay bodies in a Danish modern aesthetic (Bonner 74). The Danish-Canadian Deichmanns also embodied the ideal of the studio potter: rural home and studio, professionally educated, influential friends within the cultural community and high national and international profiles (Inglis *Turning Point*). Although essentially self-taught ceramists, they were seen as quintessentially "professional"[11] and appropriate to present a brief on the arts and crafts to the Massey Commission (Report 11). Two decades later, Gordon Green made the important strategic link between their ceramic works and an Eastern aesthetic and practice when he compared their forms and glazes to Chinese Song Dynasty wares, "the golden age of Chinese ceramics" (98). This comparison has since been repeated when extolling the work of Wayne Ngan and Harlan House (CMC *Transformation* 59, 83). The urge to insert twentieth-century Canadian studio pottery within an Asian tradition continued with the pottery of Alice Hagan, a contemporary of the Deichmanns (Elwood 4). Hagan's work, fabricated with local materials, was described as an early expression of Japanese influence on British and American conventions of studio ceramics (Inglis "Company"178).

Robert Archambeau.
Jar with Bronze Cover.
1986. Stoneware, salt glaze. 21.2 x 20 cm.
Winnipeg Art Gallery
G-92-569 ab.
Photo: Ernest Mayer.

Ebring and Rupchan, as working immigrant rural potters in the early decades of the century, were linked to the European folk tradition, a positioning that was perhaps responsible for their delay in being celebrated at the national level. While these potters did sell their works at the time, were known regionally and were supported by local arts and crafts societies, it was not until 1977 that Ebring was recognized in a major publication, while a book on Rupchan did not appear until 1991. In 1997, Stephen Inglis included references to them both, along with Alice Hagan in "A

Company of Travelers: Some Early Studio Potters in Canada" (173–183). In retrospect, their pioneer approach to pottery can be seen as an historical precedent to Ngan's, but it is also possible that Ngan's national recognition opened the way for their widespread acknowledgment and their elevation from "folk" to "studio" potters. In fact, their re-inscription into the Canadian ceramic narrative in the 1970s was part of a larger philosophical movement that promoted exploitation of local land resources championed by Tam Irving, an educator and potter who is included in the Massey Collection (Flanders 42–45). Celebrated as someone who has created "a special relationship with the British Columbia environment" (Tibbel 79), Irving collected materials throughout the province to create glazes and inspire others, such as the members of the Cariboo Potters Guild, to explore the geology of their own local environment (Kingsmill 24, 92).

The entry of the European immigrant potters Peter Rupchan and Axel Ebring into the mainstream of Canadian ceramic culture in the late twentieth century and the inclusion in the CMC of works by new Canadian ceramists can be attributed, among other things, to the impact of the federal policy of multiculturalism[12] and to the shifts of agents in the economic, educational, political and cultural fields. The promotion of culture in 1978 was seen as important "so that Canadians will come to know the different environments as well as the different backgrounds of the peoples who inhabit all the pieces of this sprawling land" (Ostry 181). This position was formalized in the Fine Crafts Gallery Concept Statement for the projected Fine Crafts Gallery of the CMC, which was "to be devoted to demonstrating the development of Canada's cultural identity by showing the origins of immigrant cultures, the process of adaptation to a new environment and the continuing evolution of cultural expression" (Fine Crafts Gallery). The shift from an earlier exclusive and exclusionary definition of Canadian as white, masculine, northern and Christian (Grace et al. 8–9) is evident in the choices of ceramic artists for the Massey and Bronfman collections, including the Chinese-Canadian Ngan, the Japanese-

Canadian Satoshi Saito, Louise Doucet Saito, and the Zen-inspired works of Walter Dexter.

In an attempt to unify this diversity by seeking common ground, artists were suggested as "symbols of integration" (Fulford 4–5), while it was optimistically hoped that culture for a unified country could be built upon the romantic and idealistic appeal of the land (Woodcock 300). Interaction with the land was certainly one of the cherished things that communities in the west could claim in common with those of central and eastern Canada. In British Columbia during the 1960s, a return by some artists to landscape painting has been linked with the rise of the environmental movement in the province and a new awareness of, and relationship with, the vulnerability of the land. In 1977, Tippett and Cole described how "as more artists of diverse styles find a new visual experience in landscape, it seems that British Columbians are on the verge of another cycle of perception, perhaps a renewal of the ineffable bonds that tie people to the landscape around them" (137–141). The Canadian literary community emphasized the link between the land and the national character throughout the 1960s into the 1980s. Popular authors wrote of the role of Canada's wilderness in defining the country and Canadians.[13] Pierre Berton romantically proclaimed "we are a shield people . . . a wilderness people . . . (i)ts mystique affects us all. . . . Even as we threaten to fly apart, the love of the land holds us together" (95–97). The need for a focus on national identification was based on fears of self-destruction through Québec separation and American corporate and cultural dominance. In addressing the issue of Canadian cultural sovereignty, Susan Crean called for a national mythology, suggesting that ours was "conquering the trackless wilderness" (22). The inclusion of Doucet-Saito ceramics into a Canadian collection at a time when the Québec Sovereignist movement was flowering inserted a Québec vision of the land into the creation of the national ethos.

In 1982, Northrop Frye made an eloquent and emotional argument for Canada's national cultural consciousness to be linked to the conserva-

tion of the Canadian wilderness: "We were the land's before the land was ours" (79). The rise of the environmental movement in the 1960s and its subsequent growth was tied to both the Canadian national identity and the "back to the land" movement. In the Toronto World Craft Council's 1974 exhibition catalogue, *In Praise of Hands*, James Plaut, the secretary general, recognized the protest against establishment and industry that led many young people to abandon urban centres (10–11). In 1976, the Director of Sheridan College linked environmental deterioration with cultural deterioration, but saw crafts as a solution to the problem (Kelly 7) in much the same way that William Morris, in *News from Nowhere*, had done a century earlier. During the 1960s Arts and Crafts revival, many young people moved to the country to pursue a lifestyle dedicated to the protection of the environment and the use of natural materials, concerns which were recognized in 1984 as general national concerns (Inglis "Quest for Balance" 19–20). The environmental movement became increasingly visible during the late 1960s with the formation of local, provincial and national groups across Canada employing iconic Canadian paintings by Emily Carr and the Group of Seven to publicize the legitimacy and morality of their cause (Cooper interview), successfully lobbying the national government to enact new environmental protection legislation (Bryan 15). Between 1969 and 1972, ten parks were added to Canada's national park system, which grew to twenty-eight from the eighteen that had been designated between 1885 and 1957. The early years of national parks policy had seen a conflict between tourist exploitation and resource exploitation; by 1969, the policy focused on the preservation of the parklands from any exploitation (253, 256). The conflation of *Canadian* art, nationalism and environmentalism was heightened in the public eye.

This was the conceptual framework in which Canadian ceramic artists and Canadian writers on ceramic arts found themselves at a time when Modernism's taste for sparse decoration promoted the ceramic vessel by "putting it on a pedestal." Its artistic value was recognized, and its value shifted from the functional into the imaginary (Alfoldy 160). This trans-

formation is particularly evident in the CMC contemporary craft collection. In the 1970s, the Massey collection was conceived to celebrate functionality (Massey 5). In contrast, the Bronfman collection preferred to put ceramic objects on pedestals, particularly in the exhibitions and catalogues *Masters of the Crafts* and *Transformation*. Writers on ceramics were conscious of the shift, as throughout the 1960s and 1970s, pleas arose for ceramists to look to the Canadian landscape and the fine arts for inspiration in expressing national temperament.[14]

The transformation of the Canadian ceramic object from function to symbol involves what Mieke Bal calls "rhetorical strategies" and engages three tropes: synecdoche, metonymy, and metaphor (106). As synecdoche, the work of each artist links to similar work executed by other Canadian ceramic artists employing the same or similar strategies. Thus, the work of Robert Archambeau, whose glaze textures and colours have been described as evocative of the landscape (Brunner 7 and Walsh 29); of Tess Kiddick, whose angular forms are reminiscent of Northern Ontario (Crawford 13); of Les Manning, whose mountainscapes are created from layered clays and glazes; and of Richard Surette, whose Raku vessels make use of forest woods, local rocks and found antlers — all such work is linked to a national aesthetic and national ethos. These contemporary landscape-evoking ceramic vessels, collected and stored in museums, function as metonyms for the fragility of the Canadian wilderness areas, itself a precious commodity to be kept safe in the Canadian park system. These vessels stand metaphorically for the Canadian nation as imagined in the last half of the twentieth century and confirmed in the twenty-first — no longer white, northern, Christian, male and capitalist, but multi-ethnic, multi-cultural, female-inclusive and environmentally conscious.

At the turn of this century, landscape imagery continues to pervade

Richard Surette. *Weathered*. 2003. Stoneware, raku-fired, found antler, copper recuperated from Hydro Quebec lines downed during the Ice Storm. 68 x 41 x 13 cm. Photo: Steven Crainford.

the discourse of Canadian ceramic vessels. It is now subsumed within the umbrella of "identity" politics and conjoined with issues of globalization. Stuart Hall proposes that while globalization favours the development of supra-national identities within capitalism, the development of stronger local identities serves as a counterpoint. Movements in both these directions tend to threaten the modern nation as we know it (353–354).

Ann Roberts responded to this trend in her 1998 catalogue essay on Canadian ceramic identity produced for the exhibition accompanying the International Academy of Ceramics conference held at the Canadian Clay and Glass Gallery in Waterloo. She identified the image of landscape inscribed within particular locales as common to much of Canadian ceramics (47–48). As national identity effects negotiation within an increasingly heterogeneous global society, landscape imagery continues to present a common reference for many Canadian ceramists through which to engage contemporary theoretical issues.

NOTES:

1. In *Exhibiting Canada: Articulations of National Identity at the National Gallery of Canada*, Anne Whitelaw examines the performative power of temporary exhibitions to confront the pedagogical within the National Gallery. I believe that this analysis can be extended to include the performative power of private collections to challenge the pedagogical within the national museum system.

2. Jones made similar comparisons in his 1985 article for the Koffler Gallery's Doucet-Saito retrospective, which fulfilled the requisite exhibition requirement following presentation of the Bronfman Award.

3. Canada's colonial relationship to Britain gradually diminished legally, economically and culturally throughout the nineteenth and twentieth centuries. During this same period, the United States' economic and cultural influences on Canada increased, threatening Canada's economic and cultural sovereignty.

4. Osborne defines *Gemeinschaft* as a community that is local and immediate, a "lived-in landscape," which embraces day-to-day activities. These activities create evocative associations that symbolically charge the local place. He defines *Gesellschaft* as a society, an abstraction formed by constantly nurturing shared symbolic constructs among the members of the group and developing a sense of distinctiveness.

5. A fine example of the kind of discussion that arose in 1951 with the issue of the Massey Commission report can be seen in Wilfrid Eggleston, "Canadian Geography and National Culture," *Canadian Geographical Journal* 43.6: 254–273.

6. See W.J.T. Mitchell, "Imperial Landscape;" Gayatari Spivak, "Can the Subaltern Speak?"; and, from a Canadian literary standpoint, Susan Glickman, *The Picturesque and the Sublime* (Montreal and Kingston: McGill-Queen's University Press, 1998).

7. I am not suggesting that an American national ceramic identity is uniform or static; rather, I am recognizing that national anxiety about identity-creation in ceramic production has ceased to exist. See Garth Clark, *The History of American Ceramics: 1876 to the present*, (New York: Abbeville Press, 1987) and Elaine Lavin, *The History of American Ceramics from 1607 to the present* (New York: H.N. Abrams, 1988).

8. These publications include Elizabeth Collard, *Nineteenth-Century Pottery and Porcelain in Canada* (Montreal: McGill University Press, 1967) and *The Potters' View of Canada: Canadian Scenes on Nineteenth-Century Earthenware* (Kingston and Montreal: McGill-Queen's University Press, 1983); Robert Cunningham and John B. Prince, *Tamped Clay and Saltmarsh Hay* (Fredericton: University of New Brunswick, 1976); R.W. Finlayson, *Portneuf Pottery and Other Early Wares* (Toronto: Longman Canada Ltd., 1972); Serge Fisette *Les potiers québécois* (Ottawa: Éditions Leméac, 1974); George Maclaren, *Antique Potteries of Nova Scotia* (Halifax: Petheric Press, 1972); Philip Shackleton, "Potteries of Nineteenth Century Ontario" (Ottawa: Report to the Department of Northern Affairs and Natural Resources. Historic Site Branch, 1964); David Taylor and Patricia Taylor, *The Hart Pottery, Canada West* (Picton, Ontario: *Picton Gazette*, 1966); Donald Webster, *The Brantford Pottery: 1849–1907: History & assessment of the stoneware pottery at Brantford, Ontario, including results of excavations and analysis of products* (Toronto: Royal Ontario Museum. Division of Art and Archaeology. Occasional papers no. 13, 1968); *Early Slip-Decorated Pottery in Canada* (Toronto: C.J. Musson, 1969); *Decorated Stoneware Pottery of North America* (Rutland, VT: C.E. Tuttle, 1971); *Early Canadian Pottery* (Toronto and Montreal: McClelland & Stewart, 1971); and *The William Eby Pottery, Conestogo, Ontario, 1855–1907* (Toronto: Royal Ontario Museum, 1971).

9. Marius Barbeau, *Maîtres artisans de chez nous* (Montréal: Editions Zodiaque, 1941) and Jean-Marie Gauvreau, *Les Artisans du Québec* (Montréal: Editions du Bien Publique, 1940) did not neglect this subject, but specifically dealt with Québec.

10. *Nègres blancs d'Amerique* by Pierre Vallières (Montréal: Editions Parti pris) was published in 1967, and, in translation as *White Niggers of America*, in 1971.

11. Sandra Flood analyzed the view of professional vs. folk production within this time period. "Literature defines the studio craftsperson by class, income generation and formal education, which are components of 'professional'. . . . Studio, therefore, links craft to the elite fine arts and suggests a stronger emphasis on an articulated aesthetic, and on 'decoration' rather than 'function'" (219).

12. Multiculturalism arose from the "reluctant" discovery of the 1963 Royal Commission on Bilingualism and Biculturalism that Canadians in the west from a variety of ethnic backgrounds opposed the assumption that only two groups, the French and the English, founded Canada, as they, too, had contributed to the building of Canada. Thus multiculturalism "eventually came to be accepted as a reality by all federal parties." See Bernard Ostry, *The Cultural Connection: An Essay on Culture and Government Policy in Canada*, with an introduction by Robert Fulford (Toronto: McClelland & Stewart, 1978), 107. An in-depth examination of the current state of multiculturalism today and a critique of it in Canada can be found in Robert Stam, "Multiculturalism and the Neoconservatives," in Anne McClintock, ed., *Dangerous Liaisons: Gender, Nations and Postcolonial Perspective* (Minneapolis & London: University of Minnesota Press, 1997), 188–203.

13. Some of these writers include Pierre Berton, Margaret Atwood, Marion Engel, Northrop Frye and Farley Mowat.

14. These include James Koyanagi, "Japanese Arts and Crafts," *Ontario Craft* 2 (Nov. 1968): 19; Juror's comments, "Biennial Competition," *Tactile* (May 1969), n.p.; Peter C. Swann, "Introduction," *Craft Dimensions Canada* (Toronto, Ontario: Royal Ontario Museum, 23 September to 2 November 1969), n.p; and Hugh Wakefield, "International Ceramics," *Tactile* 6/5 (1972): 11.

WORKS CITED:

Alfoldy, Sandra. *An Intricate Web(b): American Influences on Professional Craft in Canada 1964–1974*. PhD Thesis. Concordia University, 2001.

Anderson, Benedict. *Imagined Communities*. New York and London: Verso, 1991.

Baker, Alan R.H. "Introduction." *Ideology and Landscape in Historical Perspective*. Ed. Alan R.H. Baker and Gideon Biger. Cambridge: Cambridge University Press, 1992.

Bal, Mieke. "Telling Objects: A Narrative Perspective On Collecting." *The Cultures of Collecting*. Eds. John Elsner and Roger Cardinal. Cambridge, Mass: Harvard University Press, 1994. 97–115.

Bal, Mieke and Norman Bryson. "Semiotics and Art History." *Art Bulletin* 73 (1991): 174–208.

Barbeau, Marius. *Maîtres artisans de chez-nous*. Montreal: Editions Zodiaque, 1941.

Berleant, Arnold. *The Aesthetics of the Environment*. Philadelphia: Temple University Press, 1992.

Bermingham, Ann. *Landscape and Ideology: The English Rustic Tradition 1740–1860*. Berkeley, Los Angeles, London: University of California Press, 1986.

Berton, Pierre. *Why We Act Like Canadians*. Toronto: McClelland & Stewart, 1986.

Blanchard, Paula. *The Life of Emily Carr*. Vancouver: Douglas & McIntyre, 1987.

Bonner, Mary K. *Made in Canada*. New York: Alfred A. Knopf, 1943.

Bourdieu, Pierre. *Distinction: A Social Critique of the Judgment of Taste*. Trans. Richard Nice. Cambridge Mass.: Harvard University Press, 1984.

Bovey, Patricia. "An Interview With the Artist." *Robin Hopper: Ceramic Explorations 1957–1986*. North York and Victoria: Koffler Gallery and the Art Gallery of Greater Victoria, 1987.

Brunner, Astrid. *Robert Archambeau: Vessels*. Winnipeg: Winnipeg Art Gallery, 1986.

Bryan, Rorke. *Much is Taken, Much Remains*. North Scituate, Mass.: Duxbury Press, 1973.

Canadian Museum of Civilization. *Masters of the Crafts: Recipients of the Saidye Bronfman Award for Excellence in the Crafts, 1977–86*. Hull: Canadian Museum of Civilization, 1989.

——. *Transformation: Prix Saidye Bronfman Award 1977–1996*. Hull: Canadian Museum of Civilization, 1998.

Carless, William. *The Arts and Crafts of Canada*. Montreal: McGill University. Publication Series 8 no. 4, 1925.

Collard, Elizabeth. *The Canadiana Connection: 19th Century Pottery: Collection of the Winnipeg Art Gallery*. Winnipeg: Winnipeg Art Gallery, 1998.

——. *Nineteenth-Century Pottery and Porcelain in Canada*. Montreal: McGill University Press, 1967.

——. *The Potters' View of Canada: Canadian Scenes on Nineteenth-Century Earthenware*. Kingston and Montreal: McGill-Queen's University Press, 1983.

Cooper, Kathy. Researcher, Canadian Environmental Law Association. Personal interview. 17 October 2002.

Crawford, Gail. *A Fine Line*. Toronto, Oxford: Dundurn Press, 1998.

Crean, S.M. *Who's Afraid of Canadian Culture?* Don Mills: General Publishing Co. Ltd., 1976.

Elder, Alan, "Leaving Footprints in the Museum." *Transformation: Prix Saidye Bronfman Award 1977–1996*. Ed. Canadian Museum of Civilization. Hull: Canadian Museum of Civilization, 1998. 23–30.

Elwood, Maria "Alice Hagan." *Women's Work*. Halifax Upstairs Gallery, Mount Saint Vincent University. 26 June to 30 August 1981.

Fine Crafts Gallery Concept Statement, 19 December 1985. *Bronfman Archives*. Canadian Museum of Civilization. Acq-97-F0009 B612 F2.

Flanders, John. *The Craftsman's Way*. Introduction Hart Massey. Toronto, Buffalo, and London: University of Toronto Press, 1981.

Flood, Sandra. *Canadian Craft and Museum Practice 1900–1950*. PhD Thesis. University of Manchester, 1998.

Frye, Northrop. *Divisions on a Ground: Essays on Canadian Culture*. Ed. James Polk. Toronto: Anansi, 1982.

Green, H. Gordon. *A Heritage of Canadian Handicrafts*. Toronto and Montreal: McClelland & Stewart, 1967.

Groth, Paul. "Frameworks for Cultural Study." *Understanding Ordinary Landscapes*. Ed. Paul Groth and Todd W. Bressi. New Haven: Yale University Press, 1997. 1–24.

Hall, Stuart. "Culture, Community, Nation." *Cultural Studies* 7.3 (1993): 349–363.

Hickey, Gloria. "Harlan House." *Hindsight: A Harlan House Retrospective 1969–1989*. North York: Koffler Gallery, 1991.

Inglis, Stephen. "A Company of Travelers: Some Early Studio Potters in Canada." *The Potter's Art: Contributions to the Study of the Koerner Collection of European Ceramics*. Ed. Carol E. Mayer. Vancouver: University of British Columbia Press, 1997. 173–183.

——. "A Quest for Balance." *Works of Craft From the Massey Foundation Collection*. Ottawa: Canadian Centre for Folk Culture Studies of the National Museum of Man, Balmuir Book, 1984.

——. *The Turning Point: The Deichmann Pottery 1935–1963*. Ed. Canadian Museum of Civilization. Hull: Canadian Museum of Civilization, 1991.

Jones, D.G. "Doucet-Saito." *Doucet-Saito: Concept in Clay*. North York: Koffler Gallery, 1985.

——. "Doucet-Saito." *Momentum in Clay*. Coaticook, Québec: Musée Beaulne, 1980.

Kelly, Giles Talbot. "Sheridan's Second Decade." *Craftsman* 1.3 (1976): 7.

Kingsmill, Bob. *A Catalogue of British Columbia Potters*. Bowen Island B.C.: Bob Kingsmill, 1977.

Lemay, Laurent and Susanne Lemay. *La Renaissance des métiers d'art au Canada français*. Québec: Ministère des Affaires culturelles, 1967.

Litt, Paul. *The Muses, the Masses and the Massey Commission*. Toronto: University of Toronto Press, 1992.

Massey, Hart. "Introduction." *The Craftsman's Way: Canadian Expressions*. By John Flanders. Toronto, Buffalo, and London: University of Toronto Press, 1981.

Mitchell, W.J.T. "Imperial Landscape." *Landscape and Power*. Ed. W.J.T. Mitchell. Chicago and London: University of Chicago Press, 1994.

Morris, William. *News From Nowhere* (1891). Ed. James Redmond, London: Routledge & Kegan Paul, 1970.

——. *On Art and Socialism*. Ed. Jackson Holbrook. London: John Lehmann, 1947.

Morton, W.L. *The Kingdom of Canada*. Toronto: McClelland & Stewart, 1963.

Ngan, Wayne. "Artist statement." *Bronfman Archives*. Canadian Museum of Civilization. Acq-97-F0009 B 607 F 1.

Osborne, Brien S. "Interpreting a Nation's Identity." *Ideology and Landscape in Historical Perspective*. Ed. Alan H. Baker and Gideon Biger. Cambridge: Cambridge University Press, 1992. 230–254.

Ostry, Bernard. *The Cultural Connection: An Essay on Culture and Government Policy in Canada*. Introduction by Robert Fulford. Toronto: McClelland & Stewart, 1978.

Pascoe, Joseph. "Australian Ceramics 1800–1960: Toward a National Style." *Ceramics Monthly* 47.4 (1999): 49–55.

Pfeiffer, Harold. "Appreciation of Past Would Enrich Canadian Ceramics." *Saturday Night*. 27 July 1946: 27.

Plaut, James S. "Foreword." *In Praise of Hands: Contemporary Crafts of the World*. By Octavio Paz. Toronto: McClelland & Stewart and the World Craft Council, 1974.

Read, Herbert. *The Meaning of Art*. London: Faber & Faber, 1951.

Roberts, Ann. "Identifying Identity." *A Question of Identity: Ceramics at the End of the Twentieth Century*. Ed. Ann Roberts. Waterloo: The Canadian Clay and Glass Gallery, 1998. 43–48.

Rose, Gillian. *Feminism and Geography*. Minneapolis: University of Minnesota Press, 1993.

Shadbolt, Doris. *Pottery by Wayne Ngan*. Vancouver: Vancouver Art Gallery, 1979.

Short, John Rennie. *Imagined Country: Environment, Culture and Society*. London and New York: Routledge, 1991.

Silverthorne, Judith. *Made in Saskatchewan*. Saskatoon: Prairie Lily Cooperative Ltd., 1991.

Spivak, Gayatari. "Can the Subaltern Speak?" *Marxism and the Interpretation of Culture*. Ed. Cary Nelson and Lawrence Grossberg. Urbana and Chicago: University of Illinois Press, 1988. 271–313.

Tibbel, Deborah, ed. "Tam Irving." *Made of Clay*. Vancouver: The Potters Guild of British Columbia, 1998.

Tippett, Maria. *Making Culture: English-Canadian Institutions and the Arts Before the Massey Commission*. Toronto: University of Toronto Press, 1990.

Tippett, Maria and Douglas Cole. *From Desolation to Splendour*. Toronto and Vancouver: Clarke Irwin, 1977.

Wallace, Stewart W. *The Growth of Canadian National Feeling*. Toronto: Macmillan, 1927.

Walsh, Meeka. "Robert Archambeau's Divine Pots." *Border Crossings* 16.1 (1986): 29–33.

Williams, Raymond. *The Country and the City*. New York: Oxford University Press, 1973.

Willis, N.P. *Canadian Scenery*. 2 vols. 1842. London: James S. Virtue. Facsimile Edition, Peter Martin Associates, 1967.

Wright, D. Henry. "Paradise Found." *Ontario Craft* 17.4 (1992): 6–11.

Woodcock, George. *The Canadians*. Don Mills: Fitzhenry and Whiteside, 1979.

The Brown Pot
and the White Cube

Paul Mathieu

The Morris and Helen Belkin Art Gallery at the University of British Columbia is a conventional institutional space for the display of art, for the provision of the necessary context for the experience of "art now." Experiencing the objects — pots — in *Thrown: Influences and Intentions in West Coast Ceramics*[1] in such a context creates a feeling of displacement; it provides a shock with its seamless combination of familiarity with newness and warm domesticity within the bland, "neutral" context of institutional display, what has come to be known as the "White Cube."[2] It makes one see the work in a new way, which is, after all, the point of such an exercise. The "White Cube" is a relatively recent development in the display and experience of art. The original intention of presenting artworks in this context might have been to interfere as

little as possible with the operative powers of the art itself, but its purposes are manifold. One of its main purposes is to make it obvious that one is having an art experience, if not always an aesthetic one per se. What I mean to say is that the context of the "White Cube" serves as a sign to inform viewers that all experiences taking place there are art experiences: one is in the presence of art. This semantic experience of the space is necessary because, otherwise, judging from the things on display, one might not be too sure of the kind of experience one was having. The familiar and specific qualities of the gallery space provide the clues necessary to understand the work as art. The other operative function of institutional display is to tell us that what we are experiencing is "good," "significant" and "important" art, because a selection has taken place, a rigorous choice has been made by authorities, by experts whose job it is to make these normative distinctions for us. The gallery space not only confers the status of art onto the objects it presents, it also implicitly confers importance and meaning.

View of Belkin Art Gallery, Gallery One, Tables 2-5, left to right: Leach Pottery Standard Ware and Leach Pottery Potters (including Bernard Leach, Michael Cardew, David Leach and Janet Leach); Ian Steele.

The experience provided by the gallery space in the exhibition *Thrown* is beautiful, and I, for one, was surprised how well these rather humble, ordinary and unassuming objects occupy the imposing space. Placed on simple table-like plinths, the sheer number of works presented signifies the general emphasis in pottery production practices on multiplicity and the sheer dynamism of the times, when this sort of pottery making was in its heyday. The effect combines the commonality of domestic objects with the transcendental art experience one expects in the gallery space. In most conventional institutional display contexts, the objects or experiences on view are changed drastically by a change of context. For example, if they were placed in the middle of a street, in most cases their meaning would be altered, very often to the point of meaninglessness. That is not the case for the objects on view in *Thrown*. These particular objects do not need the context of the art gallery to have meaning, to operate, to be understood

Belkin Art Gallery,
Gallery One, Table 8:
Michael Henry and Slug
Pottery. Stoneware.

and appreciated, to "work." Pots, like most craft objects, carry their own context implicitly. In fact, they are rather out of place in such a gallery context; they would be much more at ease in use in a kitchen or displayed in the domestic environment for which they were created in the first place. But, as is the case with any other object in an art gallery, this context confers on them instantly the status of art and, implicitly, of "good," "meaningful" and "important" art. Otherwise, they simply would not be there. And, like most if not all art made today, these pots need that context to be taken seriously as art. It is a particular obsession of contemporary experience that clarity of context is now essential for clarity of understanding. The particular physical context of the White Cube implies a loss in experience through removing the noise of life, but it provides a gain in symbolic meaning.

The work under scrutiny here has other, multiple contexts: material, technical, geographical and temporal, among others. I will let others explore these contexts elsewhere. I am not particularly interested in how, when, where and by whom any of these objects were made. While this is interesting and possibly necessary information for a complete understanding, in the end, it remains relatively superficial and at best incidental.[3] I am more interested in why these objects were made, how they operate,

what is (was) their role in our culture, what is their meaning and why make these kinds of objects at the end of the twentieth century in the first place? What is their importance? How do we experience them? What is their phenomenology? This is very much work about the experience of making first, of using, second, and, now, of viewing them in the particular context provided. This is deeply phenomenological work. Why also is it relevant to experience them at the Belkin Gallery or elsewhere in similar places? Why implicitly confer on them the status of art (good, important, significant, meaningful)?

Driving the making of these pots — these simple, unassuming, ordinary, humble yet beautiful and robust brown pots, made by hand, one by one — was their makers' utopian lifestyle. While I am aware that I am reducing a complex social context to a simple and possibly trite cliché, these objects embody an ideal. Their moral imperative is (was) to propose a better world, a different world from corporatist consumerism. Made by hand in a "new age" that was highly idealistic, they were produced in reaction to the prevalent culture of their days. Yet, interestingly, they situate themselves parallel to — and, often, in close proximity to — avant-garde practices current at the time. In fact, a reassessment of the deep relationship between craft practices and avant-garde practices in Vancouver and elsewhere at the end of the twentieth century is something that will need to be explored in depth. Such an eventual reassessment will shed a potent and very revealing light on aspects of art and culture that are so often perceived erroneously as distinct and unrelated. As the exhibition *Thrown* demonstrates clearly, it is acceptable to show these kinds of works only in isolation, as a separate phenomenon, distinct and disconnected from everything else happening simultaneously. This is a subtle form of ghettoization, of marginalization and segregation of culture. However, I am optimistic that an inclusive exhibition combining both aspects, avant-garde and craft practices, such as we have seen recently for Modernism,[4] will eventually take place, and this is something to which I look forward.

At this point, curatorial practices of display and acquisition as well as current academic theories of culture still position craft objects as separate and disconnected, when they are not simply ignored altogether, as if the craft phenomenon did not ever and still does not exist. The pots in *Thrown*, while deeply connected to avant-garde practices, were also positioned in a diametrical opposition to them. By being resolutely physical, material and tactile in their making, and through their privileging and appreciation of skill, process and mastery, they, possibly inadvertently, contested new art forms of their day. These art forms celebrated dematerialization, embracing mediation and new technologies, while the work in *Thrown* uses some of the oldest technologies known to humankind. Avant-garde art at that time embraced performance art and theatricality, whereas the aspects of performance and theatre present in these pots remain largely private and without real public significance.

Yet many similarities and parallels do exist between these craft and avant-garde practices. Both were socially informed yet utopian; both were generated within groups of tight-knit communities, and both used appropriation and precedence to generate new forms. Originality was not always a necessary attribute of the work, yet personality (alter egos, personas, etc.) played a larger role in avant-garde practices than it ever did in the craft world, where anonymity historically has been a rather common, if not necessary, aspect of the work. Most of the objects in *Thrown* are not signed. Many are simply stamped, and their forms refer more to historical models than to personal originality. It remains obvious that both avant-garde and craft practices were then, more than now, critical of society, of institutions and of the art world. Both contested, ignored or denied the existence of the market as an inevitable economy, seeking to propose new modes of exchange as well as new experiences and new forms of understanding. Their nature as multiples added to their accessibility and reduced the originality usually associated with expression in art, and it did so in a positive way, through a healthy emphasis on universality and anonymity.

What is important to realize and acknowledge is that the pots in *Thrown* are at core conceptual in nature, that they are true conceptual art. This is where their meaning lies. Any functional object is implicitly a conceptual object, something that is so often forgotten. Conceptually and stylistically, the most difficult and complex thing one can do in ceramics is and always has been to make pots. With the possible exception of the brick, pots are, by far, the greatest contribution ceramics as a distinct and specific art form has made to culture and civilization. This remains true today.

There are two main concepts at work in these pots, as in all pots ever made: function and decoration. Functional objects in ceramics are tools: they act on the world in three different ways. First, they act practically, usually as containers, combining binary oppositions in a non-hierarchical fashion (see my "Object Theory" in this volume). Second, they act semiotically as signs, encoding meaning and aesthetics. Thirdly, and this is too often forgotten, they act as archives — of time, of knowledge and of experiences. Ceramic objects are instant fossils; of all man-made archives, ceramics is still the most efficient. It is cheap, non-recyclable, and, even in its fragility as a shard or fragment, it retains its archival potential to communicate important cultural information. Thus, one of the main cultural functions of ceramics and pottery is to act as an archive. This has been true historically, and it will continue to be so in the future.

This is how the objects in *Thrown* find their most potent reason to exist. Images work only as signs and not as practical, functional tools. And, contrary to what we have been led to believe, images do not work very well as archives, at least, not for very long. Ceramic objects are conceptually much more complex than images, since they alone operate on all three levels — the practical, the symbolic and the archival. They fix time, memory, knowledge and experience with skill, which is something too easily forgotten or ignored. Interestingly enough, both these important

Belkin Art Gallery,
Gallery Two, Table 17
(detail): Charmian
Johnson. Stoneware.
Photo: Chick Rice.

concepts, function and decoration, which played such essential roles historically in culture, were largely forgotten or dismissed by Modernism as well as by most contemporary art practices. We might make an exception for design, which is itself largely a Modernist construct. Design, by definition, embraces function, yet it largely denies the validity of decoration. Modern art denied function since it violated the false precept that art, by definition, is useless. It denied decoration for its connection to beauty and seduction, insisting that art must, on the contrary, shock and confront. The decorative was perceived as trivial, excessive, superficial and superfluous, while art must be deep, profound, necessary and essential.

If the objects in *Thrown* are quite obviously and proudly functional, they are much more discreet as decoration. Was this function utilitarian in a practical way, or was it essentially contemplative and aesthetic, rendering these objects not dissimilar to other art objects? It is probably a very interesting and complex hybrid of both. It is worth questioning how many of these objects were actually used. How many still are, especially now that they have been granted the status of important art? Yet few of them are decorated or even decorative in an obvious way. They have a specific and very characteristic aesthetic presence, which is stylistically close to — but obviously distinct from — Minimalism. It is important to

note that basic Modern and Minimalist aesthetic principles have always existed in pottery making and other craft practices. But this is a debate for another time. The aesthetic presence of these pots is classical, with multiple historical references. There is a strong sense that certain forms and shapes are ideal and perfect, and that their basic structure need not change radically over time. The emphasis is on volumetric form and less so on surface, on these unassuming yet beautiful, deep, dark, brown glazes. To refer here briefly again to the historical context, these brown glazes first appear during the Tang Dynasty (618–907) in China, at the very beginning of truly glazed high-fire stoneware. Thus the genealogy of these objects extends in time directly, in an uninterrupted manner, for 1300 years or so. How many contemporary phenomena, within art or elsewhere, can make such a claim?

Of course, their more direct ancestry is the Leach aesthetic (England, circa 1930–1970), combining aspects of Chinese, Japanese and English pottery sensibilities in the middle of the twentieth century, within the major developments of Modernism. It is interesting and important here to note that the Leach movement, of which these pots are not only a part but a major contribution, was a true international movement. These types of pots were made (and are made still) all over the world and all over Canada. The British Columbian contingent is very important, in part for its more-or-less direct connection with the Leach pottery in St Ives, Cornwall, but also because of the exceptional quality of the work as representative of the type.

These pots can only be understood in the light of this global movement, much as Vancouver photo-conceptualism, for example, can only be understood and appreciated in the light of its international manifestations. I wonder where photo-conceptualism in Vancouver would be now if it had been treated with the same institutional neglect as has been the work in *Thrown*? By way of comparison, this type of work has had a very dynamic presence in Australia, where examples of objects such as these can be found in art institutions all over the country, up to and including in

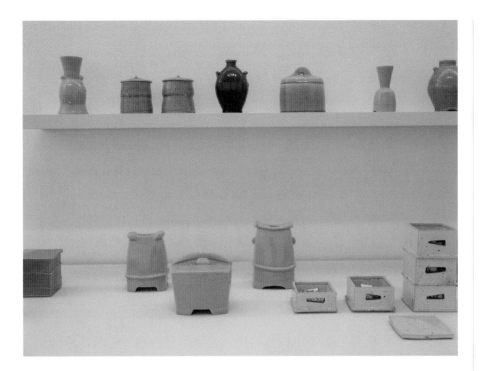

the National Gallery of Australia. I am afraid this is not likely to happen in this country anytime soon.

If I do not want to expand here on the material and technical aspects of these pots, it remains important to note how incredibly difficult and demanding it is to make these kinds of objects, with their simplicity and directness, in an experimental context and in a place where a precedent in tradition did not exist. These pots are highly experimental in nature. They may be perceived as traditional, but what they really are is experimental and conceptual, as experimental and conceptual as anything else taking place in culture at this time. The sheer amount of technical and material knowledge required, the capacity to understand and be capable of building essential tools and equipment, to say nothing of the economic difficulties of marketing such products in an unsupportive environment are impressive. This all transpired in a context in which there was no infrastructure, no professional gallery, no real market beyond cheap giftware and no institutional support of any kind. To this day, there is not one

single serious venue in Vancouver for the exhibition and marketing of objects of this type. The only cultural institution in Vancouver with a national mandate, the Canadian Craft Museum, closed recently without anyone seeming to notice. To this day, it is almost impossible to find examples of these kinds of objects in Canadian art institutions except for very limited and provisional regional holdings, something that amounts to nothing less than a national shame. To paraphrase First Nations artist Brian Jungen, to be an artist in craft practices in Canada, one must address at some point the fact that the art gallery is inaccessible.

These pots, which were not so much the result of an individual activity, but, instead were deeply connected to a certain idea of community, are, in the end, in so many ways, failures. Ideologically, their utopian roots and reactionary foundation led nowhere; the world simply continued its march without paying much attention other than simply to turn these kinds of products into (cheap) commodities. They also failed socially, as the practice of this type of craft in the world we live in is basically unsustainable and largely perceived, again erroneously, as irrelevant. And they failed economically, as the market — again, in the absence of institutional support that could have lifted the field to another level of pricing — has no need for these kinds of objects beyond their limited function as markers of social status and particular taste in domestic displays. Obviously, the present world has no need whatsoever for these kinds of objects in a practical, functional way. All these failures may simply explain why so many of the makers represented in *Thrown* eventually gave up being potters, shifting their practices to other activities. The few who were able to continue often held teaching positions, basically subsidizing their pottery practice. This partly explains why so few of them are still practising potters today.

If these pots failed miserably on ideological, social and economic grounds, aesthetically, they succeed admirably. The aesthetic experience they provide for us, which is deeply sensual beyond the visual, is still profound. They remind us that some experiences are universal and timeless,

that we all have them, always have had them, and, hopefully, always will have them. They are not grounded in the now, in the fleeting and impermanent contemporary; instead, they seamlessly connect the past with the present and the future. Due to the particular properties of ceramic materials, their extraordinary permanency and resilience to time, these objects, like all similar ones preceding them, act as the memory of humankind. In the distant future, they will embody the particular time in which we now live, again, as an archive of this time. That is not only their potential, it is their responsibility. The pots in *Thrown* are made with mastery and confidence, and their operative power remains in their display. Their whole existence is justified by the aesthetic experience and the critique they so effectively provide. This important, seminal exhibition at the Morris and Helen Belkin Art Gallery demonstrated this fact with sensibility and rigour, and I salute the foresight and courage of its curators.

NOTES:

1. The exhibition, held 30 January–30 May 2004, was curated by Lee Plested and Scott Watson with Charmian Johnson. As described in an accompanying brochure, the exhibition focused on work from the "Vancouver studio pottery movement of the 1960s and 1970s," a movement influenced by Bernard Leach. In fact, of those featured, "four apprenticed at the Leach pottery, one had a strong connection to him and two arrived at a similar practice independently."

2. The term "White Cube" was originally coined by Irish-born artist Brian O'Doherty, whose lecture at the Los Angeles County Museum of Art in 1975, "Inside the White Cube: The Ideology of Gallery Space," was reprinted in three issues of *Artforum* in 1976 and re-issued as *Inside the White Cube: the Ideology of the Gallery Space* (Berkeley and Los Angeles: University of California Press, 1999).

3. Renowned German art historian Heinrich Wöfflin (1864–1945) proposed the creation of an "art history without names," choosing to focus instead on stylistic, conceptual and psychological aspects of works of art.

4. Several exhibitions featuring a range of objects including art, craft and design come immediately to mind: *Modernism: Designing a New World 1914–1939* (Victoria and Albert Museum, London, 6 April–23 July 2006); *Cool '60s Design* (Canadian Museum of Civilization 25 February–27 November 2005); *A Modern Life: Art and Design in British Columbia 1945–1960* (Vancouver Art Gallery 15 May–3 October 2004); *Designing a Modern Identity: The New Spirit of British Columbia, 1945–60*

(Kelowna Art Gallery 8 June–9 September 2001). Important catalogues and texts accompanying exhibitions include *Victoria Modern: Investigating Postwar Architecture and Design on Southern Vancouver Island: an Introduction* (Victoria: Maltwood Art Museum Gallery, University of Victoria, 2005); *Made in Canada: Craft and Design in the Sixties*, ed. Alan C. Elder (Montreal and Kingston: McGill-Queen's University Press, 2005) and *A Modern Life: Art and Design in British Columbia 1945–1960*, eds. Ian Thom and Alan Elder (Vancouver: Vancouver Art Gallery and Arsenal Pulp Press, 2004).

Irish Studio Ceramics of the Twentieth Century: An Outline of its Origins and Evolution

Michael Moore

 This paper comprises a series of reflections based on a two- to three-year period of research cataloguing and analyzing the evolution of studio ceramics in Ireland since 1950. Normally, I am a maker of, rather than a writer on, ceramics, and my paper explores the experience of analyzing production from the perspective of a maker within an Irish context. While it is true that writing about practice takes time away from the very practice it aims to describe, it is important that an accurate record of the tacit knowledge of that practice be preserved. This record incorporates the history and understanding of a people and a way of life from the perspective of a maker, which is essential if we are to preserve a full range of options for the future.

It became apparent at the beginning of this research that no one, not

even a maker of ceramics, had ever attempted to compile a history of contemporary Irish studio ceramics. Since, at the outset, I had no idea how to write about ceramics, the methodology evolved as the research did. All the time, the words of English potter Julian Stair were in my mind:

> Modern crafts [sic], for the first time, seems to be interested in going back and looking at its own history. So if makers aren't going to get involved in writing the definitive history of their own past, not only are we going to have to have inaccuracies about our work in a contemporary sense, but also inaccurate versions of the history of our own discipline written for us. So I think it is imperative that makers are involved in writing in a contemporary vein as well as on the historical developments in our field (16).

With these words in mind, I set about to research that experience in the light of Irish history, culture and identity. The cultural landscape in which studio ceramics evolved in Ireland in the twentieth century is one that could be considered a wasteland for anyone other than the writers and poets of Ireland. Justin Keating, former Minister for Industry and Commerce and Chairman of the Crafts Council of Ireland, perhaps described it best:

> The whole thrust of our cultural preoccupations was verbal. Remarkable playwrights, novelists, poets, a great focus on the Irish language and on traditional music and song, but the concern with material culture was slight. The brightest children of the new proprietors of small farms were busy making money in the retail trade, primarily drink, and their grandchildren were rushing to become doctors, lawyers and priests. Their ideal of a beautiful house was a "desirable bungalow residence" the type that would have been at home in Cheltenham or Croyden. They furnished this in the style of British mass-produced furniture and textiles of the time, either imported directly or copied here. There was no "William Morris" strand of national revolution. The thirties, forties and fifties were a time of terrible pious petty bourgeois respectability; for the craftsman and the artist, a period of disaster (232–33).

Topical debate stresses the need for makers involved in the applied arts to write about their practice, as, for example, with the University of

East Anglia Research fellowships in the United Kingdom. Makers might write about their own histories, the histories of their predecessors or their contemporaries. English potter Julian Stair was one such research fellow. If this research activity was lacking in the past, Pamela Johnson may have touched on the reason for this:

> Is the silence or reluctance to talk about practice in some way connected to a long tradition of not writing about craft? Historically craft knowledge was not written down, but guarded and protected in guilds and handed down through the apprentice system. However in today's fast moving culture, and a craft community now dependent to some extent on public funding, it seems impertinent to expect others to talk intelligently about crafts if those within the field are not prepared to do so (10).[1]

So where did this landscape, this "period of disaster" leave ceramics, or craft practice in general in Ireland? During the 1730s, Belfast merchant John Chambers established the Worlds End Pottery in Dublin, which was taken over by Captain Henry Delamain in the 1750s (Francis 206). The Worlds End Pottery had three registered offices in Dublin before its demise at the turn of the nineteenth into the twentieth century: on Mary St., Henry St., and Moore St. If one were to look at a map, one would see that these streets all intersect, so it could well have been the same pottery site with different street entrances.

Mass U.K. pottery production put an end to this venture, as the Worlds End Pottery could not compete with U.K. import prices. The pottery itself was not the only thing to be imported. When Philip Pearse set up Carrigaline Pottery in 1928 in County Cork, he actually imported the craftsmen to design and make his wares. The Carrigaline Pottery flourished during the Second World War:

> The war years proved a successful era in the history of the pottery. Great Britain, the source of most imported ware, redirected its industrial output in the cause of the war effort, leaving the domestic market to the Irish potteries (Doyle 3).

In 1962, Justin Keating, the same man whose comment above defines the desperate times of the visual arts in Ireland up to the 1960s, commissioned *The Scandinavian Design Report*:

> *The Scandinavian Design Report* of 1962, edited by Paul Hogan and Coras Tractala [The Irish Export Board], identified the problems facing industrial design in Ireland, namely, a general lack of design awareness in the country, inadequate higher education for designers in art colleges and universities and the absence of effective design managers (Caffrey 1997 373).

Selected designers from Scandinavia were invited to Ireland to survey the standard of Irish design and make recommendations as to how design or the industrial applied arts could be bettered within an emerging independent nation. The designers did not find much to get excited about. They had, however, very positive comments to make about stamp design, coinage, and Donegal tweed and hand weavers. Art Education and industries such as pottery were found to be highly underdeveloped:

> The main criticism of the Ceramics Industry was that what was produced was based on bad English production both as regards design and form, decorated with transfers which had been imported from England and elsewhere. The solution was in the education and training of decorators, casters and printers. They stressed the importance of smaller potteries in design innovation as well as providing opportunities for individual potters to develop their work (Caffrey 1998 39).

Recommendations were made by the designers, which led to the setting up of the Kilkenny Design Workshops. Again, artisans were imported into Ireland. This time, however, their responsibility was to establish studios and workshops and to research local materials. This led to extensive glaze research by Dutch artist Sonja Landweer, who also explored the use of local clays.

The Scandinavians surveyed potteries in existence during this period. Educational structure incorporating design and applied art training, by which young designers and craft practitioners could be educated and ex-

posed to the best design and production practices, was missing. It might be a coincidence, but the publication of the *Scandinavian Design Report* occurred at the same time that Friedrich Herkner, Head of the National College of Art and Design, Dublin, approached Peter Brennan to teach ceramics. John Turpin wrote in *A School of Art in Dublin since the 18th Century* that Peter Brennan was responsible for introducing the concept of studio pottery (384).

Peter Brennan, born in Dublin in 1916, set up the first studio pottery in Ireland in the Bull Ring, Kilkenny City, in 1945. This was on the land of the Smithwicks Brewing Company. Another potter, John ffrench, born in 1928, later became a co-director of this "Ring Ceramic Studio" with Brennan and Dublin-based gallery owner, Victor Waddington. ffrench set up his own studio pottery within Arklow Pottery in Co. Wicklow in 1962. Brennan remained in Kilkenny until 1962, at which time he returned to Blackrock, a suburb of South Dublin, to begin a pottery class in the Blackrock Technical College.

Gratten Freyer, born in Cambridge, England, set up Terrybaun Pottery in Co. Mayo in 1948, having apprenticed with Bernard Leach in St. Ives, Cornwall. Brennan and Freyer both took their inspiration from the St. Ives Pottery of Bernard Leach. Freyer worked as an apprentice there for one year with his wife. During this time, Brennan visited Leach, as recalled by Peter Brennan's widow, potter Helena Brennan. She reported Peter noting:

> I met Bernard Leach at St. Ives who invited me to join his workshop, but as I had a commitment to Victor Waddington to establish a craft pottery in Kilkenny (the first in the south of Ireland).[2] I was unable to take up his offer. However, I stayed for 10 days and became friends with David Leach. Bernard was the philosopher who made occasional appearances, but David ran the day-to-day routine. He was a tower of strength and has given us much help over the years (Brennan).

It can be argued that, even given their pioneering spirit, these burgeoning Irish artist potters, like their more industrial counterparts, looked

to the U.K. for aesthetic inspiration and studio practice guidelines. But what other option did they have? Where could they go to understand how to build kilns, or process clay and glazes, without going to the U.K.? As the Scandinavian designers reported, fine and applied art education in Ireland was limited and underdeveloped. Underdevelopment did not mean no one tried to change this. The design and implementation of the Scandinavian Design Report and the introduction of new courses in the Art Colleges in Dublin and Cork paved the way for a new generation of applied artists who set up practice in Ireland in the 1960s and 1970s.

Even as far back as the 1930s, Kathleen Cox, a graduate of what was then called the Metropolitan School of Art, set up her studio behind Molesworth Street in Dublin, where she made slip-cast figurative ceramics. If you were to walk onto Kildare Street from the location of her studio, the first building you would encounter is the Ministry for Trade and Industry. The façade depicts all the trade industries in Ireland on a small, first-floor balcony. The cigarette, electricity, engineering and boat-building industries are depicted. But as one turns the corner from Kathleen Cox's studio and looks up at this balcony, one can see the image of a potter throwing a pot on a small panel of the balcony. Although the pottery industry was considered by the Scandinavians to be underdeveloped and over-influenced by the U.K., it was recognized by the government of the Republic of Ireland as an industry that did exist, and, occasionally, it did flourish.

Although, Cox, Freyer, Brennan and ffrench were active through the mid- and late-twentieth century in Ireland, they represent the only evidence of studio ceramic practice in Ireland that was not intended for mass production. It was not until the 1970s that the first evidence of a studio ceramic movement began to emerge in Ireland. Writing in 1997, Michael Robinson, retired curator of the Ulster Museum in Belfast, describes a landscape not dissimilar from the one described by Justin Keating:

> My involvement in contemporary ceramics in Ireland began thirty years ago. At that time ceramics meant pottery and pottery meant a limited range of kitchen and dining room wares in orthodox, earth fire colours, all accep-

table to the official Bernard Leach School of the perfect pot. There were forays into more experimental vessel forms most of which could trace their inspiration back to the Far East but practically everything made was done so as to fit into a modest domestic situation. There were exceptions to the rule; Europeans moving to Ireland brought a modernism that had little to do with Leach (12).

At this point, history might have repeated itself in terms of studio ceramics in Ireland. With the exception of Sonja Landweer moving to Ireland in the 1960s from the Netherlands, from where did the ceramists who, with the financial encouragement of the Irish government, set up studios in places like West Cork come? For the most part, they came from the U.K. The difference this time was that graduates from art schools such as the Camberwell School of Art set up studio potteries in Ireland. They also began teaching in Ireland. The ceramics produced — and still produced today — are of excellent evolving quality. But, once again, the aesthetic is imported. It is only in the 1980s with the graduates and apprentices of these studio ceramists and potters that one finally begins to see the emergence of some form of cohesive identity for Irish studio ceramics. Soon after, however, the Irish government, which had encouraged rural craft practice in Ireland, pulled the funding for potters and other practitioners, which left many with a sense of alienation and suspicion in quite remote parts of Ireland (Turner).

Reliance on an imported aesthetic generated another consequence. The ceramists who graduated from the Royal College of Art and Camberwell School of Art during the 1970s and 1980s represent a revolution in ceramics in Britain. Much has been written about the revolt against the Leach style. However, I feel the cultural context of this revolution should be considered. While these makers were students in London in the 1970s, fashion, values and music were also in a state of revolt. The Clash, The Sex Pistols and The Jam were all thrashing out their angry youthful rebellious sounds. That spirit of rebellion was also reflected in the visual arts. That revolution never took place in Ireland in terms of ceramics. There was little indigenous applied art to revolt against in studio ceramics. The

movement was still too young to produce a second generation of practitioners wanting to buck the established system or aesthetic.

That is not to say that ceramics in Ireland has not evolved. Consider makers such as Katharine West, an Alfred graduate (1990), Claire Curneen and Deirdre McLoughlin. Each is a maker of clay sculpture that is challenging and innovative, but each has an international portfolio that sets her apart from other contemporary Irish makers. Curneen lives in Wales, McLoughlin lives in the Netherlands, and West travelled to France and the USA for her formative education.

To illustrate this emphasis on an international career, consider Claire Curneen. To date, Curneen's production is material specific: ceramic. Early works such as the two standing pieces in the collection of the Ulster Museum in Belfast are made of terracotta clay. Later works are predominantly porcelain. However, Curneen's solo exhibition, *Succour*, at the Ruthin Craft Centre in 2003, included slip-cast as well as hand-built elements. Glaze and lustre elements reflect moments of loss or sorrow, pain or hurt in works imbued with a sense of waiting and fatigued anticipation, yet still alive and surviving. Her inspiration ranges from Bill Viola's video installations to Renaissance artist Andrea Mantegna. *Figure with tree* (2003) reflects a sense of patient anticipation.

The addition of a second element, the "tree," is a new departure in Curneen's work. It creates a sense of place, a location, crossroads or, perhaps, a meeting point that transforms the isolation of Curneen's earlier works. Although often exhibited in groups of two or more, early works such as *Standing Figures*, in the 1997 Irish Contemporary Ceramics national touring show (Fielding 15), or *Standing Figure*, exhibited in the 1999 Ceramics Monthly Sculpture competition at NCECA, in Columbus, Ohio, USA, conveyed collective alienation. With *Figure with tree,* the two elements of the piece are certainly connected. This evidence of evolution is reflected in the words of Amanda Fielding when she interviewed Curneen in Cardiff in October 2003:

> With hazy images of her early figures in my head: awkward postures, bony hands "as large as shovels" (her simile), roughish modelling and dark fis-

sures, I can tell these bodies have moved on. The handling of the material — still porcelain — is more assured, more sensitive, and there are no black cavities. The poses are more varied and relaxed, the forms less mannered. Arms, which used to hang stiffly at the sides, are now more often bent, with hands entering gestural relationships (15).

Fielding also considers the change in separation and isolation in Curneen's work:

> Spiky trees, their branches stretching out like multi fingered hands, often appear alongside the figure, connecting it to the landscape, diminishing its sense of alienation in the world (16).

Perhaps emigration is one of the ways truly to challenge applied art practice in Ireland. Ireland is an island, linked to only one other country across a border established just eighty years ago. Otherwise, one has to go overseas to get anywhere. This insularity may have created a unique literary and musical culture, but that culture is not evident in the ceramic arts. Why is this the case? It is the case because the history is not there yet. The history is too young. It has been argued that the reason for this stems from years of colonial dominance. What does a nation do when constantly faced with enforced transience both nationally and internationally? It carries its culture in music and song, stories and poetry. It cannot manifest its cultural identity in a period of transience by making things that define that culture, only to be forced to leave those things behind at the next period of transience. The culture had to be light, memorable and transported in the mind, one of the reasons why studio ceramics in Ireland is still an emerging practice.

At this point one can consider the words of Michael Robinson in relation to the evolution of ceramics in Ireland in the twentieth century:

> There were exceptions to the rule; Europeans moving to Ireland brought a modernism that had little to do with Leach. A few daring or eccentric individuals were exploring the properties of clay and its process for their own ends, and, of course, there were those people able to make the vessel an experience of much more than the utilitarian. However, there was no doubt about the fact that the early seventies in Ireland was the age of the pot (17).

We can now reflect on these comments written a decade ago, offering an analysis of craft practice from forty years previous. Many of those potters are still potting, as they moved to Ireland from the U.K. and Europe to set up studios and begin new enterprises. Now they are employing younger potters. The establishment of ceramics in education has allowed for ceramics to develop within both the apprenticeship and the academic arenas. The Crafts Council of Ireland has operated a pottery skills course for many years now. Students in art colleges in Ireland attend this course during and after their degree courses, testifying to its standards and rigour.

To conclude, the evolution of ceramics in Ireland has stemmed from a craft background that was seriously revamped due, in part, to the visit by the Scandinavian designers in the 1960s and the subsequent arrival of European practitioners throughout the 1960s and 1970s. These practitioners are now established and senior in their respective fields of expertise. They have trained and educated the next generation of practitioners and applied artists. It may be that now, at the beginning of the twenty-first century, ceramics in Ireland will define itself as a new movement in the applied arts.

NOTES:
1. This opens a question that may only come from a maker's perspective: If writers are asking makers to write, should the writers not also start making? It defines a personal dilemma for a practitioner who has tentatively embarked on a new direction: writing about contemporary craft practice in Ireland. Why do this? The reason in my case reflects Pamela Johnson's words. If I didn't, who would? Someone had to take the plunge and down tools for a period of time and compile this research. And, yes, as the tools were downed, it became increasingly difficult to make ceramics, to the point where I stopped completely, only beginning to make again when I completed the research. What I concluded from that is that writers should be careful what they ask makers to do; otherwise the writers will have nothing to write about because the makers will have no time to make if they are to meet the demands of contemporary craft criticism, through writing about their practice. Writing about one's own practice is certainly a viable and challenging method of developing one's work, but it takes time out of studio practice. Some makers seem to be able to exist in both worlds, but it would be presumptuous to

believe that all makers can do this just because some can. This poses the same question from a different perspective: Why do this? This was done because time was running out. Some of these practitioners were elderly or ill and if their history was not documented soon, it would be lost forever. I was frustrated researching when I seemed to be the only one who was conscious of the need. It turned out my concerns were not without foundation. One practitioner, Sarah Ryan (1952–2000) did pass away through illness during the research timeframe, but I had interviewed her beforehand. Also, at the time of her interview, it became apparent that this was the first and ultimately the only time the artist had been formally interviewed.

2. In reference to "the south of Ireland," the twenty-six counties of Ireland, excluding the Ulster counties, have formed the Republic of Ireland since the 1920s.

WORKS CITED:

Barnard, Rob. "Rob Barnard interviews Julian Stair and Edmund de Waal." *Ceramics Art and Perception* 38 (1999): 14–18.

Brennan, Peter. "The early years. Pottery 50 years ago." Unpublished notes from the archive of Peter Brennan's widow, Helena Brennan.

Caffrey, Paul. *Contemporary Designers*. Ed. Sara Pendergast. Detroit: St. James Press, 1997. 373–74.

Caffrey, Paul. "The Scandinavian Ideal, a model for design in Ireland." *Scandinavian Journal of Design History* (Copenhagen) 8 (1998): 32–43.

Doyle, Paul. *Carrigaline Pottery, 1928 to 1979*. Dublin, 2001.

Fielding, Amanda. *Claire Curneen, Succour*. Ruthin, Denbighshire, North Wales: The Ruthin Craft Centre, 2003.

Francis, Peter. *Irish Delftware, an Illustrated History*. London: Jonathan Horne, 2000.

Johnson, Pamela. *Ideas in the Making*. London: Crafts Council, 1998.

Keating, Justin. "Contemporary Crafts." *Ireland and the Arts*. Ed. Tim Pat Coogan. London: Namara Press, 1986.

Robinson, Michael. *Irish Contemporary Ceramics*. Dublin: Irish Contemporary Ceramics, 1997.

Ryan, Sarah. Interview by author at her Cashel studio, Ireland, 2000.

Turner, Jim. Interview by author at his Co. Cork studio, 1999.

Turpin, John. *A School of Art in Dublin since the 18th Century: A History of the National College of Art and Design*. Dublin: Gill & Macmillan, 1995.

Archetypes, Prototypes and Artefacts: Formal and Conceptual Connections Relevant to the Ceramics of Pablo Picasso

Léopold Foulem

 This lecture will discuss formal and conceptual links that can be established with the ceramics of Pablo Picasso (1881–1973). It will explore a diversity of sources available to Picasso, which he might well have consulted to nourish his ceramic output. Through his intelligent, thoughtful and innovative use of ceramic archetypes, prototypes, and artefacts, he created a highly singular ceramic oeuvre. What my lecture will also demonstrate is the importance of research conducted by artists, who are well-positioned to recognize the utopic potential of thinking generated through the haptic experience of material practices. My experience as a maker alerts me to the depth of Picasso's understanding of the specific properties of ceramics as a material, his familiarity with its compelling archive of historical objects and the degree to

which this intimate knowledge shaped meanings embodied in his ceramic work. My understanding enables me to make connections and draw conclusions about Picasso's working processes, which arise within the ceramics discipline itself.

To begin, it should be pointed out that "Archetypes, Prototypes and Artefacts: Formal and Conceptual Connections Relevant to the Ceramics of Pablo Picasso" is a continuation of my on-going research on Picasso. This exciting endeavour started well over twenty-five years ago. The angle I will explore today is another step in the explanation, understanding and interpretation of Picasso's production in clay. This is not a definitive evaluation, but, rather, a work-in-progress. Nevertheless, this presentation will corroborate some hypotheses presented in my earlier texts, and it will offer new ones.

Before delving into the substance of this subject, let us briefly review some significant facts pertaining to Picasso's major contribution to ceramics. Contrary to popular belief, the encounter between Picasso and ceramics was not a fortuitous incident, nor was it a one-time-only event. As the catalogue *Picasso and Ceramics* demonstrates,[1] his involvement with pottery started at the end of the nineteenth century, before he left Spain for Paris, and it is possible to trace other episodes that precede his better-known and very productive Vallauris sojourn. Nevertheless, it is in 1946, at the age of sixty-five, that his interest in ceramics became consequential. According to Dominique Bozo, the first director of the Musée Picasso in Paris, 3,222 ceramic objects were in his private collection when he died on April 8, 1973. His total output is estimated at around 4,500 pieces.

More than thirty years after his death, the extent of his whole production is still not known. To this day, there is no catalogue raisonné of his ceramics, and many preparatory drawings for them are still to be exhibited. Admittedly, these facts complicate somewhat the task of independent research. Nevertheless, it is possible to assess fairly the aesthetic and conceptual value of his outstanding and exceptional contribution to ceramics.

Possible connections between Picasso's fired clay objects and the discipline of ceramics constitute the primary interest of my research. Picasso's ceramics fascinate me because they are more than ceramic objects — indeed, much more than that. Establishing and exploring links confirming bonds between Picasso's work and the wider ceramic corpus are focal points of my investigation into this domain. One might postulate that ceramics made by Picasso are true to paradigms present in a given group of related works. Pursuing this idea, then, permits one to demonstrate not only how his pieces relate to the prototypes, but also to identify innovations within the general category.

His ceramics are not inventions in the literal sense, because they are not new forms. They are syntheses. Even his most singular objects, such as the spectacular *Female Faun* of 1947–1948 (cat. 16/frontispiece), made at the beginning of his involvement with the Madoura pottery in Vallauris, are appropriations. This piece is a minimal structure constructed with forms borrowed from the pottery lexicon. The volumetric component within each form dominates. If there is a group of works where his celebrated "*Je ne cherche pas, je trouve*" applies, it is to the ceramics.

When I travelled to Europe in the fall of 2002, my main objective was to find artefacts and publications that were plausible sources for some of Picasso's ceramics. The Picasso archives at the Musée Picasso in Paris seemed the appropriate place for discoveries. An exhibition held in 1988 at the Musée led me to believe that Picasso could have used printed material as sources for his ceramics.[2] This exhibition had already shown the role printed material such as ethnographic postcards played in the preparatory sketches for the famous painting *Les demoiselles d'Avignon*. In addition, two of Picasso's close friends alluded to his considerable book collection, leading me to suspect that it was in this collection that some of his ideas might have originated.

In 1933, Françoise Olivier wrote in *Picasso et ses amis* that, when they moved out of the Bateau Lavoir, "they had to purchase some furniture because they had not much to carry from the old studio besides paintings,

easels and books." Photographer David Douglas Duncan states in *The Private World of Picasso* (1958): "He owned thousands of books but kept them in crates in the attic. . . . His library lay on tables wherever he first unwrapped them or around his bed." It seems that no inventory or catalogue of the thousands of books he owned exists, to the detriment of researchers. A document in the Picasso archives mentions only a few of them.

During that trip, I did not find as much material as I had expected. Luckily, I found *Les poteries françaises* by François Poncetton and Georges Salles in a second-hand bookstore specializing in decorative arts. Since then, this 1928 publication has become a primary resource confirming the cross-fertilization of Picasso's ceramics with a group of French historical pots. In addition, this well-illustrated monograph of traditional French earthenware pottery illustrates a surprising symbiosis between Picasso and Suzanne Ramié, the owner of the Madoura pottery, in that it corroborates the important role photographic images of ancient ceramic forms played in the establishment of the contemporary ceramic corpus of them both.

An eighteenth-century Pilgrim's Bottle (fig. 100/196), from Languedoc, illustrated in *Les poteries françaises*, became *Gus* (cat. 141/125) in 1942 through the initiative of Suzanne Ramié. Nine years later, Picasso transformed this vessel into *Gus with Insect* (cat. 40/197). A lunch pail (cat. 134/196) is another historical French pottery shape borrowed from the Poncetton and Salles book. This nineteenth-century artefact is from the Île-de-France Yvelines region. Once invested with Picasso's inventiveness on 17 March 1957, it became *Pot du laboureur with a bacchanalia scene* (cat. 69/198–99). In 1953, Picasso also painted a traditional blue and white surface on a nineteenth-century flower brick from the same area, metamorphosing it into *Anthropomorphic Vessel*.

In 1998, in a lecture entitled "Sources and Resources," I speculated that *The Photographic Encyclopaedia of Art* was a likely source for some models Picasso could have appropriated. Some time before that lecture, I had found the fascicule number 15, dated 1 February 1937, of *The Photo-*

graphic Encyclopaedia of Art, by chance, again, in a bookstore in New York City. That instalment featured antiquities from Carthage, Elche and Cyprus. A reproduction of a Bronze Age *Composite Vase* (fig.99/195) from Cyprus, dated from 2300 to 2000 BCE, reminded me of the architectonic allure of Picasso's 1951 *Tripod Vase with Head of a Woman* (cat. 41/194). A closer examination of this publication shows very clearly that other ceramics by Picasso may have had their origin in this booklet.

The Photographic Encyclopaedia of Art is a fully illustrated record of art works. Initially published in 1936, it was sold either as fascicules or as a hardcover book. Numbers I, II and III are devoted to the art collections of the Louvre Museum in Paris. Issue II contains the largest number of examples that might have been used for the ceramics made in Vallauris. Picasso probably consulted these three volumes at one time or another. However, he may have used other sources. One must also bear in mind that those objects were in the Louvre collections and, since he lived in Paris over a long period of time, Picasso might actually have seen them when he visited the museum. One could possibly argue that Picasso's famous sculpture *Head of a Bull* of 1942, which combines a bicycle seat and handlebars, has its formal ancestor in a nineteenth-century BCE *Copper Sculpture from Tello* representing a wild bull, also called *Bos Primigenius*, which the Louvre owns.

A study of Suzanne Ramié's work sheds light on the starting point of some of Picasso's clay pieces. An undated drawing (fig. 97/195) by Suzanne Ramié of the Cypriot red clay composite vase from Vunus, also in the Louvre and included in instalment II, provides irrefutable proof that she knew of the bilingual *Photographic Encyclopaedia of Art*. Many correlations support this fact. The discrepancies between the size of the original and her own *Vase tripode* (cat. 72/128) is an indication that she did not make the drawing after the piece in the Louvre, but rather after a photograph of that piece. The Vunus artefact is 33 centimetres high, whereas the one from Madoura is 75 centimetres. Picasso's version of the tripod vase exists as an edition as well as an artist's copy.

Since the *Picasso and Ceramics* catalogue tackles this subject only briefly, I will discuss other examples not mentioned in that text. Let us return to that most important fascicule 15 from volume II, the same one that contains the Cypriot Terracotta Vase. The juxtapositions of these two images could let one think that Picasso himself knew about *The Photographic Encyclopaedia of Art*. Anne Baldassari, director of Musée Picasso in Paris, mentioned to me that Dora Maar (1907–1997), Picasso's mistress at one point, had some instalments of this encyclopaedia in her personal library. In order to support that assertion further, let us take Picasso's 1947 *Seated Women* (cat. 5, 6/162–63) and compare it to a Boetian Modelled Image of a Seated Idol from the archaic period, on page 167 of the *Encyclopaedia*. A second artefact on page 154 reinforces my point. Let us now compare this sixth-century BCE Cypriot Oinochoe with Horizontal Bands and *Pitcher with Pitchers and Nude* (cat. 56/246) by Picasso, dated 11 January 1954, also called *La Source*. One should pay attention to the narrative content of the pot, not to its shape. A modelled female figure, perhaps Aphrodite, holding a smaller oinochoe, stands on the belly at the base of the spout. A description of the historical artefact states that it usually designates a vessel with a figure in the act of pouring, a type of pottery that dates from the archaic Greek period to the Roman times, with Eros accompanying Aphrodite. We should keep in mind that the already discussed wild bullhead, *Bos Primigenius*, came from the same volume. All of these examples provide evidence that Picasso might well have had access to this illustrated source.

Perhaps a Greek vase from the fifth century with Kore crowned with foliage, from Volume III of *The Photographic Encyclopaedia of Art* is a more convincing model related to *Pitcher with Pitchers and Nude*. This same volume gives us additional material for discussion. A fourth-century white ground funeral lekythos with a painted female figure dressed in a traditional chiton, holding, in one hand, an alabaster lamp and, in the other, a flat basket, recalls the veil covering the dancers on Picasso's *Large Vase with Dancers and Musicians* (cat. 34/52–53) of 24 June 1950. This piece is

in the Musée d'art et d'histoire in Saint-Denis, on the outskirts of Paris. It is an artist's copy inscribed to the French poet Paul Éluard. Picasso himself painted this vase, taken from a series of edited forms, making it a unique piece. One can speculate that the a posteriori decision to cover the female nude with a translucent drapery is a reference to the frescoes of the Sistine Chapel, which Picasso had visited only a few months earlier.

Before we set aside *The Photographic Encyclopaedia of Art*, let us review the process, the steps an artefact would have gone through before becoming a Picasso. Suzanne Ramié borrowed another model from that same volume III on page 69. It is an oinochoe "with a trefoil lip and a belly shaped like a fish, sustained by fins that take the place of feet." In 1950, Madame Ramié made a sketch of this Etruscan vessel from the sixth century BCE. She took care this time to indicate the measurements of the vase. She called that form a *Tarasque* (fig.69/126) and glazed it with the traditional *alquifou* (lead glaze). In 1953, Picasso appropriated the form and turned it into a *Zoomorphic Pitcher* (fig.70/126), now in the collection of the Museu de Ceràmica in Barcelona.

A truly exciting exhibition could be devoted to the formal exchanges between Picasso and his "teacher" Suzanne Ramié, and to their respective affinities with the history of ceramics. The better one knows the range of the pottery forms generated by the Atelier Madoura, many of which, regrettably, are not catalogued, the greater the number of connections one can establish with Picasso's ceramics. Furthermore, it is clear that Mme Ramié's approach to pottery was compatible with Picasso's own. Both were ceramists rather than potters. The autonomy of the form, more than the making process itself, was their main objective.

Even if it is always a matter of "theft," Picasso's own word, artistic exchanges between Suzanne Ramié and Picasso can be divided into two categories. One group consists of Picasso's appropriations of Suzanne Ramié's own models, and the other consists of forms taken from actual studio production. As an example of this latter category, one can identify various pieces of the Louis XV dinner set, such as the fish plates, which were

magisterially transformed into stadiums with a bullfight (cat. 74/234). The edges of these oval platters were transformed into bleachers. The scene depicts an aerial view of a bullring. At times, the curve of the shadow emanates from the contour of the arena, which is transposed onto the volumetric space fashioned by the well of the container.

Suzanne Ramié's own pots are less standardized than the pieces made at the pottery. Her forms are straightforward, often without decoration. Such a refinement of form combined with architectonic qualities implies that she had to make prior studies to arrive at these shapes. It is known that she drew on *Les poteries françaises* and *The Photographic Encyclopaedia of Art* for some of her works. However, she could have studied at least a third source. Some of Suzanne Ramié's own ceramics share common characteristics with the standard production wares illustrated in two articles published in catalogues of the Faïenceries Massier located on the French Riviera. Such a conclusion is warranted by the fact that a large number of Ramié's forms appear to be inspired by Massier's prototypes found in one single publication. It is worth considering that Jules Agard (1905–1986), thrower at the Madoura pottery, had previously worked at one Massier factory. However, a closer look at the whole of the production of Madoura reveals that many forms are too idiosyncratic to be universal; they are not visually as neutral, as a sphere or a cylinder can be.

These examples are published in the catalogue of the exhibition *Massier, l'introduction de la céramique artistique sur la Côte d'Azur*, held in 2002 at the Musée Magnelli, Musée de la céramique located in Vallauris. This publication reprints two catalogues listing the factory's merchandise for sale to customers. For the purpose of argument, I have selected four pages that convincingly establish the lineage. However, these are not the only instances where similarities exist within this group of documents.

Let us consider carefully page eighty-eight from the catalogue for the Manufacture de faiences d'art Clément Messier in Golfe-Juan. A closer look at the top row of samples, the *Series A*, shows that the fifth, sixth, and ninth vases have obvious affinities with Picasso's *Carved Bottle* of 1959,

which, as a matter of fact, blatantly appropriates one of Suzanne Ramié's pieces. Links can also be established with *Bourrache provençale*, also "stolen" by Picasso. The *bouteille kabyle* found on page nine of this catalogue is the twin sister to Mme Ramié's bottle. Perhaps *Series B* is more convincing when Picasso's *Vase with Two Handles* (cat. 55/67) of 1954 is compared with items four, five and ten. One has to admit that the similarities are even greater. Another probable model is on page ten of the same source. Connecting the *bougeoir kabyle* on the bottom left of the plate from the Art Pottery Factory with the *Candle Holder* covered with a traditional green galena glaze of 1945, by Suzanne Ramié, is not difficult. It is worth mentioning that pieces from Clément Massier were presented in the exhibition *Palissy à Picasso* in the summer of 1949; Picasso could have seen them on that occasion.

It is also important to note the relationship between the 1947 *Green Fish Lamp Base* by Suzanne Ramié and an ancient Peruvian pottery *Fish Vase* illustrated in *La décoration primitive: Amérique précolombienne*, a book written by Daniel Real and published in 1922 by the Parisian editor Calvas. Picasso could have employed a second artefact as a prototype, Nazca vase with handle and spout with fisherman hauling a fish net, from this same book, keeping the intrinsic volumetric quality of the container as a component of the final image. This formal characteristic is also seen in oriental pottery.

The fact that a second object illustrated in Daniel Real's book was used as a prototype shows that books indeed offered sources for the ceramics. This last hypothesis is mentioned in the catalogue *Picasso and Ceramics* when Picasso's *Jug with Bull with Yellow Banderillas* of 17 April 1957 (cat. 72/237) is discussed. This jug is part of the *Éditions Madoura* production. A third possible proof lies in the numerous stirrup vases illustrated in *La décoration primitive: Amérique précolombienne*. They remind one of the "Aztec" vases, as they were called in the Madoura catalogue, which Picasso transformed into artist's copy, such as the *Undated Vase Aztec*. The formal associations between pre-Columbian pottery and Picasso's ceramics are

plentiful. A number of other ones are referred to in the catalogue *Picasso and Ceramics*.

It is equally possible that other kinds of artistic relationships with pre-Columbian ceramics and the oeuvre of Picasso exist. A comparison of Mexican Terracotta Figurine of a Woman with double face, from Tlatilco, dating from between 1300 and 700 BCE, with works by Picasso such as *Seated Woman*, a painting dated 24 April 1938, or even with a folded metal sculpture, *Jacqueline with a Green Ribbon*, circa 1962, reveals surprising similarities.

PREPARATORY DRAWINGS

Even if I knew of the existence of the preparatory drawings that Georges Ramié mentions in his 1975 book *Les céramiques de Picasso*, I did not pay attention to them until fairly recently, because they apparently had no direct link with the ceramic tradition. Of course, it was obvious that the eccentric constructions imagined by Picasso, such as *Black Bird*, 1954, referred to the inherent volume of pottery forms and prototypical historical forms. This group of early pieces reminds one of the stirrup vases of pre-Columbian Peru, such as those mentioned earlier, which were illustrated in *La décoration primitive: Amérique précolombienne*. The preparatory drawings were little known then, and some of them are still unpublished.

In the winter of 2003, as we were scouting European collections and looking for works for the exhibition *Picasso and Ceramics*, a fundamental change of attitude occurred after meeting with a curator at the Louvre in Paris. During a conversation with curator Mme Annie Caubert, of the department of Oriental Antiquities, I enquired if the specimens we sought to borrow had been illustrated before 1946 in publications other than *The Photographic Encyclopaedia of Art*. I wanted to know if Picasso could have used some of them as sources for the preparatory drawings. She replied that they probably had been documented in the *Corpus Vasorum Antiquorum*.[3]

The *Corpus Vasorum Antiquorum* is a major enterprise to promote the collections of ancient ceramics under the tutelage of L'Union académique

internationale, to which twenty-six countries have belonged since its inception in 1921. This encyclopaedia of ancient pottery forms is presented by themes, by country and by museum. For instance, one volume is identified as *Great Britain — Fascicule 2, British Museum — Fascicule 2* and so on. Would I be able to locate images in some books that would permit me to establish credible links with the intriguing preparatory drawings?

To answer this question, I decided to comb through as many volumes of the *Corpus Vasorum Antiquorum* published before 1946 as I could find, searching for illustrations that might compare with my set of photocopies documenting Picasso's drawings. After completing this exercise, it appeared very clear to me that, in fact, certain plates had inspired many of the drawings. I can safely state that it is quite possible because, on the one hand, the formal prototypes on one given page of preparatory drawings and on a precise plate from the *Corpus Vasorum Antiquorum* have affinities, and, on the other hand, the number of corresponding artefacts and drawings in a fascicule is high. I discarded any fascicule that had only one ancient pottery form corresponding to a mate on a sheet of drawings. If more than one plate from a single fascicule could be connected to the drawings, I retained it as a possible source.

At the end, a pattern became obvious. The quantity of congruent features linking the illustrations to the drawings leads to the conclusion that Picasso likely consulted more than one instalment of the *Corpus Vasorum Antiquorum*. Many of the items selected by Picasso are Cypriot in origin. Notably, both sides of a given plate could have been used as a source for some drawings. This, to me, is a major argument in favour of Picasso examining that document. Furthermore, in one instance, the disposition of the drawn animals on the sheet of paper is the same as that of the artefacts pictured on the plate to which they relate — that is, one left and one right, facing each other. Usually, more than one artefact was adapted from a single plate as a point of departure for a drawing.

I am not interested in correlations between drawings dated 1 October 1947 showing *Studies for Ceramic, Reclining Kid* (cat. 90, 91/104) and the

actual work (cat. 13/105), an early ceramic dating from the beginning of Picasso's involvement in Vallauris and now in the Musée Picasso in Antibes. However, the possibility that a third-century BCE southern Italian vase in the shape of a stag, illustrated on page sixty-four of volume III of *The Photographic Encyclopaedia of Art*, could have been a prototype for the *Reclining Kid* engages me much more. There are models in the *Corpus Vasorum Antiquorum* that resemble this Italian vase more closely. However, the Italian vase in the shape of a stag and the askos in the shape of a duck (cat. 113/200), which is the likely source for Suzanne Ramié's duck flower brick of 1950 (cat. 140/129), are on the same page sixty-four of *The Photographic Encyclopaedia of Art*. This requires further examination as it is more convincing and serves my goal better.

An analysis of two drawings for the *Reclining Kid* shows the lines are straightforward and fluid; the image is minimal and direct. The sheets are numbered at the bottom with Roman numerals, which is significant. It suggests a progressive evolution in the studies, and, as Picasso made more drawings on successive sheets, it becomes more difficult to recognize the original model.

The drawings demonstrating the closest affinities with certain objects in the fascicules of the *Corpus Vasorum Antiquorum* are those that are the least resolved aesthetically and those with scribbles. Let us consider *Studies for Ceramic Zoomorphic Forms* of 30 September 1947 (cat. 88/100; cat. 89/103). The vase located on the bottom left with a ribbon-like foot resembles a group of Cypriot vases found in the *Corpus Vasorum* from the Louvre (France 341). They can also be compared to an artefact on Gr. Brit. 45, Br. Mus. II C. c Pl. 1 in *Great Britain — Fascicule 2, British Museum — Fascicule 2* published in 1926. The aim of this exercise is to demonstrate that the so-called preparatory drawings are not inventions, as was emphasized earlier, but rather interpretations, because they are constructed with models appertaining to the history of ceramics. A connection with the discipline is then justified.

Using once again the same plate Gr. Brit. 45, Br. Mus. II C. c Pl. 1 with

the vase with ribbon foot (number 22), one can establish a formal kinship between the Cypriot vessels with side handles on the bottom row and quite a number of pots usually referred to as *Vases chouette à tête de faune*, such as a specimen dated 9 November 1952, held in a private collection. Cypriot antiquities with the same profile are on plate Gr. Brit. 56, Br. Mus. II C. c Pl. 12 of this same publication. The reconstruction of the owl vase is accomplished by superimposing one of the Cypriot vases on top of the other upside down. For that matter, the image can be seen as two different animals: an owl with two wings set on top of a faun head with a pair of horns. Gr. Brit. 62, Br. Mus. II C. c Pl. 18 recalls the *Pitcher with Pitchers and Nude (La Source)* (cat.56/246), 11 January 1954, in a private collection, mentioned earlier, when links with *The Photographic Encyclopaedia of Art* were discussed. This ceramic, called *La Source*, is an edition dated 11-1-54. There is a difference at the pictorial level in this piece. The liquid pours directly on top of the head of the female nude until it forms a pool at her feet. It is also important to notice the sizable number of fish dishes reproduced on Gr. Brit. 92, Br. Mus. IV E. a Pl. 12. This theme recurs in Picasso's output, as a work in the collection of Marina Picasso, *Plat Espagnol with Fish and Slice of Lemon*, dated 17 April 1957, manifests. However, in this case, the central motif found on the Greek prototypes was transformed into a slice of lemon.

When I was preparing this lecture, I intended to use only one instalment of the *Corpus Vasorum Antiquorum* as a support for my thesis that Pablo Picasso could have consulted this compendium for the preparatory drawings for the ceramics made in Vallauris. I had to revise this decision because, on the one hand, he could have used at least four fascicules, and on the other hand, the fact that there is more than a single source increases the probability that it was indeed a data bank for Picasso's preparatory drawings. Credible formal connections can be demonstrated with two of the volumes that document the collection of the British Museum in London. Another volume devoted to the Louvre Museum in Paris, *France — Fascicule 5, Louvre — Fascicule 4* was most probably used as a reference

too. However, the most convincing of all the instalments deals with the Sèvres Museum collection, *France — Fascicule 13, Sèvres — Fascicule unique*. The latter was published in 1935.

The second plate from *France — Fascicule 5, Louvre — Fascicule 4 Louvre II C a Pl. 4* is included in the catalogue *Picasso and Ceramics*. The vase number 7, a ship vessel, which has a group of modelled figures set around the rim of the container, is the same artefact as that illustrated on page 146 of Volume II of *The Photographic Encyclopaedia of Art*. It is possible that this vessel in the Louvre inspired Picasso to fill the raised edge of the oblong plates with spectators, transforming the plates so ingeniously into bullrings. A 1957 *Black and White Bullfight* form was presented in the *Painter and Sculptor in Clay* exhibition.

Even if formal kinships can be established between the preparatory drawings and, among other things, the mentioned *Corpus Vasorum Antiquorum*, it is fair to say that Picasso never copied a prototype faithfully, as was the case with Suzanne Ramié when she drew from photographic sources. Picasso metamorphoses his appropriations progressively; as the numbers on the sketches increase, the forms depart further from the original. The preparatory drawings show appropriations that are closer to borrowing than stealing.

Let us return to *Corpus Vasorum Antiquorum, Great Britain — Fascicule 1, British Museum — Fascicule 1*, published in 1925, comparing several of Picasso's drawings with artefacts in Gr. Brit. 4, Br. Mus. II C. a Pl. 4. Due to its eccentricity, a vase on the lower left with a handle reminiscent of, at first sight, a lung attracts attention. This is a Cypriot Antiquity from the Bronze Age. On Picasso's *Studies for Ceramic, Zoomorphic Forms*, 30 September 1947 (cat.89/103), one can trace this easily recognizable form resting on two bases similar to pots turned upside down at the bottom right. It is also likely that pot number 23, which could have been drawn upside down, was used as the feet of those two architectonic constructions. This vase is the one before last at the bottom right of plate 4. A formal lineage may be observed when the superb *Large Bird on a Base* (cat. 57/102),

1947, which Picasso gave to the Antibes Museum, is juxtaposed to the plate just mentioned. It is one of the masterpieces in its major collection of ceramics by Picasso. As far as we know, all the preparatory drawings were not actually transformed into ceramic forms. Nevertheless, the volumetric models were obviously conceived after historical pottery prototypes.

Let us go back to the same plate showing antiquities from London's British Museum. At least three other drawings by Picasso relate closely to plate 4. Like the one mentioned directly above, this one is also dated 30 September 1947, and another is dated 16 September 1947. All have sketches resembling the lung-shaped vase (number 19). There is an additional reference on that same plate, namely to the top part of the bottle with side handle — the second vase to the left identified with the numeral 20, or the next one to its right. This exercise might seem tedious, but it is one effective way to decode this series of preparatory drawings and subsequently confirm connections with published literature. Trying to find a logical order to them is useless, because they were not conceived this way. Often there is no top or bottom, and, in some instances, the bottom is the top and vice versa. It is the same situation for each side of the sheet. The signature does not provide an indication of the orientation either, since it is applied only when the drawing is completed. Its position depends solely on how the sheet was placed at that precise moment.

By examining a drawing of 1 November 1947 upside down, I can provide evidence that images from the *Corpus Vasorum Antiquorum* might have served as sources for some preparatory drawings. In comparing vases from this drawing to the source, Gr. Brit. 4, Br. Mus. II C. a Pl. 4, formal correspondences emerge. Placing vase number 2 or even number 23 from the source above an elliptical form on Picasso's sketch, one can observe a link between them. Moreover, another appropriation from that instalment documenting the collection of the British Museum appears at the bottom row, number 20. It is possible to connect the Cypriot artefact to two other forms sketched by Picasso on the page dated 1 November 1947. The cones

visible in the greyish smudged area and adjacent oval are keys to deciphering the links. One more plate, Gr. Brit. 34 Br. Mus. III H. f, Pl. 4, from the *Great Britain — Fascicule 1, British Museum — Fascicule 1*, depicting a group of runners on the Panathenaic vase 2b at the bottom centre, deserves to be analyzed. A pairing may be made by comparing this model to the stylized figures depicted on the surface of *Pitcher with Runners* in the collection of the Picasso Pavilion in Hakone Japan. A second plate in this fascicule depicts an antique vase with runners. The fascicule devoted to the Sèvres Museum also includes, on III H f et H g Pl. 17 (France 546), a Panathenaic Amphora with Running Athletes in the black figure style.

One additional drawing made the same day, 1 November 1947, helps to substantiate very convincing relationships with the *Corpus Vasorum Antiquorum* dedicated to the collections of the Musée de Sèvres. The less sophisticated the state of the study, the better the chances one can find its source. The vase on the bottom of this drawing could be the brother to the large vessel at the centre of Musée de Sèvres II E et II F Pl. 12 drawn upside down. In this sketch, other vases can be deciphered, such as the long neck bottle (number 8) above vase 19.

The composition of Pablo Picasso's 1904 *Studies with Nude with Raised Arms*, an India ink sheet of sketches, lacks coherence and order within the whole page. For example, the figure in the centre is a motif that has been reused to form a decorative frieze in a 1906 watercolour called *The Blue Vase*, in the collection of the Metropolitan Museum in New York. Would it be too bold to pretend that the rather hemispherical form situated right above the head, precisely between the two raised arms of the female nude, is an allusion to Paul Gauguin's 1889 *Ceramic Vase with a Grotesque Self-Portrait* (cat. 136/159)? Could we also presume that the stylized face on the front side of the container is an ancestor to numerous *Head of a Faun* motifs painted by Picasso on numerous dishes made at Madoura (for example, cat. 7, 8, 9/176–77)? Can one trace a connection from this 1904 work to drawings from various *Studies for Ceramics, Zoomorphic Forms* (cat. 86/99) made by Picasso on 24 September 1947?

Let us consider the spectacular and unique *Bull* from 1947, one of his major ceramic pieces in the Musée Picasso in Antibes. What formal and conceptual aspects can one discover when analyzing it meticulously? At first glance, it is easy for a ceramist to figure out that this zoomorphic structure has been erected using two inverted pots joined together. This system of modular construction has precedents in the history of ceramics. The ancient Haniwa ceramics from Japan or the elegant Amlash bull vessels from the early first millennium Iran are good examples. Arriving at such a pure form implies a deconstruction process, in which the new image is reconstructed using pre-constructed volumetric forms. Suzanne Ramié selected the same kind of formal tactics to make her *Small Horse* of 1944. Combining thrown parts to build an image is an age-old practice in ceramics. Picasso worked the same way in this series of preparatory drawings, such as an undated *Unsigned Drawing*. The *Bull* from the Antibes Museum has a surface reminiscent of classical Greek pottery. It is an eloquent example of the formal relationships between pottery and image, which Picasso carried through his practice as artist potter. To arrive at the volumetric structure manifested in that piece, one could connect two Mycenaean pots from Cyprus, perhaps appropriated once again from the *Corpus Vasorum Antiquorum Great Britain — Fascicule 1, British Museum — Fascicule 1 Gr. Brit. 14, Br. Mus. II C. b Pl. 2*. The configuration that results from joining together those two pots appears to substantiate these relationships.

A pre-Columbian Chancay Vase from Peru might have been another source of inspiration. This vessel was illustrated in the July 1924 issue of the American periodical *The Arts*. The July issue depicted this vase in a review of the book *Histoire des beaux-arts de l'ancien Pérou*, published that same year in Paris by La Société du livre d'art ancien et moderne. The photographic reproduction might have served as formal origin for the two connected vases on the right of Picasso's drawing. Supporting such speculation is the fact that, in the previous year, in issue number 4, April 1923, *The Arts* included the interview "Picasso Speaks," and this period-

ical was on sale in at least four Parisian bookstores at that time. Based on the evidence provided by these two documents, *The Arts* and the monograph *Histoire des beaux-arts de l'ancien Pérou* reviewed in the July issue, it is highly likely that Picasso was acquainted with and had access to photographic images of Pre-Columbian pottery.

Marilyn McCully and Michael Raeburn write in *Picasso: cerámica y tradición, Ceramics and Tradition* (Málaga: Museo Picasso Málaga, 2005) that Manuel Gonzáles Marti reportedly gave Picasso a set of his great work on medieval ceramics, *Ceramica del Levante español: Siglos medievales*, published in three volumes between 1944 and 1952. This fact lends further credence to the assumption that Picasso had been looking all along at books on ceramics while conceiving his own ceramics.

Picasso's ceramics look as if they were built as a succession of geological strata, as might be imagined from observing both the formal and conceptual nature of the objects themselves. They appropriate and transform implements or tools proper to the craft of pottery. A banal stacking stilt stuck at the bottom of a bowl, such as is the case in late-thirteenth- to early-fourteenth-century Polychromatic Ceramic Plate from Paterna, Valencia (fig. 87/190), becomes a predominant feature of a stylized faun face in *Plat Espagnol with Faun and Owl* of 28 April 1957, in Hakone, Japan. The *Gazelles* transform large convex clay slabs used in wood-firing as kiln furniture for either stacking props or bag wall. The convexity of these refractory clay forms accentuates and affirms the volumetric character of the figures painted with slips. Picasso's compositional strategy of separating form and surface as distinct components of ceramic forms is radical. This can also be observed in the surface painted on the exterior wall of locally purchased, domestic culinary utensils, which Picasso transformed into pseudo-Greek vases. A *Pignate provençale* (cat. 35/207), appropriated in 1950, depicts a reclining man holding a drinking vessel in his right hand in the style of red figure vases.

The mnemonic value of signs is a major component of Picasso's conceptual practice. *Vase with Musicians and Female Nudes* (cat. 49/228) of

1953 is a vase that looks uncompromisingly like a vase. The outline of the form is austere, conventional in shape, and minimal in appearance. This simplicity accentuates the nature of the ceramic vessel. Here, the vase becomes an image, a sign. The strata alluded to earlier are here obvious, readable — not as part of a narrative — but as the essence, the fundamental structure, of the work. The reddish surface of the vase suggests Greek or terracotta pottery. The applied geometric vignettes with incised drawings have been pinned on the exterior wall of the pot, reminding one of the trompe-l'oeil monochromatic faux-prints found on vessels throughout the history of ceramics. An eighteenth-century Niderviller earthenware trompe-l'oeil coffee pot (fig. 113/229), with a fake-wood surface on which faux-prints have been attached, illustrates this very well.

The white rectangular cartouches with inscribed figural motifs might also find echo in a vase from Senkereh, dating from the end of the third millennium BCE. This vase can also be linked to another work by Picasso, *Vase with Two Faces*, also called *Large "Pekiné" Vase* (cat.64/170), from 1956, in a private collection, for both depict the pubic area similarly. This large vase is conceived as if it were a four-sided image with two independent fronts and related backs. As is often the case with Picasso's pots, a single view does not give a total picture of the piece. In this case, the exterior wall of the volumetric structure has been deconstructed as a flat surface, disconnected from the physical form.

What is interesting in these comparisons is the fact that the vase from Senkereh is reproduced in Volume I of *The Photographic Encyclopaedia of Art*, and it is in the Louvre. However, the vignettes on *Vase with Musicians and Female Nudes* are pinned on, not simply applied as relief to the outside surface. This nuance is fundamental, demonstrating not only the complexity of his formal program, but, also, his intelligence.

The ceramics of Pablo Picasso are not child's play. His uncommon understanding of specificities proper to ceramics enabled him to generate a truly exceptional corpus of ceramics. By deconstructing the object as an image and as a sign, and by separating into independent elements object,

volume, surface and sign, he achieved a revolution in the ways of seeing, thinking, and making ceramic objects. With the great Pablo, the ceramic object becomes a subject. The extraordinary *Pitcher with Open Vase* of 3 February 1954 demonstrates magisterially that a ceramic vessel can be something other than a container. Picasso manifests the utopic impulse by imagining the impossible, presenting us with unexpected readings of everyday objects.

NOTES:

1. Paul Bourassa, Léopold Foulem et al. *Picasso and Ceramics*. Trans. Charles Penwarden and John Tittensor (Montreal: Musée national des beaux-arts du Québec and Toronto: Gardiner Museum of Ceramic Art, 2004). All references will be made to pages in the English version of this text and to catalogue numbers from this exhibition.
2. The title of the exhibition was *Les Demoiselles d'Avignon*, 16 January–18 April 1988, Hélène Seckel, curator, Musée Picasso, Paris.
3. This project sponsored by L'Union académique internationale, the Beazley Archive and other academic institutions can be viewed on line at *Corpus Vasorum Antiquorum*. 19 November 2004. 28 September 2006. www.cvaonline.org.

Generating
Theory

"Generating Theory" presents three essays, all of which contribute to the re-examination and theorization of the role of craft practices in a reconfigured, digital world. Amy Gogarty, in "Remediating Craft," examines theoretical models for articulating the position of contemporary craft within a continuum of current visual practices. Using the concept of remediation, or "the representation of one medium by another," she extrapolates from theory designed to critique new media to examine its relevance to contemporary craft practice. Paul Mathieu's "Object Theory" develops a very personal perspective in which he claims, "At the CONCEPTUAL level, all objects are CONTAINERS." From that unique position, Mathieu describes how objects integrate with their environment through relationships of continuity, while images are experienced through rupture. He explores the function of handmade objects within various cultures of display. Penelope Kokkinos, in "Contemporary Ceramics: Piecing Together an Expandable 'Fit,'" delineates clay practices and objects that embrace the expression of marginal positions. Using psychoanalytical concepts developed within "Objects Relations Theory," Kokkinos argues that many clay objects are "transitional objects," which symbolically represent bodily experiences.

Remediating Craft

Amy Gogarty

One of the interesting discussions engaged in by contemporary craft practitioners today revolves around craft's status — or non-status — as art. Whereas several decades ago, artists working in clay, fibre, metal or glass aspired to enter the hallowed halls of fine art, contemporary practitioners today find much to sustain them within the traditions, processes and discourses of their chosen media. Craft practitioners find much to exploit in terms of meaning within the disciplines, technologies and values inherent in their choices. Increasingly, craft is evolving its own narrative and theoretical understanding of its position and relevance within a contemporary world defined by global communication, mass marketing and cultural diversity.

Craft in the West functions today in a cultural space defined largely by

theories relating to visual — even immaterial — art. While this places craft at some disadvantage, the heterogeneous nature of craft practice enables it to interpret and adjust much of this theory to its own purposes, as, indeed, it must. As Paul Mathieu points out in "The Space of Pottery," "Craft has always been inherently political, open to change, and aware of contemporaneity; it still is. . . . I believe it is essential to confront the art world in the language it speaks, to address the problem on *its* territory" (28). Among some practitioners, this statement arouses antipathy if taken as prescriptive or doctrinaire. Clearly, not all makers wish to confront the art world, and not all seek to legitimize their activities according to a system that consistently devalues them. However, for those wishing to contest that field — to engage with the politics and economics of representation and commerce — the confrontation is inevitable. In this paper, I will examine strategies and models for articulating the particular position and relevance of contemporary craft in terms of its difference from other forms of visual art. I will focus on a specific strategy, that of remediation, and on work that extrapolates meanings inherent in traditional craft materials and processes to construct positions from which to address a larger world of visual practice.

A recent analysis of new technologies by Jay David Bolter and Richard Grusin, *Remediation: Understanding New Media*, explores ways in which new media contest and transform existing media. Defining remediation as "the formal logic by which new media refashion prior media forms" (273), the authors identify two strategies, immediacy and hypermediacy, which they term the "twin logics of remediation" (21). While they focus on new media, their analysis offers much that is useful to thinking about craft. In what follows, I will examine the tenets of this analysis and apply them to the particular conditions of contemporary craft to see what sorts of new understandings they might provoke.

According to the authors, immediacy has circulated in the West since the Renaissance as a persistent fantasy of unmediated access to the real (23). From the twelfth or thirteenth century, one can trace a pattern in

which artists attempt to present ever more realistic renditions of visual reality, culminating in the introduction of linear perspective in the fifteenth century. Perspective appeared to deliver an almost magical sense of power to represent reality, as observers were trained to "see through" the picture plane to an alternative reality bounded by the frame. The introduction of oil paint and the mastery of representational skills further heightened the effect. In the nineteenth and twentieth centuries, photography and motion pictures recreated the experience of "being there," a state now emulated by Virtual Reality (29). As the authors explain, *immediacy* operates as a paradox — it promises unmediated access to the real, yet it insists on "some necessary contact point between the medium and what it represents" (30). The imaginary pleasure of unmediated access rests on the viewer both buying into and resisting that paradox.

Calling attention to the distinctive qualities or materiality of a given medium, hypermediacy opposes immediacy as a form of opacity in contrast to transparency (19). William J. Mitchell characterizes the visual style of web pages or video games as privileging "fragmentation, indeterminacy, and heterogeneity," which emphasize "process or performance rather than the finished art object" (qtd. 31). Bolter and Grusin explain:

> If the logic of immediacy leads one either to erase or to render automatic the act of representation, the logic of hypermediacy acknowledges multiple acts of representation and makes them visible. Where immediacy suggests a unified visual space, contemporary hypermediacy offers a heterogeneous space. . . . In every manifestation, hypermediacy makes us aware of the medium or media and (in sometimes subtle and sometimes obvious ways) reminds us of our desire for immediacy (34).

In most cases of hypermediacy, the new medium is embedded within the framework of the old. Historically, one might point to seventeenth-century Dutch paintings, which included maps, mirrors, artworks and other visual signs within the single image. The technology of mapping, which was new in the seventeenth century, is embedded within the more established technologies of oil painting and linear perspective. In the eigh-

teenth century, encyclopedias, and, in the twentieth century, collage and assemblage, similarly exemplify modes of hypermediacy in their visual and textual presentation. In each of these cases, the juxtaposition of text and image and the deliberate fragmentation of the picture plane contest visual unity while calling attention to style and medium.

Marshall McLuhan noted that "the 'content' of any medium is always another medium" (qtd. in Bolter and Grusin 45). In his examples, the form of the original medium is subtly incorporated or represented in the new, as with the previously mentioned seventeenth-century Dutch paintings. Remediation as a sort of scavenging has long characterized art, which frequently borrows the content — without the form — of the original. For example, artists illustrated "scenes" from the Bible as if they occurred in the present day, with no reference to their origin as text. Films borrow plots from historical novels, carefully reproducing costumes and settings, but ignoring the original written form of the novel. Hollywood calls this "repurposing properties" (Bolter and Grusin 45).

In more obvious or naive forms, the new medium asserts its improvement upon — without significant alteration of — the original. Digital web museums claim to present "original" works of art as better and as more accessible than they would be "in real life." More sophisticated forms of remediation call attention to the gap between the new (improved) and the old (less desirable) medium. Web encyclopedias and dictionaries reproduce the forms of print-based versions, which they expand through links, hypertext and multi-media. Bolter and Grusin call this "translucent" as opposed to transparent borrowing (46).

More aggressive remediation, such as one might find in music sampling, "refashions the older medium or media entirely, while still marking the presence of the older media and therefore maintaining a sense of multiplicity or hypermediacy" (46). Douglas Gordon, the Scottish conceptual artist who plunders film archives, restages classic films such as Hitchcock's *Psycho* (1960) as a 24-hour continuous stream. In its original format, the film is experienced at 24 frames per second, and, with its classic Holly-

wood editing, it presents a seamless experience of dramatic reality. Slowed down to two frames per second, plot and continuity are lost; Gordon's *24 Hour Psycho* (1993) progresses as a series of discrete black and white photographs. "This tactic," writes Christopher Brayshaw, "calls attention to film's relationship to the older pictorial arts, and to aspects of staging, lighting and actors' micro-gestures that flow by in real time, but, slowed down. . . . Perspective shifts, and incredible complexity emerges from what at first seemed 'simple.'" In *I wonder when I stopped dreaming that I was gonna be a movie star* (2001), Calgary artist Arlene Stamp selected 80 frames from an 8 mm film clip of her mother as a young woman turning to flirt with the camera. Electric diodes illuminated the clip, which is hung as a continuous horizontal strip (Tousley). The poignancy of the mother's revealing gesture is heightened by the disjunction between the imagined original, which would pass across the view in a few seconds, and its remediation as a static artefact.

Forms of mediation construct reality and exist as "real artefacts" in the world. They do not represent a perversion of reality but are forms of reality in and of themselves. A new form may appear that completely obliterates the original on which it is based. In such cases, discontinuities between the two are minimized. The displaced original may return to remediate on its own. For example, websites remediate and absorb the information of television only to be remediated in turn, as television incorporates the visual style of the Internet into its presentation (47). Mediums borrow — repurpose or refashion — examples from within their own history, as a form of homage or critique, or as a formal rhetorical device to reinterpret older media. What becomes clear is that all mediation is a form of remediation. Media constantly comment on, reproduce or replace other media, operating within webs of cultural meaning and social relations (55).

If the goal of remediation is to refashion or rehabilitate other media — and all mediations are both real and mediations of the real — remediation can be understood as a process of reforming reality. Whereas Bolter and

Grusin exhaustively examine remediation as performed by new media, I am interested in how "old" media remediate, refashion or rehabilitate new media, and how they refashion the reality of a media-saturated virtual world. I am interested in questions, such as Do handmade objects problematize concepts of reality and mediation? If virtual reality is seen as constructing a multi-sensory world, is its address to the body "more real" than craft's? Or is craft uniquely placed to mediate the experience of the body — to reform or refashion the overdose of electronically mediated reality we encounter daily? How do craft objects participate in the "twin logics of immediacy and hypermediacy" that, according to Bolter and Grusin, operate within and between all media and art forms (21)? What might this remediation look like in actual practice, both historically and in contemporary work?

In its ability to simulate other materials, clay has long remediated other materials and objects. Its tendency to accept and preserve impressions parallels photography's ability to retain the impression of light falling on objects in the visible world. In the nineteenth century, photography was likened to plaster casts; one important early photographer, Hippolyte Bayard, made a career of photographing such casts (Lowenthall). One theory for the origin of ceramic pots suggests clay-lined baskets set too close to the hearth caught fire, vitrifying the clay and preserving the imprint of the basket. Later, decoration simulating basketry or other textile designs reinforced the relationship between baskets and pots. As metallurgy developed and came to be associated with elite containers, ceramics adapted to imitate metal forms, from rolled handles to rivets, to burnished metallic surfaces. Roman sigillata were formed in moulds, which themselves were often taken from more expensive repoussé metal originals. In the nineteenth century, lustre wares mass-produced for middle-class markets imitated costly silver, and its less costly imitation, electroplate.

Nineteenth-century industrial production churned out low-cost consumer goods in great abundance, a phenomenon that raised concern among design reformers, class-conscious conservatives and social acti-

vists alike. For theorists like Pugin, Ruskin and others, the very notion of cheaper materials imitating more costly ones smacked of deceit, bad faith and an attack on the social order. William Morris did not believe that new materials rehabilitated the old through acts of remediation but that they lowered taste to the least common denominator across the board. The influence of these philosophers and critics undermined notions of craft materials remediating in a positive way, a situation that continues to infect late-modernist values dominant in many areas of craft practice.

Surely the social, religious and moral values originally underpinning this argument have lost currency, opening the way for creative and critical remediation in the fields of craft. I will look here at three representative examples of remediation, each of which serves to clarify aspects of this creative and critical strategy. The examples I have chosen are as follows:

- Penelope Stewart, whose mimicry of classical architecture through printed images on lengths of sheer fabric returns architecture to its fabled origins in textiles, with the effect of undermining tropes of stability, authority and timelessness.

- Marc Courtemanche, whose ceramic chairs perversely remediate the technologies of wood-turning and furniture construction to question values of function, sense perception and the relationship between works of craft, art and "mere real things." (See Courtemanche's artist project in this volume.)

- Anne Ramsden, whose installations of broken, and carefully repaired, commercial pottery call into question notions of history and truth as generated by the science of archaeology and museum/curatorial studies. (See Ramsden's artist project in this volume.)

———

Penelope Stewart's monumental fabric installations actualize Gottfried Semper's assertion of weaving as the origin of architecture and the tent as the earliest constructed shelter:

As the first partition wall made with hands, the first vertical division of space invented by man, we would like to recognize the screen, the fence made of plaited and tied sticks and branches, whose making requires a technique which nature hands to man, as it were. The passage from the plaiting of branches to the plaiting of hemp for similar domestic purposes is easy and natural (qtd. in Rykwert 30).

Semper's text is relevant to Stewart's series *Sentinels . . . the notion of the measure* (2001). *Façade*, one of the main components in this series, reproduces a neoclassical landmark in Toronto, a building that once housed the University of Toronto's Department of Household Sciences and the first to which women were admitted to study in 1908 (unpublished artist material). A silk-screened-organza image measuring 396 by 432 centimetres is suspended some 15 centimetres in front of an identical image attached to the wall. Excess fabric crumples as it meets the floor, contradicting the impression of erect columns. The doubling of the image creates a strange moiré or hologram effect, which, paradoxically, grants it volume and physicality only to undermine that appearance as the sus-

pended fabric sways at any breeze. This apparently simple and straight-forward presentation belies the work's conceptual complexity.

Stewart focuses on buildings in crisis — those faced with demolition, decay or simple neglect. Their precarious state stands in contrast to the authority of their architectural style and innate grandeur. As Gary Michael Dault explains:

> The architectural ideas incarnated in the work . . . are real architectural ideas and have been with us throughout cultural history: ideas about classical style and scale, structural ideas about pillars and proportion, eloquent ideas about capitals and corbels and other modalities of architectural decoration.

Stewart's work originates in photography; she photographs the building, grids and enlarges sections and then screens each section onto the fabric. Photographs simultaneously document the "real existence" of the structure and immediately date it to the precise moment of the image's making. They are instantly "out of time," historical mementoes, paper memories. While appearing to testify to reality, they mark the impossibility of seizing what slips continually beyond the grasp. This interplay of stability and in-stability transpires in the exchange between billowing fabric and wall-mounted image.

The scale of the work and the use of photography's indexical repre-sentation of reality approach immediacy. As Stewart states in describing a related work, *columns*, "The optical illusion of volume created by the spac-ing of the two layers allows the viewer for a millisecond to believe that these soft floating images are actually solid structural forms" (unpublished artist material). That something as feminine, insubstantial and "low-tech" as silk organza might deliver the experience of immediacy comes as an ironic shock. The momentary visual paralysis and confusion generated by the moiré effect locates the illusion of reality in the body rather than in a technological prosthesis. I would argue that the craft-based materiality of the work insists on the active physical presence and bodily perception of the viewer, placing it at odds with much of the technologically inspired

dream of reality beyond the body. The illusion situates the work more in the context of optical experiments conducted in the nineteenth century, which located the sense of sight clearly in the contingencies of the body, as discussed by Jonathan Crary and others, rather than in the electronically enhanced world of virtual reality. In a sense, it is a "cheap trick," but I use that term advisedly. Craft has always thrived on an economy of effects that utilize the experience of the body to more fully engage — and not simply represent — reality. The sort of immediacy promised by handmade craft objects is one of bodily experience and sensory engagement, not simply illusion.

Stewart's work also looks back to an older form of media, architecture, which she remediates through textiles. She engages the rhetoric of classical architecture, focusing on cropped details of capitals, corbels and bosses, yet her use of sheer, light-weight fabric and handmade artefacts renders these images of authority and power deracinated and bereft. Traditionally, architecture and monuments were tied closely to specific sites, meanings and commemorative acts. They drew their authority from the civic and political power that marked these sites as significant and worthy of commemoration. Stewart's installations are nomadic; they can be disassembled and re-installed with minimal effort in comparison to the original. They mark our culture's essential rootlessness and addiction to constant change, conditions imposed by a consumer economy in the context of global capitalism. The irony embedded in her choice of this particular structure is compounded by her revelation that the building is currently used as a Club Monaco retail store and Ombudsmen's office, twin services of commerce and government. As she comments:

> These buildings were grand gestures of our domestic autonomy and independence, metaphors of what once had been core values of citizenship, stability, democracy and community. . . . The building articulates the tension between our shifting ideals and values (unpublished artist material).

Stewart questions the repressive role of official collective memory and the symbolic burden of architecture in a world in which such memories

and values are increasingly products of politically charged messages, forced consensus and highly mediated illusions. The widely televised funeral of Ronald Reagan in 2004 provides an instructive example of such illusions. During this event, journalists and broadcasters alike exerted great pains to suppress all memories other than the patriotic, such as those of Reaganomics or the Iran-Contra affair. Stewart locates the construction of her optical illusion well within the perceptual apparatus of the body. Motivated by scepticism towards official collective memory, she provides a utopic space of reflection out of conviction that individual acts of perception and recollection can establish a radical basis for common ground, shared memory and resistance.

Marc Courtemanche's ceramic chairs embody Marshall McLuhan's assertion that "the content of any medium is always another medium," which, incidentally, parallels Bolter and Grusin's definition of "remediation" as "the representation of one medium in another" (45). Courtemanche's chairs borrow the "content" of wooden chairs, scrupulously reproducing not only the visual appearance of the original chair, but also, as closely as possible, the mode of production. What is the "content" of a chair? One could point to the function or strictly utilitarian purpose for which it is intended — the chair exists to support a seated individual human (Deetz 50–51). Of course, chairs do more than this, which is one reason chairs come in so many styles, forms and materials. Many of these styles and materials designate the class and social standing of the individual who owns the chair. Some, such as original Mies van der Rohe or Charles Eames' chairs, designate their owners as sophisticated connoisseurs of modern art and design with large amounts of disposable income. Others, such as wooden rockers, connote pioneer spirit or homey sentimentality. Connotations of objects, still in the realm of content, are termed by material culture specialists "socio-technic" aspects (Deetz 50–51). Socio-technic aspects communicate the social standing, identity and social pres-

ence of their owners and/or users, making possible the culture of display. Courtemanche boldly appropriates multiple aspects of this content.

Are Courtemanche's chairs actually chairs? Or are they sculptures of chairs? Can they be both? Courtemanche states that his sculptures "resemble" chairs, but they are not replicas. These chairs differ sharply from

Marc Courtemanche.
Mortise and Tenon
(detail). 2003.
Stoneware, leather,
wood dowels.
101.5 x 43 x 43 cm.

reproductions of antiques produced by modern-day furniture makers, gunsmiths or potters, who carry on traditions out of respect for their integrity, skill and historical value. Henry Glassie discusses a number of traditional potters, who make "amazingly exact sculptural representations of useful pottery" (34). Despite being closely based on authentic, functional examples, these pots are not the same as the originals. They are not used by the city people who buy them in the same ways as their farmer forebears might have. Instead, the replicas — or amazingly exact sculptures — are consumed for their symbolic values, as metonymic ciphers connecting modern urbanites to their perceived authentic roots. Courtemanche's chairs hold no such symbolic, nostalgic value, and the fact that they are not "used" connects them more to sculpture than to the original chairs on which they are based.

Courtemanche employs techniques such as wedging together or layering different clay bodies to simulate the appearance of actual wooden chairs (email May 7), techniques that date from at least the early T'ang Dynasty in China. The chairs are not "trompe l'oeil" (Courtemanche 2, 26). They momentarily confuse, but never deceive, the eye, and thus they are unlike the eye-fooling sculptures of artists such as Marilyn Levine (Courtemanche 18). Levine's masterful simulations of leather boots, jackets and other objects place them in the utopic realm of visual art (website). Despite being constructed from slabs of clay much as one might mold fabric, the illusion of their reality vanishes at first touch. Courtemanche's chairs are more ambiguous, more subversive, in that they broadly simu-

late not only the appearance, physicality and function of a chair (they can be sat upon, albeit with great care), but also the methods of production that go into making a chair. Returning to the two terms defined at the beginning, immediacy and hypermediacy, we might classify work by Levine and others as approaching immediacy — the illusion of transparent access to the real. In contrast, Courtemanche's chairs call attention to their essential heterogeneity, hypermediacy or constructedness.

In simulating modes of production appropriate to working with wood, Courtemanche approaches the perverse. There is no reasonable explanation for turning, lathing, biscuit-joining, dowelling and/or screwing together components of clay just as one might pieces of stock lumber. He uses these methods despite the fact that this way of working counters all known properties of clay — its lack of structural integrity in an unfired state and tendency to shrink, warp or crack when fired. Yet these chairs are more than simple demonstrations of unimaginably stubborn loyalty to known ways of working materials. It is through this insistence on process that his chairs embody "chairness." This permits them to stake their claim to craftedness and to a fundamentally different relationship to representation than that occupied by traditional art.

By treating clay exactly as one might wood, Courtemanche remediates the medium of wood through clay to produce an entirely new understanding of both clay and wood. The simulation of carpentry techniques forms part of the content of the work, and in so doing, he moves beyond those who choose these techniques for practical or structural purposes. In his perversion, he causes us to re-think the degree to which everyday objects are as much products of their material properties as they are of design, tradition or aesthetic intention. Gottfried Semper maintained that forms of objects as they exist in the world might be analyzed under two aspects: their intended use and the materials, tools and processes through which the objects are made (Rykwert 30). As we live in a world surrounded by objects produced by industrial processes, often from industrial materials by industrial workers, if not by robots, we lose conscious-

ness of these materials, tools and processes that so dramatically and intimately shape our lives. A wooden chair made by a skilled carpenter elicits praise, but rarely wonder. A ceramic chair made exactly as such a wooden chair might be made elicits confusion, possibly even anger, and it causes us to rethink our relationship to the material world. As Courtemanche comments, "Combining both techniques from furniture makers and ceramists results in a new object previously unknown to either tradition."

Courtemanche's single-minded pursuit of process and craftsmanship introduces critical content and conditions into his work. Citing Arthur Danto's discussion of art works and mere real things and his claim that art both represents itself and refers to or connotes something else, Courtemanche writes, "I am positioning my sculptures *between* [art and mere real things] to generate questioning about how my chairs can be classified and experienced. The space I am creating is a port for all not-quite utilitarian objects, not-quite art objects." This space is unique to craft, for which a relationship to function has always been central, even if that function be largely symbolic or ceremonial. Courtemanche creates an "in-between" space; his crafted objects remediate both the everyday world of utilitarian objects and the symbolic world of art, calling both into question through an act of critical bridging. In this process of remediation, these works "reform" reality — construct the experience of the real anew.

———

Anne Ramsden's mammoth project, *Anastylosis*, similarly mimics production modes from an external discipline, archaeology. The title refers to the archaeological practice of reassembling existing fragments of architecture in such a way that the original is made legible, but all repairs and new materials are clearly distinguishable as additions (Vacharopoulou). It thus incorporates political and philosophical perspectives on the reconstruction of the past. Ramsden's use of the term as her title signals a problematic tension between public and personal memory, material culture and identity. In this way, Ramsden's work resembles that of Stewart. The proj-

Anne Ramsden.
Anastylosis: Inventory
(detail). 1999–2002.
Metal shelving
units, ceramic
objects, epoxy glue,
acrylic paint.
244 x 190 x 86 cm.
Photo: François
Lafrance.

ect includes various components dating back to 1998. For *Anastylosis: Inventory*, Ramsden spent months collecting functional pottery from retail outlets that served a range of economic and social classes, selecting those objects that most clearly conveyed the personal lifestyle, fantasies and identities of those targeted to consume them (Ramsden 2000 7). She displayed these objects on commercial metal shelves reminiscent of back rooms in museums or showrooms. While the overall collection represents merely an excerpt from what was available, each individual item reflects the intersection of utilitarian function with market-driven consumer culture. Each partakes of both timeless archetype and time-sensitive consumer fashion.

Ramsden subjected each object to a double manoeuvre: she broke each by dropping or hitting it with a hammer, both very violent and deliberate actions, and she carefully repaired it with coloured glues that indexed the traces of damage. She grouped her purchases by colour, a classification system she deemed to be both precise and objective (Ramsden 2000 8). Classification by colour rather than function renders the objects decorative and subject to their aesthetic appearance in the domes-

tic environment. The domestic environment as a site resonates strongly with concepts of personal identity (Lacroix 17). Between complementary acts of destruction and reparation, Ramsden arranged and photographed the shards. Exhibitions of works include photographs of pieces whole and fractured, which reveal the complete cycle involved in presenting the final work.

In the field, archaeology legitimates its reparative work by collecting and preserving artefacts that time, warfare and forces of nature have brought to ruin. Ramsden undermines her claim to this sort of legitimacy by manifesting her own complicity in the destruction. Opposing "faux" to "real" archaeology as ironic imitation, her claim is not to scientific neutrality but to a critique of that claim (Ramsden 2000 7). Her simulation of museum display and archival obsession lays bare the politics and hubris attached to any reconstruction or representation of the past. Museum-goers are presented regularly with histories and artefacts deemed worthy of repair and resurrection, and historical memories are recreated from the perspective of the victor.

How might we see this project as an extended act of remediation with consequences for the materials and processes of craft practice? It is not insignificant that the subjects of Ramsden's extended meditation are commercial crockery. These sorts of objects occupy a liminal zone in terms of contemporary culture. Despised by studio ceramists, ridiculed by the counter-culture, overlooked by serious museologists and yet prized by consumer-conscious, generally female, collectors, this class of commercial ceramics exhibits a superabundance of signs, a surplus of semantic value to the attentive reader. Ramsden's feigned neutrality towards classification has the effect of rendering the objects more naked, more abject and more vulnerable in their isolated and obviously damaged state. Our own familiarity with both the class of objects, household crockery, and the material, ceramics, collapses the distance we might ordinarily cultivate towards art objects.

Here, we might point to the state of desired transparency — immedi-

acy — promised by new media, yet these objects go one step further because they actually are real. In fact, it is not at all clear if they are the artworks or "mere real things" mentioned by Danto and cited earlier by Marc Courtemanche. At what point in their trajectory did they stop being "real things" and become art objects, artefacts that refer beyond themselves to "something else"? Was this at the point of purchase, when the objects entered into a commercial exchange between the retail outlet and the artist, or did it take that initial act of violent destruction to convert them into works of art? As if to meditate upon this ambiguous state, Ramsden includes large-scale photographs of the objects as both broken and repaired. The photographs further decontextualize — literally flatten — the objects by floating them against a black background, arranged as a pattern that obliterates any reference to original identity, function or physical dimension of the objects. The photographs hyper-mediate the situation by calling attention to the constructed nature of the image, thus increasing the distance between viewer and object.

Much like Courtemanche's perverse and stubborn determination to replicate wood-working processes in clay technology, Ramsden perversely pursues archaeological techniques of restoration on objects that cannot possibly be worthy of repair. Archaeology addresses objects rendered rare through the passage of time or valuable through the use of costly materials and provenance. No one questions the time or expertise devoted to patiently assembling an Athenian kylix or Sung Dynasty celadon. In the case of oriental ceramics, connoisseurs in China or Japan lovingly repaired rare pieces, marking the repair with a thin line of gold. The repair spoke to the value and uniqueness of the object and to the veneration accorded it. Ramsden perversely mimics this with her prominently visible coloured glues. Equally perverse, the exchange value of the original ceramic object, even if a rare or valuable collectible, is exponentially increased through its being broken, repaired and resurrected as an eloquent art object.

If we reconsider the ways in which remediation functions, we can see this work performing on all three levels mentioned. These artefacts reme-

diate the activity of archaeology and professional history writing; they "mediate the mediation," not to reproduce or replace the original, but certainly to question and comment upon it (Bolter and Grusin 55). These remediations are themselves as "real as the reality they purport to mediate"; they are "real artefacts" in their own right. And they perform this remediation out of a desire to refashion or to rehabilitate other entities — most notably, archaeology, history writing and psychoanalysis — through critique. Through these interventions, our own concept of the real is reformed and forever changed.

Here is where craft materials and craft objects, in the full range of their richness from hobby craft to industry, speak with consequential voices. Gaston Bachelard related the levels of a house to various states of consciousness, insisting that domestic spaces bear an uncanny analogy to our psychic architecture (94–95). Crafted objects witness the most intimate actions of our lives — from the legitimized sexuality of the wedding trousseau to the excessive indulgence of personal display, from the pleasures and tensions of the family dinner table to the angst of the sick room. These objects witness our existence as they support and enable our progress through life. Precisely because they occupy that liminal, hybrid or "not quite" zone between intentional art objects and real things in the world, their acts of mediation exhibit social, political and psychoanalytical charges that occur rarely outside of craft media. Their relationship to the body, to the family, to the domestic and the commercial ensures an on-going series of tensions, recognitions and complex responses.

The examples I present here demonstrate active remediation on the part of makers using craft materials and processes to interrogate, re-purpose and remediate aspects of contemporary culture, disciplinary knowledge and new media. In thinking about this subject, numerous other examples come to mind, and only time prevents me from discussing them. Why do I feel this topic is important? Is remediation simply a sexier way to describe appropriation or representation in its multiple forms? Perhaps, although the currency of the term challenges me to extend the discussion

beyond new media to a consideration of craft. In this, I concur with Paul Mathieu: craft wishing to contend with art must do so on its own terms, competing with fine art as the dominant discourse while maintaining a sense of its essential difference (1994 28).

What I find attractive about the concept of remediation is that it re-configures the field for art and craft. As the dominant discourse, art has assumed a hierarchical position of superiority in relationship to craft. The various institutions of art — museums, curators, critics and historians — accept and maintain this position to the detriment of craft practice. Given such a model, ambitious makers of craft objects have had little option other than to turn their backs on craft's histories and strengths in a bid for acceptance into the elite ranks of fine art. Rarely has this achieved happy results. Even if successful, such attempts only advance a simplistic and false dichotomy (Mathieu 2001 13). What remediation opens for those of us interested in craft is a model in which art and craft co-exist in a struc-ture of affiliation and inter-dependency rather than binary opposition. Just as computers and the Internet remediate film and television, only to be remediated productively in turn, art and craft in this model engage in a symbiotic relationship with regards to contemporary culture. Contem-porary art, in its richness and theoretical complexity, provides an on-going critique that challenges craft to engage similarly in critical reflection. Craft, rooted in function and the everyday, bridges the divide between art and life that continually eludes the utopian grasp of art. Ontologically, craft both presents, and represents, the real; it is both immediately, transpar-ently real, and it represents the real through formal abstraction, surface image and conceptual presence (Mathieu 2001 19; 2007). Understanding craft's capacity to remediate its own history, "real life," art and new media reassures me of craft's strength, flexibility and power to sustain on-going and productive critique.

WORKS CITED:

Bachelard, Gaston. "*Poetics of Space* (Extract)." *Rethinking Architecture: A Reader in Cultural Theory*. Ed. Neil Leach. London: Routledge, 1997. 86–97.

Bolter, Jay David and Richard Grusin. *Remediation: Understanding New Media*. Cambridge: MIT Press, 1999.

Brayshaw, Christopher. "Douglas Gordon." *Border Crossings* 21.3 (August 2002): 101–103. *Art Full Text*. Wilson Web. Alberta College of Art & Design, Calgary, Alberta. 10 December 2004.

Courtemanche, Marc. *Not Quite*. Unpublished paper in support of Master's Thesis, University of Regina, 2003. Photocopy.

Crary, Jonathan. *Techniques of the Observer: On Vision and Modernity in the Nineteenth Century*. Cambridge: MIT Press, 1990.

Dault, Gary Michael. "Penelope Stewart at Edward Day." *Globe and Mail* 17 May 2003: R14.

Deetz, James. *In Small Things Forgotten: The Archaeology of Early American Life*. New York: Doubleday, Anchor Books, 1977.

Dormer, Peter. "Craft and the Turing Test for Practical Thinking." *The Culture of Craft*. Ed. Peter Dormer. Manchester: Manchester University Press, 1997. 137–157.

Glassie, Henry. *The Potter's Art*. Bloomington: Indiana University Press, 1999.

Lacroix, Laurier. "Anastylose: un inventaire." In *Anastylose: un inventaire*. Sherbrooke: Galerie d'art du centre culturel de l'Université de Sherbrooke, 2000. 11–25.

Levine, Marilyn. "Marilyn Levine's Website." 26 April 2004. http://users.lmi.net/ml/index.html.

Lowenthal, Anne W., ed. *Object as Subject: Studies in the Interpretation of Still Life*. Princeton: Princeton University Press, 1996.

Mathieu, Paul. "Object Theory." In this volume, 2007; see pages 111–127.

——. "The Space of Pottery." *Making and Metaphor: A Discussion of Meaning in Contemporary Craft*. Ed. Gloria A. Hickey. Hull: Canadian Museum of Civilization, 1994. 26–34.

——. "Towards a Unified Theory of Craft." *Artichoke* 13.1 (Spring 2001):12–19.

O'Brian, Melanie. "Anastylosis: Childhood." Catriona Jeffries Gallery. 25 April 2004. www.catrionajeffries.com.

Ramsden, Anne. "Anastylosis: Inventory." *Anastylose: un inventaire*. Sherbrooke: Galerie d'art du centre culturel de l'Université de Sherbrooke, 2000. 7–9.

Rykwert, Joseph. *On Adam's House in Paradise: The Idea of the Primitive Hut in Architectural History*. 1972. 2nd ed. Cambridge: MIT Press, 1981.

Stewart, Penelope. Unpublished artist material. Photocopy, 2004.

Tousley, Nancy. "Star Turn." *Canadian Art* 18.1 (Spring 2001): 82.

Vacharopoulou, Kalliopi. *Anastylosis Questionnaire for Relevant Professionals*. 25 April 2004. www.ucl.ac.uk/~tcrnkva/index.html.

Object Theory

Paul Mathieu

*A novel is, it often seems, nothing but an
elusive search for a definition.*
— MILAN KUNDERA, *The Art of the Novel*

 Among all living things, humans are the only ones with the
capacity to think (we think). This capacity for thinking gives
us a consciousness of the world: we know that we exist, that
we are born and that we will die, that we are temporal beings, with a past,
a present and a future. And this consciousness requires that we make
sense of the world. We do this through language, spoken and written
words, literature, fiction, theory, science, religion, history, and also with
music and song. We do this as well by creating images, and we do it by
creating objects. Each of these categories of action upon the world is dis-
tinct yet connected to the others. Object-making is probably the oldest
making-activity of humankind, and we can speculate that it preceded the
development of language and the making of images. To survive in the

world, humans first needed tools. Formalized language probably came next, followed by images. If there is such a "genealogy," it is actually of little importance, and if there is such a precedence, it remains irrelevant here. Yet language and images are closely interconnected, while objects are at a farther distance, temporally and ontologically, from language. We now live in a world where language, in all its fictionalized forms, rules the world, and it does so largely through images. One of the many forms of fiction that language takes is theory, or history, and, in the present instance, art history.

And the history of art is really the history of images.

In the world as it exists and as we experience it, there are two complementary phenomena, usually perceived and presented as distinct: i.e. nature and culture. Nature encompasses all the things (among other things) that exist outside humankind yet includes humankind itself. Nature is construed as either that which is created by divine intervention or that which creates itself through the laws of physics. Culture is what humans do to nature. The world of culture is vast and complex, as is nature. Culture includes speech and the written word, sounds and music, movement and everything we humans (and probably other life forms too) make, alter,

"Culture is what humans do to nature." Jingdezhen, China. Photo: Paul Mathieu.

transform and create. Material culture is more specifically concerned with physical things: architecture, engineering, design, crafts and objects of all kinds (fashion, textiles, furniture, jewelry, pottery and other containers in all their forms and materials, etc.), but also with all manifestations of image making (visual culture), that is to say, those things that are best experienced with vision alone, primarily through sight, such as painting, drawing, photography, sculpture, television programs, computer imagery, all print media, graphic design, illustration and so forth. All of these aspects of material/visual culture contribute their own potential to what is generally known as art, the world of creativity and expression, perception and aesthetics. Yet, the history of art is still largely the history of images, of things that are visually experienced, of visual art.

DEFINITIONS

By "image," what do I mean exactly? An image, in the narrow yet specific definition I am using here, is a cultural (as opposed to natural) phenomenon experienced through sight alone, visually. A painting is an image, a photograph is an image, a sculpture is also an image, a tridimensional image but an image nonetheless. A building can also be an image if it is simply looked at, and buildings tend more and more, unfortunately, to have a flat quality as a result of being generated from a flat image, a plan. Just think of the spatial complexity of Gothic cathedrals, in many ways the ultimate handmade objects, which were not generated from architectural plans but from three-dimensional examples and models. If we make some exception for blindness, anything, and certainly any perceptual experience, even sound often, can be reduced to a visual experience. Anything is potentially an image, a visual experience. And, of course, any experience can also be expressed in some way through language.

In the world of material visual culture (all those things humans do to nature), there is another category of things that are not experienced solely through sight, visually, and which do not necessarily necessitate language either, but which require other senses, primarily but not exclusively touch,

for a complete experience and a full understanding. These things are what I call here "objects," and an object theory is what I am attempting here. "Every history implies another history, one that is not being told," to paraphrase Michel Foucault.

Objects are all the things largely ignored by the history of art as we presently know it. It is possible if not requisite to obtain a terminal degree and become an authority in art history without ever considering the role and importance of objects within culture. If there is a remaining place where ignorance, prejudice, discrimination and censorship still exist within the experience of art, it is specifically where handmade objects are concerned. Entire "Histories of Art" have been written that do not contain a single object. It is more accurate to consider these books as "Histories of Images" instead.

Despite continuous attempts throughout the preceding century and before to reconcile art and life, to open up the definitions and practices of art, to blur differences and remove hierarchies, the world of art (in its theories, discourses, institutions, power structures, etc.) is still largely and often exclusively the world of visual culture, of visual art. Today, with the new technologies, it is even more so. This leaves behind large sections of material culture whose contribution to culture is immense, essential and continuous, yet still largely dismissed and/or ignored. The silence is quite simply deafening. There are two main exceptions to this state of affairs: architecture and design, either industrial design (industrially produced things of all kinds) and graphic design (the ever changing world of images constantly altering the visual landscape we inhabit, again, outside and beyond the natural landscape). Architecture and design have been readily embraced by the theories and studies of visual and material culture; they have been somewhat absorbed and included in what we understand as "art," in all its manifestations and institutions, largely because of their inherent economic power and their importance in the world we live in, in a direct relation to consumerism and capitalism. And the analysis of the importance of power structures is essential to any understanding of

theories and discourses. Seen in this light, the art world is largely a marketplace, of things as well as of ideas. This embracing of architecture and design practices by the art world was preceded by the similar acceptance of photography (in its materialization, a mechanical and chemical process, originally anyway) as a legitimate art form (and it could be said that today 95% of art experiences are mediated by photography and related practices), a phenomenon now repeated with other technologies of image making, because, quite simply, they were instantly acceptable to a world obsessed by visuality to the detriment of all other senses. Although I am not directly interested in architecture and design here, the basic principles behind the theory of objects I am exploring still directly apply to these practices, if not at the political level, at least at the conceptual.

WHAT IS AN IMAGE?

First, a better understanding of the workings of images is necessary. How do we experience images, what is their phenomenology? Obviously, images are experienced visually, primarily. This visual experience is one of distanciation, of removal, of separation. Sight establishes difference as rupture, as an opposition. This is even more the case within representation. A portrait of your mother — be it a painting, a drawing, a bust, a photograph, a film, a video or even more so, a virtual image — such an image is not your actual mother. Experiencing that image distances you, separates you, removes you from the actual physical experience of your real-life mother. It exists in opposition to reality. It creates another experience, a new experience, powerful and real, yet removed from the reality of a live experience. Images are always representation. Images establish a fundamental opposition between two types of experiences. All forms of binary oppositions are intrinsic to images. These oppositions between two very different forms of experience are also hierarchical in nature (in either direction) since they cannot possibly be equal. Most importantly, images and all representations are directly connected to language through fiction and the operative power of symbols. Images are always literal and they imply and

demand the production of a narrative. This narrative around images often takes the form of a theory (or theories), especially with abstract images, which are also representations of something else, be it a geometric form or even a drip or a stain (and, in many cases, the fiction often takes the form of myth-making around specific practices or, even worse, personalities). This is where the direct link between images and theories resides. Since our world (and certainly the academic world of institutions where art, visual art, operates) is largely constituted around power structures based on language, texts and images have become the predominant forms for the creation of meaning. This is why theory is so important and essential in order to clarify and establish the critical role played by objects (and specifically here, handmade objects).

WHAT IS AN OBJECT?

Objects are of two main types: TOOLS, which are active (the conceptual aspect of tools is function) and CONTAINERS, which are receptive (the conceptual aspect of containers is containment; that is to say, they establish a transition between interior and exterior. It is important to keep in mind that this transition does not imply an opposition but a continuity). As always with objects, these differences are not absolute, but complementary. Cars, for example, are altogether tools (when they displace their content) and containers. Tools are different within the general category of objects since they are used to make other objects and these objects are usually containers, at the conceptual level anyway. Yet containers usually, if not always, imply a tool-aspect as well, and they can be used to act upon the world. This is yet another example of the reconciliation of differences, the main framework around which this object theory is constructed.[1]

What is the main characteristic shared by all objects in whatever form they take, independent of materials, of the processes, tools, equipment and technologies used in their making, or even when and by whom they were made? My answer is that at the CONCEPTUAL level, all objects are

CONTAINERS. They are articulated around the transition between exterior and interior. Containment has to do with the relationship between the object and its environment. Containment bridges an object with its environment. Objects are about difference as continuity, not difference as rupture, which is the operative characteristic of images (if an image always represents something else, an object, on the other hand, only represents itself). A container is a space where opposites are unified, where differences are reconciled (an object is always altogether an image AND an object.). Containers bring together the extremes in reconciliation; they cancel the dialectical impulse of language, which makes them so difficult to be understood solely through language (by resisting narrative and theory). All the binaries, polarities, opposites and dichotomies present in language (and implicitly in images as well) are reconciled within the container, within the object. Containers and objects combine in symbiosis the top and the bottom, the front and the back, the interior and the exterior, the surface and the form, representation and presentation, image and object, material and concept, nature and culture, art and life, intellectual experience and physical experience, body and mind, and all and any

other binary oppositions we can conceptualize. Objects are always inherently material, inherently abstract and inherently conceptual. These three aspects are equally important, and, thus, they resist hierarchization conceptually, beyond market value and consumerism.

THE EXAMPLE OF THE FRAME

In an art context, the ultimate object is the frame. The frame is the ultimate container for paintings, drawings, photographs and other images. In sculpture, the equivalent is the plinth, now largely replaced by the floor of the museum or gallery as institutions become, by extension, a different version of the plinth. And we have seen the progressive removal of plinths and frames in art presentation in the twentieth century, where their historical role has been replaced by architecture and by the printed or projected image, which occupies the full space of the page or the screen. Yet the frame and the plinth (a form of furniture) hardly exist within the art discourse. How often have I seen in exhibitions and in museums worldwide, paintings exhibited in frames carved and painted by the artist where the identification label simply stated "oil on canvas," with no mention whatsoever of the frame! Total invisibility of the object, even when made by the artist! Does the function of frames render them irrelevant conceptually? Isn't function a concept, anyway? Could this be because they are objects first and not solely images? The frame or the plinth is the space, the place, the site where things change, where the transition between art and life takes place. An image is *always* defined by clear borders. It has edges where things stop and end. An object has ambiguous borders where things start and begin, and this is made even more complex by the presence of images on objects, when characteristics of images and objects are present on the same thing. Images are always signs for something else. They always represent something else, are stand-ins for other things and phenomena, including other images. Objects, on the other hand, do not represent anything else; they are signs for themselves. You know a chair is a chair because it embodies chair as sign for chair while still being chair

as thing. A drawing of a chair also embodies chair as sign, but it has lost the materiality of the chair. Such a drawing is then weaker as a tool but more powerful as an image; through representation and the imaginative power of language it opens, at the symbolic level. Images on objects are also very rich in potential since they bring together two aspects of conceptualization: signs and things. Still, images on objects do not operate as independent images do. An image on an object is framed differently, since the frame is the object itself, on which the image is localized. The borders of the images are then different, in concept and in experience, from the borders of images that are independent and separate from a real, physical context. Images are always inside something, they are localized. They have borders, and they need a context to operate: a frame, wall, museum, book, catalogue, theory, etc. Images are in need of institutions, while objects can dispense with them (except politically, of course, since, in our culture, it is institutions that validate all human activities). Objects are, on the contrary, conceptually outside, mobile, independent of context, since they carry context intrinsically within themselves. They can go anywhere without significant (if any) loss of identity and meaning. Objects have no real locality. Again, images are directional, in order to be read correctly, to make sense, while objects are multidirectional and retain their identity even when upside down or inside out. They do not have such a specific viewpoint as images do, either. Frames and objects create epistemological breaks, where meaning and understanding is altered; they operate paradigm shifts where a real experience suddenly takes a new form, while still remaining real. Is the frame, the object, any less important conceptually than the image? The frame and the object both define a territory and establish a frontier. Images are localized (you know where they go), whereas objects have no real locality and they go everywhere (and also nowhere, not only physically, but especially conceptually). They have no place within existing theories, beyond semiotics (which reduces objects to the status of images, as social and cultural "signs," anyway). The frame and the object fix the image, and the image is, by definition and experience, always

fixed. When the image changes, it is always really just another version of the same image. It is the frame and the object containing the image (at times, just a sign for a sign) that is, on the contrary, mobile. The frame is a prison for the image, yet images are also prisoners of their own selves, even when unframed or independent of plinths and seemingly free from physical constraints. Objects are free. You can always change the frame (and change channels). Frames and all objects are interstitial, they operate in the "space between," and, as such, they connect to reality and connect two realities, art and the real world. In psychology, the term would be "transitional," but now is not the time or place to go there.[2]

DECORATION

Today, images on objects are largely "decorative," and this decoration has retained none or little of the symbolic power of historical signs (often abstract) on objects, which connected humans among themselves and with the larger world of myths and religion. At best, decoration on objects today only plays an iconic role as referent for other signs, for history and for culture. As well, signs on objects today are too often simple optical devices for seduction in order to foster consumerism. That is as true for industrially produced design products (and design, now, is mostly a stylistic practice concerned with presentation, with how things look, based largely on the particular personalities of designers) as it is for handmade unique objects, with few exceptions. The decorative now denotes the superfluous, the unessential; yet, the surface itself of an object, at the conceptual level, is not decorative, since the surface constitutes a system of signs where everything is, on the contrary, essential.[3]

Historically, the surface of an object, its ornamentation, played a powerful, symbolic role. That surface was never purely decorative. Objects made today need to return to that stage where any marking is essentially

"Frames and all objects . . . connect to reality and connect two realities, art and the real world." "Door as Pot," China. Photo: Paul Mathieu.

symbolic and not merely ornamental, empty of meaning beyond optical excitation. Signs on the surface of objects are there to inform us about the nature and use of the object (its ontology), how it is perceived and experienced (its phenomenology) and how we come to understand it (its epistemology). Any other sign on an object is unnecessary. Modernism and modern design have largely resolved this problem of decoration and ornamentation by altogether dispensing with them, yet, in the process, transforming artworks into museum decorations and material for kitsch giftware. I foresee that this situation will very soon change, and, due to the expanding role of computer technology in both the design and fabrication of things, the potential for extremely complex and excessive adornment offered by these technologies will permit the creation of personalized, idiosyncratic and highly varied surfaces on all the things in our daily life. This might create a visual revolution the like of which we haven't seen since the reductive, minimalist, "negative" aesthetics of Modernism.

ABSTRACTION AND CONCEPTUALISM

Containers and objects are also the ultimate form of abstraction. They never "represent" anything (except themselves). The resistance of institutions toward objects and toward containment as a concept is a resistance to abstraction as a concept as well. By their very nature, objects contest the necessity for institutions; they challenge and contest present knowledge and existing hierarchies. It is much easier simply to ignore them. If abstraction as style, abstraction in its visual and formal aspects, has been embraced by art (image making) in practice and in theory, abstraction as concept hasn't been fully understood yet. To do so would have to imply a complete reexamination of the contribution to art history of certain practices (largely craft practices where abstraction has existed since the beginning of "culture"), which would destroy the present power structure of hierarchies (of materials, of practices, of markets, etc.) created by art history and other art institutions. In the 1950s, a prominent abstract painter predicted that we would have a period where abstraction in art would

predominate for one thousand years. By art, as is so often the case, he meant images, paintings, etc. Not only was this important artist proven wrong almost instantly, but what is essential to remember here is the complete fallacy of the statement, since there had already been a period of abstraction reaching back into the past for at least 30,000 years! However, this investigation of abstraction as a concept was not taking place within image-making primarily, but within other practices (object making), which were deemed (and still largely are) irrelevant, or, even worse, impossible to be considered as valid. It is important to realize that within object-making, not only are the notions of abstraction and conceptualization very ancient, but, if we truly reflect upon the generative and operative nature of objects, we discover that such categories as modernism, expressionism, minimalism and even postmodernism all have very long histories within object-making. Objects are at the source of these developments within the art discourses and theories, even if that contribution has been ignored (and will likely be denied by many).

Objects are inherently abstract (they can only represent themselves, even if, metaphorically, they often are substitutes for the human body, and, physically, they often act as extensions of the human body). Objects are also inherently conceptual; they are the materialization of an idea, even if that idea, that concept is, more often than not, function and/or decoration. Yet these notions of abstraction and conceptualization have been appropriated and absorbed by visual art practices; they are now generally perceived as intrinsic and, for the most part, unique to visual art (and to language). Object makers need to reappropriate their historical ownership of these terms. Abstraction in art is presented as a phenomenon that had no precedent before the beginning of the twentieth century. Anyone remotely familiar with the history of objects knows that this is a fallacy. We are also all too familiar with the category of "conceptual art," which is, in fact, a gross misnomer. Conceptual art is not any more or any less conceptual than any other human activity. Art is, as Leonardo said so well, "cosa mentale," a thing of the mind. That is, what we humans do is to con-

ceptualize the world through consciousness. We do this either by creating myths, fictions, narratives, theories, histories, symbols, signs and images, or, by changing the world by acting upon it and its materiality — by making objects.

Conceptual art would be much more appropriately labelled "immaterial art" since the materiality of that type of art is absent or irrelevant, but I prefer "contextual art," since it is a form of art that acquires meaning only through context, the institutional contexts of art experience, the physical context of museums, galleries, magazines, catalogues, monographs and photographs, and the literary context of art history, criticism and theory. Conceptual art, or, as we should really say, contextual art, does not exist outside these specific contexts. It relies entirely on context for meaning. "Contextual art" is a better term, more precise, more accurate and, above all, more honest. Since obfuscation and appropriation of precedence have been trademarks of art history, I do not foresee redress in the near future. But if we were to acknowledge the contribution objects have made through abstraction and conceptualization to art history, the whole structure of art history would have to be rethought, and the whole of art history itself would have to be rewritten. I am not too hopeful that this will ever happen. It is much easier to ignore the continual invisibility of certain practices.

THE HANDMADE OBJECT

Again, I propose that a re-examination of the role and importance of handmade objects within culture and their theoretical underpinnings could serve as the basis for a new type of art experience, where art and life are truly reconciled beyond the false promises (which are fundamentally little other than pressure to ever-more consume) of new technologies. New technologies are, nonetheless, important tools for new forms of creativity, yet they cannot in themselves provide satisfactory answers to the present situation of growing alienation. To make an object by hand, material, technique and skill remain central to the task. And both technique and skill,

in a world where mechanization, mediation and industrial processes are the norm, have lost their historical importance. Technique has been replaced by technology and, now, by the virtual reality of computers. The skill, the actual manual and physical skill necessary to operate a computer is almost nonexistent. It has been replaced by an expanded role for intellectual skill, but for fewer and fewer people. The others are just indentured slaves to machines. Yet intellectual and conceptual skills are not absent from handwork. On the contrary, in handwork, the manual, physical skills, and the intellectual, conceptual skills are in balance. This balance has been broken by new technologies. These technologies are also language-based and rely on a system of codes and of signs. They are primarily visual as well; even if recent advances in haptic experience show promise in reestablishing the role of the hand, they will probably find their primary use in virtual gaming and other form of entertainment.

The maker of objects by hand is like a virtuoso musician or professional dancer, while being also altogether composer or choreographer. That performance doesn't have the implicit theatricality and entertainment value of spectacles, though. It remains a performance without witnesses, which can only be experienced through the product of the performance. If images are inherently spectacular and entertaining, objects are ordinary, quotidian, domestic and based in labour. If images are reflections of the world, objects are actors on the world and their transformative power, while being different, is as great and certainly as important.

Handmade objects do not only object to theory. By resisting and undermining language,[+] they contest and subvert contemporary visual art by not being mediated, by operating outside institutional contexts, by being physically and/or conceptually permanent instead of temporary, by being timeless instead of grounded in the instant, in the present, in the fashionable now and by resisting both conceptual and stylistic change. They contest design products by being unique and, again, handmade. The focus that contemporary design presently puts on style instead of substance, on personality instead of vision, is also in need of reexamination and contes-

tation. And, above all, the best, most relevant and potent handmade objects contest and subvert craft practices by going beyond material and technique, by denying the importance of the well-made, the tasteful and the personal, to become witness and memory of our present (as well as past and future) times. If handmade objects have become largely useless in a practical sense, they nonetheless remain socially essential, as receptacle for the imagination and memory of humankind, memory of knowledge and experiences. This repository for experiences and memories, historically the domain of objects, has progressively been usurped by images, which now occupy the central stage in fulfilling that archival role (just think of photography and digital practices). Yet it might be possible that objects are slowly reclaiming that role now given to images, without notice from anyone and without anybody admitting it. Quite simply, just to make handmade objects today is a potent form of contestation and an effective exercise of criticality. This might be where objects' most important role within culture resides now, and, I repeat myself again, as recipient for the memory of humankind, a memory of knowledge as well as a memory of experiences. It could be argued that the only place where contestation, subversion, criticality and the real possibility for change reside, remains within those practices that have the making of objects as a central activity. At the very least, they offer a potent, if marginalized, alternative to the current state of general aesthetic and physical alienation.

Handmade objects in the global world we now live in have the amazing potential to be transnational and operate beyond geographical borders. Their universality attests to that potential. They can also be truly transcultural, combining various cultures in juxtaposition, blurring identities while remaining significant to the local particularities of makers and users. And, most importantly, they can also be trans-historical, working timelessly, reuniting past, present and future seamlessly. Only objects, and, more specially, handmade objects, have such a complex role to play within culture now.

Handmade objects contest the contemporary and disrupt the apparent

cultural consensus. In handmade objects, we find the last traces of what we used to call "work" (beyond agriculture, yet for reasons as vital as producing food), the last place where effort in use still exists, non-mechanical and non-mediated, and the last place where contestation and subversion are still possible in the cultural sphere. To make an object by hand is a profoundly political act.

If objects, and particularly handmade objects, have not received the attention they deserve, it is not because they have become irrelevant and meaningless in the world in which we live. It is because, of all cultural phenomena, they imply a complexity that exists beyond language and beyond theory, thus beyond the reach of those who are confined by language and theory. Images are complicated, they need to be explained, to be fictionalized; they are, thus, the privileged domain of theory. Objects are much less complicated but much more complex. And this complexity resists language and theory. Yet a theory of objects, an object theory, remains essential, if we are to reexamine and reevaluate, reassess and reposition the important role played by objects within culture.

NOTES:

1. These ideas were first explored in a text "Toward a Unified Theory of Crafts: The Reconciliation of Differences," published in *Studio Potter* 29.1 (December 2000); in *Artichoke: Writings about the Visual Arts* 13.1 (Spring 2001), and reprinted in *Craft: Perception and Practice: a Canadian Discourse vol. 2*, edited by Paula Gustafson (Vancouver: Ronsdale Press and Artichoke Publishing, 2005).

2. For the development of these ideas, see the work of psychologist Donald Winnicott on the infant/mother relationship and art critic Peter Fuller, *Art and Psychoanalysis* (London: Writers and Readers, 1981) and *The Naked Artists: Art and Biology and Other Essays* (London: Writers and Readers, 1983) on this subject in relation to the art experience.

3. See Jean Baudrillard, *The System of Objects*. 1968. (London: Verso, 1996).

4. I have developed these ideas elsewhere around a reading of Michel Foucault's "Of Other Spaces" (*Diacritics* 16.1, Spring 1986), and *The Order of Things* (New York, Pantheon, 1970). "The Space of Pottery" was published in *Ceramics: Art and Perception* 22 (1995); *Studio Potter* 19 (June 1991); and *Making and Metaphor: A Discussion of Meaning in Contemporary Craft*, Ed. Gloria A. Hickey (Hull: Canadian Museum of Civilization and the Institute for Contemporary Canadian Craft, 1994).

Contemporary Ceramics:
Piecing Together an
Expandable "Fit"

Penelope Kokkinos

 The longer I work with clay, the more I puzzle over the role of contemporary Canadian ceramics within the global community. Although there have been many potters and ceramic industries such as Medalta, Blue Mountain and Céramique de Beauce scattered throughout Canada over the last 200 years, Canadian ceramics rarely receive the same attention as that paid to Chinese porcelain or Italian majolica. Given the fact there is relatively little clay from which to make ceramics, and the short history of ceramics production in this country, Canada's "new clay tradition" operates, for the most part, as a conundrum. Australia also possesses a "new clay tradition" in that aboriginal and/or domestic material culture did not include locally manufactured ceramic objects until the influx of immigrants in the eighteenth, nine-

teenth and twentieth centuries generated a market for producing them (Avicam).

Makers of "new ceramics" in new or not-traditionally ceramic-based cultures want to, and manage to, work with clay where little naturally exists. Recent developments in transportation, economics, technology and cultural exchange have generated alternative opportunities for potting. This new set of conditions presents makers with the structural and conceptual freedom to engage with and (re)define parameters of material and cultural practice. The extent and visibility of new regional ceramics asserts a growing desire to have this practice recognized as an exploratory, sustainable, "expandable fit" within current fields of national and international cultural production.

In this essay, "fit" is used as a popular expression to capture the context of ceramics-making in consideration of its intended and perceived practice. Generally speaking, "getting the right fit" reflects North American and global preoccupation with homogenization. "Getting the right fit" underlies concerns that support normative structures around accessibility and choice in everyday public and private activities. From the food we eat to the way we dress, our values are filtered through a divisive system of what is good and what is bad. Pop culture, television and media are full of "survivors" and "idols" who signify the best and the beautiful through a practice of voyeuristic elimination and triumph. The hierarchical dichotomy proposed by social notions of the "beautiful" or "good" — presented as exemplary states in contrast to all that is "ugly" or "bad" — is imbedded in current socio-cultural production.

As an object maker, I often wonder why I have so invested in a practice that, at first glance, does not "fit" well in the mainstream worlds of glitz or commerce. After all, my studio output will never be considered a fashionable contender when set next to the marketplace of science, sex or "blockbuster" economies. So, within a dichotomy of ugly/beautiful, margin/mainstream, "fitting and not-fitting," how would one position studio ceramics amongst the ebb and flow of a postmodern era?

Contemporary ceramics are often positioned as pivotal items in a sea of banal objects. They are pivotal in that they offer a sense of physicality, which sparks a reflective, contemplative state, or they make a statement that connects the holder/beholder physically and psychologically with a memory or daily reality. Some potters resemble what sculptor Liz Magor refers to as "non-commercial materialists," artists who are "interested in objects and materials, how form and content interrelate . . . how objects work in the world . . . and how we give them meaning in everyday life and in making art" (Rowley 20).

Most significantly, the writings of psychoanalyst D.W. Winnicott have been of great help to me in developing my understanding of how contemporary ceramic objects "function" or "fit" within a postmodern sensibility. Chosen ceramic objects function as connectors or material indices that reference a fluidity of cultures and identities. In discussing "Object Relations" theory, Winnicott states that the "transitional" object is a unique object of choice that bridges the gap between internal and external physical and psychological conditions. A transitional object "is not an object of status, nor is it an item that is over-commodified or over-collected. *It is a symbol of bodily experience in the world*" (1971 107).

The thought that an object can represent *a symbol of bodily experience in the world* functions as a key point for me when I reflect upon my chosen vocation as object maker. To think we have all, since infancy, selected objects that relate to or mirror our existence as we move from one physical or psychological relationship to another is quite a revelation. It is powerful to think that unique objects help us negotiate the "in-between" or "yet to be defined" spaces of existence, where we learn creatively about "our place" or "fit" in the world.

When I speak of contemporary ceramics, I am referring to uniquely considered and manufactured objects of choice. These objects operate as cultural indicators that physically and affectively locate a body within the space of everyday. As Winnicott suggests, these objects establish "the place where cultural experience is located . . . the space of potential

between the individual and the environment" (1971 108). I suggest that ceramic objects can function as transitional objects, and, in so doing, they help define where and why we "fit" — or fail to fit — and how we are "fitted" in relation to others. Therefore, contemporary ceramics can assist an individual to appreciate, negotiate and "fit" into a new space or environment.

In world of constant change and dislocation, Winnicott's concern for the necessary sense of home, environment and identity still appears relevant. Winnicott analyzed the effects of intimate contact gained through the childhood experience of relating to objects. He posited that motifs of childhood experience reappeared later in adult life, causing one to re/position or re/create a "home" or a fondly remembered environment for oneself when in a foreign or changing space.

In Canada, as elsewhere, the idea of a stable home environment is diminishing. According to Statistics Canada's 2001 Census, 18.4% of Canadians are foreign-born, and a remarkable 41% of its citizens experienced a household move within that calendar year (website). Some contemporary ceramists explore complicated notions such as diaspora through the idea of the container as a study in delineating and merging volumes and boundaries of space. Delineation, merging and boundary are defined metaphorically and materially. Volume is considered in terms of interior or enclosed space in opposition to exterior or surrounding space and in terms of the physical limit or boundary of a pot wall.

For example, Regina ceramist Jeannie Mah comments:

> In this new socio-cultural context, objects imbued with certain ideals must realign or change. . . . Mimesis, assimilation, acculturation reveal the struggles within and between identities as they produce new hybrids of pots and people (1995 8–9).

Mah's statement refers to the 1992 work *History + Memory*2 = that was commissioned by the city of her birth, Regina, Saskatchewan. She reports that this commission gave her a practical opportunity to reflect upon her historical connection to a specific physical site:

I use the tradition of the commemorative cup to my own purposes. [An image of myself], a little girl of immigrant parents surrounded by North American advertising in front of our home, the family store, is placed onto a simple cup. . . . In this way, I reinsert [into the municipal structure of the city hall] the neglected history of the Chinese grocery and the lively neighbourhood which existed before [on the same location as] the newer city hall (1995 8–9).

Winnicott said that the transitional object describes the potential space between baby and mother, between child and family or between individual and society as being (inter)dependent on initial experience, which leads to trust of self and environment. "The dynamic is the growth process . . . the 'good enough' facilitating environment . . . where the word *perfect* does not enter into the statement — perfection belongs to machines, and the imperfections that are characteristic of human adaptation to need are an essential quality in the environment that facilitates" (1971 139).

As a way to envision Winnicott's "point of initiation between whole and separateness" (1971 103), Joni Moriyama refers to "vessel resonance" as an echo or mirroring of the connectedness of in-between states:

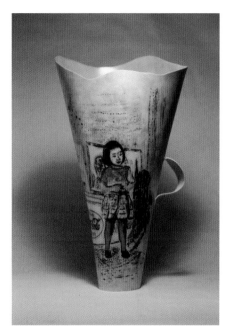

Jeannie Mah.
History + Memory² =
(detail). 1992.
Porcelain with
photocopy and
underglaze transfer
print, shelf.

I have been a maker of small objects that try to evoke the familiarity of everyday items. These objects resonate from the commonplace world and/or carry the remembrance of past histories and civilizations. I have been greatly influenced by the history of ceramics through the venues of both utilitarian pot making and vessel making. The former has taken me in the direction of sculpture rather than functionality because, as with everyday items like the cup, they represent in their ordinariness a union of experience. While many artists would want their work to have a solid point of reference, I consistently choose to circle over an array of images. I hope that this strategy of non-fixity will elicit from the viewer a feeling of connectedness, and, at the same time, one of intrigue (artist statement).

Through a persistence of unified form, Joni Moriyama's work curbs "extreme" states of postmodern fragmentation by offering a resonance of parts as being "connected" or "always, already there." This is not to say that connectedness — or what Moriyama refers to as "echo" — is about stasis. Echo is about a quiet reverberation of change. It is through the lessening of degrees of ambiguity and fracture that Moriyama implies both stability and relational change. She says, "It is about a state of reflection that supports an ability to expand and let go" (artist interview). As articulated in Moriyama's and other artists' work, contemporary ceramics "fit" as familiar articles of contemplative or playful inquiry within their presentation of difference.

Cynthia O'Brien says her work springs from an "idealism about childhood, romance, marriage and community . . . swayed by many temptations" (interview). Her ceramics have shifted from tableware to television, depicting mass media as a good/bad model of Pop culture narratives. Television projects a "popular" or mainstream version of socio-political values into people's homes. O'Brien's ceramics reorganize themes of love, lust and power derived from daytime soap operas into critical entertain-

ment with an edge that bites into expectations of "normal." Through her technical finesse and wit, O'Brien grounds a ceramic practice that openly depicts current idolizations of sex as subtle, deceptive, romantic and inventive.

O'Brien's ceramics can be taken as metaphors for the discovery and deepening of a relationship between maker and material, viewer and object. Her pieces long to be held. They seem to have weight. They are smooth and rough, shiny and matte. Their forms encourage caution and caress. O'Brien's clay stages itself as flirtatious. Small, smooth, sharp, shiny intrigues lure the viewer closer towards more intimate physical interaction, which is suddenly arrested by the object's unyielding placement on wall or plinth. The pull/push promise of the work intrigues. The reception of the pieces depends on the viewers' perspective. Sometimes, the pieces are viewed as erotic. Other times, O'Brien says the clay works represent "a conversation about sex from a woman's point of view," a view that challenges the predominant "male gaze" of media's simple-minded, glossy packaging of the available "lady" (interview). These pieces present an inquiring, playful way to see "fit" in terms of a contemporary, on-going exploration of boundaries and relational exchanges between objects and people.

Cynthia O'Brien.
Untitled. 2002.
Earthenware.
Each unit
approximately
15 x 17.5 x 9 cm.

Artists like O'Brien use a playful depiction of organic materiality to counter the mainstream's fetishistic ideals, and as a tool to uncover "bad/good," "ugly/beautiful," "not-fitting/fitting" undercurrents present in the everyday. Winnicott framed normative perceptions and the value of play and choice in the self- and social definition of the individual when he suggested that "every 'transitional' object is a 'found' object that the infant relates to creatively through 'play'. However, if unwanted objects are injected into an environment, or chosen objects are denied, 'trauma' surfaces as a break in life's continuity" (1971 197).

How might the idea of the good/bad, fitting/not-fitting object and/or social coding govern example and practice through the manufacture and use of ceramics? Thinking back to my first childhood association with mass-produced ceramics, I remember how my early indoctrination and mainstream socialization transpired through every mouthful of cereal and sip of milk fed me from my Royal Doulton™ Bunnykins bowl and cup. Bunnykins' fun-loving, sweet, anthropomorphized antics became a daily register or societal mirror, which laid out a structure of Western mores I endeavoured to mimic. Later, in my early adulthood, I remember becoming enamoured with the intrigue of hidden messages on fine bone china teacups and saucers patterned with Victorian lustres and motifs. The motifs, I learned, were representative of the "secret language of flowers," an underground visual coding developed to convey private pledges of love, friendship, mistrust, envy, etc., within a climate of emotional repression and moralizing.

In a world full of cultural clutter, the intention of many of my "not so beautiful" — what bell hooks calls "bitchified" ("Facing Difference" 98) — ceramic pieces is to exhibit that strange alliances can be formed between a diversity of handmade and commercially manufactured material forms and contexts. For example, in my piece *White Matrix: Elizabeth/Silver*, local "one-of a-kind studio ceramics" were juxtaposed with "Made in China," Dollar Store Canadian currency coffee mugs. A generic white coffee mug bearing the image of a Canadian twenty dollar bill with Queen Elizabeth's face is partnered with a generic silver-lustred mug, the shiny surface of which reflects the Queen's emblematic grin. The economically and physically co-dependent duet of "everyday" coffee mugs are then nestled into a base of shredded, impressed clay or white matrix foundation, which symbolizes the all-encompassing permeability of Western socio-economic exchange. These ceramic components were assembled together in an effort to present an object or image that puzzles about notions of national/post-national, transient identities and current modes of ceramic production.

Discovering a generic coffee mug dislocated from its everyday cycle

of use and resituated as an object of emblematic stature shifts the user/viewer's focus from considerations of the body and utility to the realm of mind and message. Rifts in perception of the use value of everyday objects hint at how political import can seep into the routine of daily existence through the guise of a "simple" mug. The desire of contemporary ceramics to fill an intrinsic need or lack and its efforts to create meaningful objects within a field of non-fixed idealism gives makers the freedom not to be bound by local ceramic traditions. This fluidity of intention and interpretation enables an expanded field of images, artefacts, table wares and knickknacks, thus supporting an array of aspirations and cultural overlays.

Penelope Kokkinos.
White Matrix:
Elizabeth/Silver. 2003.
Earthenware and
found ceramic object.
15 x 20 x 16 cm.

Carrie Mae Weems offers her account of a parallel contemporary art process:

> [W]e have to make art work for us, within the context of our own individual belief systems. . . . How do you do this . . . ? How do you describe complex experiences? . . . What should it have to look like? What does it have to challenge? . . . Who is it challenging? . . . Who is it for? All those kinds of questions are constantly shifting for me. The moment that I think that I have it locked down is the moment in which it flips (qtd. in hooks, "Talking art" 86).

Pointing to the fluidity of contemporary ceramics is not to label new ceramics as ill-fitting or dysfunctional. On the contrary, new ceramics represents the shift of ambivalence in a postmodern world. Such work is open to being labelled as good, bad, ugly, fitting or not-fitting, depending on the inclinations of maker or viewer. The way one looks at objects as wanted or not-wanted is based on personal knowledge and learned experience. One can see that a sense of play predominates in a transitional or transgressive shift from one location to another. In a sense, states of chaos and conflict promote resolution and creation.

In 1982, English ceramist Alison Britton commented on new ceramic

tradition by saying that British potters tended to fence themselves in with taboos and truth to material, while [American] West Coast potters derived "both their strength and their weakness . . . in their freedom from, and ignorance of, a clear line of tradition" (16). She thought that crafts, especially those that are art school oriented, were "getting harder to understand or at least less obviously lovable" (17). Britton further asserted that, "being a vessel is not very demanding. Once the functional requirements of holding are fulfilled, there is still plenty of room for interpretation" (18). Yet within the boundaries of new interpretation, "there must be a tendency [on the part of the maker] to trust spontaneous improvisation," not by accepting what chance brings, but rather by the "shaping of an object at the point of utterance" (21).

It is here, at the point of its "utterance," that the nature of artistic practice becomes rooted in risk; acknowledging "not working," "bad," or "not-fitting" is part of the process. Modernist discourse often overlooks ceramic work because pieces are structured in a manner that appears simple. Critics may initially assume that these objects are familiar, even basic, but contemporary makers displace, subvert or change meanings through their critical use of the medium. bell hooks remarks:

> Looking at these pieces from diverse standpoints changes their meanings. . . . I've seen individuals respond to artwork . . . I see their discomfort and I think, what this piece does is remind us of the politics of location that is operating in all our lives. The pieces displace a sense of fixed location because the meaning depends on the direction from which you gaze at the piece. Re-imagining presents images in a new way . . . in a manner that interrogates and intervenes ("Talking Art" 84).

Vida Simon observed the following about Shelly Low's installation *Compact Abundance* (1996), although it applies equally to other works:

> Individually the works are small but the whole community of them is encompassing, forming one body with no central focal point. . . . As I dwell on each piece its meaning shifts; what I perceived to be a vegetable is also a tool, or a peculiar bodily organ emanating both female and male sex-

uality. . . . While she uses a methodical, systematic approach to making and arranging the works, a paradox is that she is fundamentally concerned with dissolving boundaries.

As Low articulates, the combining of materials is intended as a symbolic act that conveys "many parts of life as interdependent" (artist statement). bell hooks approaches diversity, margin and artistic endeavour in a similar way:

> Creating a counter-hegemonic image that resists stereotypes and challenges the artistic imagination is not a simple task. To begin with, artists have to engage in a process of education that encourages critical consciousness and enables them, as individuals, to break the hold of colonizing representations. . . . To see new and different images is to some extent shocking. Since images that are counter-hegemonic are necessarily provocative, their seductiveness, their allure lies in the freshness of insight and vision. They fulfill longings that are oftentimes not yet articulated in words: the longing to look at [self] in ways that resist and go beyond the stereotype ("Facing Difference" 96).

Shelly Low. *Round Field*. 1995. Ceramic and mixed media. 240 x 240 cm. Photo: Paul Litherland.

Contemporary ceramics' presentation of an "expandable fit" constitutes the construction of playful, contemplative, "bitchified" objects. These generously mirror transitional phases of identity and cultural formation, thus allowing ceramists to become "good enough makers" of objects. These unique objects remain unhampered by past models or traditions. As such, they occupy a space of "in-between" through their acknowledgement of the past and connectedness to the future in a way that gives renewed meaning to the fluxing inclusivity of "fit."

WORKS CITED:

Avicam. "The Development of Ceramics in Australia." 7 September 2006. 10 December 2004. www.avicam.com.

Britton, Alison. "Sèvres with Krazy Kat." *Crafts* 61 (March/April 1983):16–22.

Getty, R.M. *Know Your Medalta: Vases.* Medicine Hat: Digital Fire Corp. 1995.

hooks, bell. *Art on My Mind: Visual Politics.* New York: The New Press, 1995.

——. "Facing Difference: The Black Female Body." In *Art on My Mind.* 98–100.

——. "Talking Art with Carrie Mae Weems." In *Art on my Mind.* 74–93.

Low, Shelly. Artist Statement. *Compact Abundance.* Montréal: articule, 1996.

Mah, Jeannie. "Subjective Ceramics." *Contact* (Spring 1995): 8–9.

Mah, Jeannie and Bill Rennie. *April/Paris — Jeannie Mah.* Vancouver: Grunt Gallery, 1990.

Moriyama, Joni. Artist Statement. *Joni Moriyama: Recent Works.* Toronto: Prime Gallery, 2002.

——. Personal Interview. July 2003.

O'Brien, Cynthia. Personal Interview. May 2003.

Rowley, M. *L. Magor: How Form & Culture Interrelate.* Vancouver: Emily Carr Institute of Art and Design, 2001.

Simon, Vida. Exhibition Essay. *Compact Abundance.* Montréal: articule, 1996.

Statistics Canada. 10 December 2004. www.statcan.ca.

Winnicott, D.W. *Playing and Reality.* New York: Basic Books, 1971.

Performing
Activism

"Performing Activism" concludes our selection of essays with case studies of socially engaged work. By identifying and confirming actions performed in the everyday, we support and diffuse utopic models. The writers here advocate for the significant role played by craft practices engaged with activist causes. In these examples, the interplay of aesthetics and ethics contributes effectively to social action, just as these writers contribute to recording contemporary history.

Judy McNaughton's "River and Stone: Collective Memories of a Place" draws on her experience as artist-in-residence in Prince Albert, Saskatchewan, which is on the banks of the North Saskatchewan River near the site of the suppression of the Metis rebellion of 1885. Her case study details her efforts to find meaningful ways to honour memories of tragic events and to explore the role of "participatory architectural ceramics" in constructing appropriate forms of commemoration.

Nicole Burisch, in "Reevaluating links between Craft and Social Activism," examines ways contemporary craft engages social and political issues. She borrows the term "craftivism" to describe recent activities such as "knit-ins" conducted by the Revolutionary Knitting Circle or "random acts of pottery" performed by Lisa Barry. Burisch advocates for a broader definition of activism, one that incorporates socially active craft practices.

River and Stone:
Collective Memories of Place

Judy McNaughton

There are places so steeped in the memory of historic strug-
gle that the site remains a threat to the established order even
one hundred years after the blood has washed away. In Prince
Albert, Saskatchewan, on the banks of the North Saskatchewan River,
near the site of the suppression of the Metis rebellion of 1885, a desper-
ate cluster of monuments to the conquering founding fathers stands in
almost comical contrast to the striking beauty and power of the place. Is
it possible for the memories of such a place to be honoured in a way that
involves a dialogue with present realities, in a way that is meaningful to
the people who live near or who use that site? This essay explores the role
of participatory architectural ceramics in constructing meaningful com-
memorations of site, history and memory.

Monument (to the "founding fathers"), Nisbet Park, Prince Albert, Saskatchewan, Canada.

Artists involved in public art have made many and varied attempts to address such issues. As a ceramic artist working in Prince Albert through Common Weal Community Arts Inc. and the Saskatchewan Arts Board Artist-in-Residence Program, I draw on a number of art historical precedents and discourses when searching for a method of art-making in the shifting terrain of public sites. I have found that participatory architectural ceramic works manifest collective memories of a site through personal inscriptions by community members; they bring to the surface suppressed histories and unacknowledged present realities. Art historical precedents, current artistic and political discourse and the social and physical environment informed the process of creating my work *The Riverside School Mural* (2003).

The use of public space, the representation of history and the role of the audience for public works have been widely discussed in recent art criticism. Museums, sculpture parks and "new genre" public art have negotiated shifting relationships with their various audiences. World affairs have also contributed to this discussion. Attempts to imagine a new form of public memorial in post-WWII Germany, the toppling of monuments in the collapsed Soviet Union, and, more recently, Iraq, have helped to initiate discourse around the function of monuments and memory.[1]

Riverside School Mural in situ. 2003. Clay, glaze, mirror. 1.2 x 8.5 m.

W.J.T. Mitchell, the distinguished American art historian, stated: "The pulling down of public art is as important to its function as its putting up" (qtd in Roy 73). The significance of this demolition is certainly not lost to the American spin-masters, as was demonstrated on April 9, 2003, when the giant figure of Saddam Hussein was toppled in Firdos Square, Baghdad. Many believe the event was stage-managed for the world media to suggest Iraqis welcomed the invasion of their country (Martin). History is indeed written by the victors.

Because those in power control the use of public space, their attitudes tend to be reflected in public monuments, most often to the glaring exclusion of voices challenging the self-congratulatory narratives they convey. A number of historical precedents exist of artists who encouraged works of fine artistic merit that reflected attitudes and aesthetics of those without privilege and power. Arts and Crafts movement spokesman William Morris commented in his essay "Art and Socialism," "The world of modern civilization in its haste to gain a very inequitably divided material prosperity has entirely suppressed popular Art: . . . the greater part of the people have no share in Art." Despite the ultimate failure of his utopian visions, themes dominant in Morris' writing have re-emerged in populist public art movements.

In the 1970s and '80s, a ceramic mural movement with populist aspirations took place in Saskatchewan. Victor Cicansky, Joe Fafard and Jack Sures were among a group of Saskatchewan ceramic artists strongly influenced by the pop-oriented California Funk movement of the seventies. Resisting the high art, modernist biases of the art institutions of the time, they developed a "low-brow" art form that borrowed references from the visual vernacular of their region.

The "Saskatchewan Funk" artists looked to their communities of origin for inspiration in this venture. Rather than emulating an imported aesthetic and philosophy, they created work that reflected the culture and geography of their specific location. Victor Cicansky's personal webpage states:

> Public art in contemporary society is a reminder of our values and who we are. It should be meaningful and accessible. It should enhance the visual landscape and stimulate the imagination of people in the communities where art is placed.

These Saskatchewan ceramic artists produced public murals depicting images strongly influenced by the folk art styles of the area. This is especially evident in the work of Victor Cicansky and Joe Fafard. Victor Cicansky's father, Frank, was a recognized folk painter, and Victor's sculptures are reminiscent of the subject and manner of Saskatchewan folk painting. Likewise, much of Joe Fafard's work evokes traditional French-Canadian wood carving, which is familiar to the large Fransaskois community in Saskatchewan. These references to agrarian and working-class aesthetics produced a populist art style in Saskatchewan, which had the effect of critiquing the current institutional art environment while speaking to the lifestyles and aesthetics of the majority of the province's people.

Growing interest in engaging audiences previously marginalized from the arts world gave rise to community-based arts projects in North America in the late 1980s and early 1990s. Coined "New Genre Public Art" by Suzanne Lacy, this approach to public art invites members of non-arts

constituencies to participate in the creation of art in their environment. Although this movement opened the experience of the arts to many who had not previously had such exposure, it proves to be a complex field, as is well documented by writers such as Grant Kester and Miwon Kwon. Many critiques of this genre concern the intent and manner of the artists and institutional partners involved, emphasizing the importance of a committed, thoughtful practice when working in non-arts communities.

The changing perception and form of monuments over the past twenty years parallels the evolving discourse surrounding art in public sites. The collapse of the Soviet Union in the late 1980s filled the media with images of toppled monuments from the totalitarian regime. Artists such as Vitaly Komar and Alex Melamid, in their exhibition *Monumental Propaganda*, which toured in 1996, brought issues of monumentality to the forefront of the art world. In May 1992, Komar and Melamid placed an ad in the journal *Artforum*, asking for artists' suggestions on how to "save" Russia's Socialist Realist monuments. They asked that artists send them ideas of what could be done with the outmoded monuments of Lenin, Stalin and other Communist figures. Many of the resulting proposals bordered on the absurd, such as a memorial statue converted into a children's slide. The drawings and photographs of the ensuing exhibition sat in cases propped on inverted models of Lenin's head.

Some artists have attempted to alter the public's perception of existing monuments in order to highlight their hierarchical undertones and cultural biases. In his 1992 performance titled *Artist as Politician: in the Shadow of a Monument,* Ukrainian-born, Saskatchewan-based artist Taras Polataiko questioned the raising of a monument to the newly appointed Ukrainian-Canadian Governor-General, Ray Hnatyshyn. For his performance, which nearly got him deported, Polataiko, covered in bronze powder, stood next to the commissioned statue on a pedestal bearing the inscription "Dedicated to the 100th anniversary of Ukrainian settlement, in honour of those Ukrainians who never became Governor-General" (Lerner).[2]

In an atmosphere as loaded as this, what form can a contemporary memorial take? Attempts to memorialize the atrocities of the Holocaust and deal with the complex social aftermath gave rise to innovations such as the *Harburg Monument against War and Fascism and for Peace* (1986–1993), in Harburg, Germany, by artists Jochen Gerz and Esther Shalev Gerz. This monument began its life as a conventionally shaped mortuary structure. The surface, however, was easily marked, and visitors were invited to leave inscriptions. The structure was gradually lowered into the ground, leaving blank space on which to write, until, eventually, the entire monument was submerged. The monument reflected a controversial complexity of issues rarely shown in more conventional monuments (Rosen 33).

When deciding on an approach to take during my residency in Prince Albert, I was influenced by these art historical precedents and related critical discourses. I was also stirred by the social and physical environment of the city in which I found myself. Upon arriving in the northern city of Prince Albert from Southern Saskatchewan, my partner, Michel Boutin, and I noticed immediately a tense segregation of First Nations, Metis and European descendants in the city. Michel, being a mixed-blood Fransaskois, encountered a startling amount of prejudice from the portion of the population retaining a strong British or European identity. This is a highly charged region in Saskatchewan's history of colonization. It is the first point of European contact with the First Nations in what is now Saskatchewan and an original homeland of the Metis people. In 1885, when the rights of the Metis were not acknowledged by the government of the day, the Metis refused to acquiesce and were crushed by the army. Today, this is one of the few places in Canada where Metis flags can be seen flying over residential and commercial buildings. The memories of this and other issues concerning colonization are still fresh for many residents of the area. In fact, many Prince Albert residents struggle daily with the present social repercussions of this colonial legacy.

As a resident artist, I worked closely with an advisory committee com-

prising local artists and community representatives. While final decisions were ultimately mine to make, I consulted with the advisory committee and other community members with whom I was working in workshops and on art projects. The architecture and imagery of the inner city area where I was resident was dominated by a modernist sensibility that was largely insensitive to the various First Nations, Metis, East-European and other cultures of its residents. The various participants in the residency wished to create a large architectural ceramic artwork that would respond to the cultures and aesthetics of the local residents. The mural was to be placed on the front of Riverside Community School, a modernist building facing the North Saskatchewan River. I felt that a work of such "monumental" scale could have significance countering the cluster of monuments to the founding fathers just down the block.

I consulted Laura Merasty, a highly respected local elder about appropriate imagery to use in the work. We agreed that the medicine wheel would be an effective image, as it is recognized by many of the First Nations, particularly the Dakota and Cree, who make up a large portion of the local population. It is also a very inclusive symbol. One reading of the

Riverside School Mural (detail showing medicine wheel). 2003. Clay, glaze, mirror. 1.2 x 8.5 m.

four coloured quadrants of the circle refers to four races of people. We felt this would be particularly pertinent in this area of the city, which includes a rich variety of cultures. The elder gave her blessing and permission for the use of this image in the piece and remained part of the process as an advisor, speaking eloquently about the medicine wheel image at the opening celebration for the work.

We decided to make an overall design in which each participant would paint and decorate a small piece of the large mural with a set of coloured slips. The participants could draw and write into the clay tile, not unlike the visitors' inscription into the surface of the *Harburg Monument*. As in the community-based model of public art, we invited any and all residents to work on the mural. Work stations were set up at neighbourhood functions, flea markets and parent-teacher nights at the school. We went to seniors' centres, soup kitchens, classrooms, youth drop-in centres and parent council meetings. About 500 participants ranging from preschoolers to seniors took part in the project. All took their contribution very seriously, writing messages to their mothers, babies or even missing loved ones. Often they drew images with cultural or religious significance. Some teens put their "tag" or name with a jersey or gang number. What

resulted is an unexpectedly intimate snapshot of the Midtown area neighbourhood at a specific time.

In the spirit of populist art movements such as the "Saskatchewan Funk" artists and new genre public art, this mural is made for the general populace. It is intended to provide an opportunity for participation in the arts for people who have perceived barriers to these experiences in the past. Despite attempts in recent years by art institutions to address audiences larger than the traditional art world initiates, many, particularly in economically challenged communities, still feel uncomfortable entering museums, galleries and performance spaces uninvited. By our coming as artists into their daily world for an extended time, learning what is important to them — what art or cultural activities they appreciate — and responding specifically to these priorities, we found that the gulf between the world of contemporary art and this potential audience diminished.

The education goes both ways. During our immersion into this new community, my partner and I learned about the history and social fabric of our province, and, as a result, about ourselves. An incident reflecting this took place one night when I was walking downtown after dark. I saw a group of tough-looking characters walking toward me, their faces hidden in hoodies, and I considered crossing the street. As I approached the group, the streetlamp cast light on a sea of shy smiles, and, as we met, I heard a quiet chorus of "Hi Judy." I realized this was a group of youth who had taken part in the project. My preconception of these young people needed to be addressed at least as much as their understanding of art and artists. My partner, Michel, also experienced revelations about himself through this residency. Being in this highly charged political environment has caused Michel to rethink his Fransaskois roots. Being commonly identified as Metis after arriving in Prince Albert caused him to look into his own aboriginal ancestry and into political and social reasons why many mixed-French communities in Saskatchewan masked this part of their heritage.

The artwork that emerged from this convergence of artist and audi-

ence/participants involves a melding of influences — art history, local tradition, contemporary cultural styles and personal stories. The overall design resembles graffiti, with large swirls and small, personal messages. The economy of Prince Albert is built, in part, on the business of incarceration, with seven penitentiaries, numerous halfway houses and related facilities. This tends to exaggerate the economic split between those with jobs in the local facilities, and those coming out of a facility or entering the city to be near incarcerated loved ones. Like other inner-city "hoods," the Midtown area of Prince Albert is home to many of those without economic privilege. The mural's subtle reference to graffiti and its placement on the imposing modernist structure of the school interject a local aesthetic into an alienating urban environment, marking the institution as belonging to the people.

Riverside School Mural (detail). 2003. Clay, glaze, mirror. 1.2 x 8.5 m.

Imagine the reaction this aberrant addition to the building would induce in Adolf Loos, harbinger of modernist architectural style and author of the essay "Ornament and Crime." Elevating voices of the "criminally suspect" portion of the population — youth and the economically challenged — to monumental scale and referencing the "illegitimate" decorative style of graffiti subverts the normal social order of the city (Loos 167).

The use of First Nations symbolism also challenges the status quo. Using this imagery in respectful acknowledgment of a living culture serves to defy a romantic fiction around European conquest. In a city in which the First Nations and Metis population approaches 50% and is still growing, Eurocentric narratives of conquest seem particularly absurd. The numerous monuments to European conquerors remain down the block from the mural. However, like the work of Taras Polataiko, which re-examines meaning behind existing monuments by juxtaposing an alternative viewpoint, the placement of this mural shifts the social context of the pre-existing monuments for viewers.

Memorials and monuments in the past have been self-servingly

amnesic. Like the Prince Albert monuments to the founding fathers, they assert a version of history that supports the existing power structures despite — or perhaps because of — the rising awareness of historic injustices and present social consequences. But forms of commemoration may also be used to resist these preferred histories. Cultural memory theorist Maurice Halbwachs argued in the 1920s that memory is a collective, socially rooted phenomenon. Individuals isolated from social interaction lack the societal narratives necessary to build meaning from memories. Alternative perspectives on the past and present can add to a more comprehensive understanding of our collective and individual identities, ultimately enriching all of us (Rimstead 4).

As trained artists immersed in a rich and gratifying art community, we commonly become absorbed in professional dialogue with colleagues through our visual art. In such a milieu, architectural ceramics may seem anachronistic. However, asserting an alternative version of social priorities might require more-lasting forms through which to express populist aesthetic and historical understanding. There are situations demanding we adjust our visual language to include a vernacular if we are to speak respectfully with a specific audience to honour their unique environment, memories and experiences. Populist movements such as community-based arts and "Saskatchewan Funk," among others, pursue ideals that take them outside the institutional aesthetic of their day. These movements operate in a manner that is meaningful to their audience, respectful of their traditions and mindful of historical art-forms and priorities as perceived at that time. Such examples inspire those of us who continue to negotiate the delicate landscape of the public sphere.

NOTES:

1. For discussions about art and the public, see Andrew McClellan, ed., *Art and Its Public: Museum Studies at the Millennium* (Malden: Blackwell Publishing, 2003); and Régine Robin, "Requiem for a Toppled Statue: History as Kitsch and Remake," in George Baird and Mark Lewis, eds, *Queues, Rendezvous and Riots: Questioning the Public in Art and Architecture* (Banff: Walter Phillips Gallery, 1994).

2. For further information on Taras Polataiko, see Robert Enright, "Truth or Glare: The Formal Deceptions of Taras Polataiko," *Border Crossings* 15.2 (Spring 1996): 18–27; Dan Ring, *Taras Polataiko: Cradle* (Saskatoon: Mendel Art Gallery, 1996); John Lavery, "Taras Polataiko: A Ukrainian artist in Saskatoon exposes the pretensions of public art," *NeWest Review* 19.2 (December/January 1994): 9–11.

WORKS CITED:

Cicansky, Victor. "Cicansky's Mural and Public Art Work." *Victor Cicansky — Sculptor.* 25 June 2004. www.cicansky.ca/public.

Lerner, Loren, ed. "Taras Polataiko." Canadian Artists of Eastern European Origin. Department of Art History, Concordia University. 20 June 2004. http://art-history.concordia.ca/eea/artists/polataiko.html.

Loos, Adolf. *Ornament and Crime: Selected Essays.* Ed. Adolf Opel. Riverside CA: Ariadne Press, 1998.

Martin, Patrick. "The stage-managed events in Baghdad's Firdos Square: image-making, lies and the 'liberation' of Iraq." *World Socialist Web Site.* 12 April 2003. 25 June 2004. www.wsws.org/articles/2003/apr2003/fird-a12.shtml.

Morris, William. "Art and Socialism" 1884. *The William Morris Internet Archive: Works.* 20 June 2004. www.marxists.org.uk/archive/morris/works/1884/as/index.htm.

Rimstead, Roxanne. "Double Take: The Uses of Cultural Memory." *Essays on Canadian Writing: Cultural Memory and Social Identity* 80 (2003): 1–14.

Rosen, Joseph. "The Public Space of Memory: Opening to the Future of Justice." *Fuse* 26.3 (2003): 29–35.

Roy, Marina. "Saddam's Arms." *Public* 28 (2003): 57–76.

Craftivism: Reevaluating the
Links Between Craft and
Social Activism

Nicole Burisch

 I first began researching the idea of links between craft and activism in 2002. In light of the activist response to global trade meetings in Seattle, Quebec City and Calgary, and the corresponding increase in awareness about activist values and concerns, it was exciting to consider how contemporary craft practices could be involved in this action. When I first encountered "craftivism" in late 2002, an online search for the term yielded a few thousand hits. The idea of craftivism was circulating and gaining currency at that time, but it was still an emerging idea. Since then, the craftivism scene has exploded; an on-line search produces over 30,000 hits (October 2006). The pool of available examples has grown beyond what could credibly fit into an essay of this scope. While my local examples still hold weight, my research and

analysis have expanded to account for a plethora of artists, curators, activists, crafters and DIYers who are now practising something that could be called craftivism. This is a movement that will continue to grow and change, and my investigation is best understood as a snapshot of the movement at a particular time.

In its many forms, craft has long been positioned to address various social and political issues. Recent writing about craft theory and history includes references to historical connections between craft and social justice issues, suggesting ways in which contemporary craft practices can continue to be considered in this way. However, as new political and social issues emerge, together with new approaches for addressing and publicizing them, the time has come to reevaluate these connections. This essay will revisit some of the historical precedents for linking the fields of craft and activism, and it will use this history in considering contemporary examples of craftivism. The growing number of people using the term "craftivism" also suggests that it is time to consider what this new movement might mean for contemporary craft practices as well as its effectiveness as an activist strategy. I will look at overlaps in the work of crafters, artists, and activists, as well as at how, specifically, contemporary ceramics practices can be included within this discussion. I am interested in how small changes in awareness and inclusiveness on the part of all these fields can encourage mutual understanding that can only benefit them all.

CRAFT+ACTIVISM=CRAFTIVISM

For the sake of this discussion I am choosing to expand my definition of craft to include various ways craft is used and produced throughout the world. I mainly use the (intentionally gender-neutral) term *fine-crafters* to refer to those who fit into Bruce Metcalf's "crafts[person]-business[person] and . . . crafts[person]-artist" models (19). These are professional craft producers all over the world who make a living from their craft and who label what they do as "craft" and often as "art." This group also typically contains those who have pursued some level of formal training

for their craft through post-secondary education or apprenticeships. This label is also a direct derivation of the term *fine artist*, which implies work made within/for a particular market and that emerges out of a particular history and critical discourse. I also use the term *hobby-crafters* to discuss those who, while still incredibly skilled at their craft, do not necessarily make a living from their work and who do not participate in the fine art or fine craft market. Of course, this is not to say that each craft producer fits solely into one category, that there are no exceptions to these types or that these are the only types. These distinctions are not meant to privilege or rank different types of crafters. If anything, craftivism has encouraged something of a democratization of craft, creating a situation in which any-one can participate and in which distinctions between "high" and "low" craft are purposely subverted or ignored. These definitions are intended to provide an expanded and more inclusive view of craft extending beyond definitions constructed by much of the recent writing about craft. My terms will allow for a clearer discussion of how craft practices of all kinds can be considered through the lens of craftivism.

This leads me to my next term. Rather than using the term "anti-glob-alization" to talk about what Naomi Klein calls "the next big political movement, [the] vast wave of opposition targeting transnational corpora-tions" (*No Logo* xviii), I have chosen to use terms like "social activism" or "social justice." Through all my research, one thing has become clear: this is a growing and changing movement comprising many different kinds of people and organizations, with connections that span the globe and causes that transcend regional concerns.

This is a "movement of movements" (Klein *Reclaiming* 220): many groups of people all over the world speaking out and speaking to each other about certain "key ideological threads . . . self-determination . . . democracy . . . freedom . . . the right to plan and manage [their] own com-munities" (Klein "Introduction" 7), often in opposition to the policies and practices of large multinational corporations and international trade or-ganizations. Work is being done on issues as diverse as feminism, environ-

mentalism, workers' rights, indigenous rights, AIDS advocacy, media control, culture jamming, anti-war, homelessness, reclaiming public spaces, opposition to increased corporate influence, fighting racism, questioning over-consumption, global trade issues and many more linked to the social activist movement. There are hundreds of groups with thousands of members all around the world involved in this movement, including students, community groups, non-governmental organizations, farmers, indigenous communities, raging grannies, guerrilla gardeners and more.[1]

Since this is an evolving movement with no one concrete definition or manifesto, I have chosen to take the most inclusive view possible of what constitutes an activist. Calgary activist Grant Neufeld suggests that activism can take place in many different forms and can also involve many small actions. While Neufeld stresses that a lot of the best activism "is the stuff that you work on for years or decades or centuries," he also points out that

> someone who encourages their neighbor not to put pesticides on their lawn is an activist, someone who calls up their city councilor and says they would rather see more money go to bicycle paths than to roads, they're an activist. People doing what they're able to do . . . buying local, fair-traded objects, voting with your dollars, slowing down" (Neufeld Interview).

I intend to make apparent through the following examples and analysis the concerns of the social activist movement that are specifically relevant to craft and craftivism.

There are many practices that can be included under the umbrella of *craftivism*, which at its simplest can be understood as a uniting of craft and activist practices. This concept has grown and expanded significantly in the last four years. Currently, the term is used primarily by activists who use craft as part of their work. However, I feel it is important to include a broader range of practices that engage with this idea (intentionally or not), since they all influence how we understand its strengths and implications. For example, a humanitarian group like Potters for Peace (whose projects I will discuss in more detail) may not identify itself as craftivist,

but their work certainly fits the basic definition and belongs within the context of this discussion. The same can also be said for certain crafters or artists who use aspects or materials of craft in their work to address political or social issues.

A LITTLE BIT OF HISTORY

Taking these expanded definitions into consideration, I will first look at the Arts and Crafts movement of the late nineteenth century as an example of how crafts and social concerns have been linked in the past from a fine craft perspective. William Morris wrote extensively about the conditions of workers and the rights of all people to have "work to do which shall be worth doing, and be of itself pleasant to do; and which should be done under such conditions as would make it neither over-wearisome nor over-anxious" (Morris "Art and Socialism"). Morris identified craft as a way for people to engage in this kind of work and championed the practising of craft as a form of "unalienated labour" (Greenhalgh *History of Craft* 34). By practising craft, people could work outside the dehumanizing effects of factory labour, all the while making "handiwork which, done deliberately and thoughtfully, could be made more attractive than machine work" (Morris "Useful Work"). Hand-crafted objects and those who made them could thus be seen as opposing machine-made goods and the factories that produced them. In this model, fine craft objects have an important symbolic role: they represent the possibility of work that is not "over-wearisome," that is creative and fulfilling and nothing like the drudgery of working in factories.

This symbolic view of craft, though significant, has little to offer in the way of actual tools or strategies for how to use craft practices to remedy problems of the factory system. Although it is doubtful that we could or would want to build a society where everyone made his or her living making craft, the idea that everyone is entitled to work under humane conditions at a job that is fulfilling is an important one, which has much in common with current activist concerns about labour issues. Similarly, it

is an appealing idea that by practising and purchasing craft, we avoid consuming goods made under unfair conditions and express our dissatisfaction through a form of boycott. Some contemporary followers might oppose machine-made goods altogether and advocate the superiority of handmade objects. However, Bruce Metcalf suggests "a more legitimate complaint is against the exploitation of workers, rather than the existence of the system in the first place" (16). As we find increasing uses for and benefits of technology and machines, especially in the activist movement's use of the Internet (Klein, *No Logo*, xx, 393) and the explosion of craft/craftivism-based websites (Greer), this argument of craft set in opposition to machines is one we can set aside so as to better focus on how craft practices and objects might be used to address issues of labour exploitation and manufacturing practices.

The strategy of making things by hand as a way to avoid supporting certain systems also has historical precedent in the example of Gandhi using spinning as a way to protest British control of the Indian textiles economy at the turn of the twentieth century. Rather than purchasing clothes from their oppressors, Gandhi suggested that Indians return to traditional cottage industries and modes of self-sustaining production outside of British control (Bean 355). In this case, spinning was used as a tool of protest. Although the term was not used at the time, I would suggest that this use of craft foreshadowed craftivism — craft used as a tool to further a specific cause. Although he wanted the material to be used and the cloth to be worn, Gandhi did not promote spinning merely as a more fulfilling or beautiful form of work; he advocated a method of production outside of British control in order to further a point and spread a message. This kind of work was not made to be placed in a gallery or fine art context, as were some of the Arts and Craft products; its value was as a tool for protest.

The retrospective exhibition of Canadian craft *From Our Land: The Expo '67 Canadian Craft Collection*, held in 2004–2005 at the Confederation Centre Art Gallery in Charlottetown, investigated the "utopic idealism"

that was a feature of the craft scene in the 1960s and '70s (Plested 14). This kind of idealism certainly influenced some of the current attitudes around craft's suitability as a tool for opposing and critiquing the dominant capitalist/consumerist model. Exhibition curator Lee Plested traces how

> dedicated to art as a way of life, many of these [craft artists] moved away from cities to live closer to the land. They sought in nature a way of life that wouldn't support the growth of global trade and corporate monopoly (12). . . . The artisans' holistic attitude about their lifestyle, artwork and relationship to their community was constructed as an attempt to establish a new model of living (15).

While today's activists have perhaps abandoned some of the more romantic leanings associated with this time, the idea that craft-making and its aesthetic could be part of an alternative or anti-corporate lifestyle (and thus function as an inherently rebellious or political act) has continued its influence through to the DIY culture that is a feature of some types of current craftivism.

So how are these historical ideas being put to use now? Do these ideas and strategies still have value in terms of today's activism? How have they evolved to meet the new challenges and concerns of this movement? And how can fine crafters and ceramists be a part of this discussion? Paul Greenhalgh writes:

> Three of the most important issues which face the global community as we enter the new century are unemployment, the exploitation of labour and the environment. If the great thinkers and motivators of the Arts and Crafts movement were still with us, these are the issues they would focus on. So should we ("Progress" 113).

The question, then, is how can craftivism help crafters to focus on these issues? And how are the various manifestations of craftivism informing this focus?

BUYING IN: CONSUMING CRAFT

One current approach to viewing certain contemporary ceramics practices as activism involves considering craft objects (and their production) as a vehicle for addressing issues of purchasing and consumption. In response to activist critiques of unethical labour conditions or unsustainably produced goods, one common strategy is to make a point of purchasing goods that are made sustainably, locally and ethically. The idea of "voting with your dollars" is certainly applicable here. When we purchase ethically made goods, we place our spending power behind those businesses and goods that reflect these values and send the message we do not support the practices of businesses that do not. Gloria Hickey suggests that buying craft directly from the maker's studio can be a rewarding and educational experience as well as "an effective way of validating alternative values" (94–95). Purchasing craft objects from local fine crafters can be a way of participating in this kind of "voting," and craft objects themselves can represent an embodiment of these values. This idea has grounds in common with Morris' symbolic positioning of craft in opposition to systems of mass-manufacturing. Ceramics made within this market thus can be seen as participating in a form of alternative economy — one that supports activist values.

One problem with this model is that not everyone can afford to purchase studio-made craft (or organic food, or fair trade coffee), and these goods risk becoming status symbols rather than embodiments of alternatives to the corporate system. Joseph Heath and Andrew Potter argue that "Organic food is one of the major forces driving the return to an almost aristocratic class structure in the United States, in which the wealthy no longer eat the same food as the poor" (154). While purchasing ethical or sustainable products may be an option for consumers who can afford them, it is important to acknowledge that this option might not be economically feasible for all and that there are other effective ways of responding to and critiquing the way goods are manufactured and distributed. Given that it would be nearly impossible to function outside of a

consuming system, it is perhaps more useful to think of the voting-with-your dollars strategy as one possible component of an activist approach, and to acknowledge the enormous significance of proactive hands-on involvement with other political or humanitarian actions.

The other side to this argument is that we need to rethink the values we assign to the products we consume. Rather than always searching for the cheapest deal, we must factor in the actual cost of producing objects (or food, or coffee) in sustainable, ethical ways, and be prepared to pay slightly more for goods produced in these ways. This form of "true cost economics" may result in higher prices, but these prices reflect the actual cost of producing goods when things like ecological impact and improved working conditions are considered. Alternatively, reducing overall consumption and waste by investing in high-quality reusable goods — using a ceramic mug instead of Styrofoam, for example — is both cost-effective and sustainable.

There is a difference, however, between trying to change the world through buying better products and confronting the problems head-on. A recent *Adbusters* article offers a strong critique of the supposed power of this side of activism:

> It brings up that whole issue of change, and whether change is best achieved through political or consumer action. . . . In [Sharon] Beder's opinion, consumerism is inherently reactive — you select from what corporations put in front of you — while politics is proactive, about finding your own solutions to problems (Rockel 34).

The idea of voting-through-spending places the power — and the responsibility — with the consumer. Although it involves the participation of crafts producers, it does so indirectly, and it still does not answer the question of how craft producers themselves can respond to issues of responsible/conspicuous consuming.

One of my fellow Alberta College of Art & Design graduates, Lisa Barry, has initiated a project called "Random Acts of Pottery," which uses her ceramic work to address these issues. Barry makes functional wood-

and soda-fired ceramics, some of which she uses to commit "muggings." These muggings involve giving away her handmade mugs to all kinds of people, especially those who might not normally think to use them, or be able to afford them (Barry). While Barry sees the muggings as an excellent opportunity to introduce people to the aesthetic merits of handmade objects, they also represent a way of subverting the values of the current consumption model, with its emphasis on "Hallmark-holidays" and over-priced brand-name products. Contrasted with models of competitive consumption, Barry's decision to give mugs away is shocking, even revolutionary. Many of Barry's recipients are not quite sure how to interpret being "mugged." This element of surprise opens up an opportunity to discuss further issues of consumption and gift-giving. I have also seen her take a Styrofoam mug out of someone's hand and replace it with a ceramic one, broaching the possibility for discussion about reusable and ecologically sustainable products. The face-to-face interactions created through these muggings provide a space for dialogue and education. Barry has found a powerful tool with these muggings, a form of ceramics-activism that positions her mugs to address issues ranging from over-consumption to ecologically sustainable products to ways we value objects.

CONSCIOUS CRAFTING

One important question that remains about viewing ceramics through the lens of activism is the ecological impact of making things in this way. Granted, reusing a ceramic mug is a far better choice than using Styrofoam, but what are the ecological costs associated with mining clay and glaze ingredients, using gas to fire kilns and using water as it is often used? Witnessing the (mis)use and waste of water in the ceramics studios at the Alberta College of Art & Design — no doubt not an isolated case — I can only imagine the cumulative effect of this kind of water usage in schools and studios across North America. Regardless of whether ceramics is to be included as an activist activity, ceramists — and all craft producers — must consider how their materials are obtained and processed and the cumulative impact of their studio practices. It may well be the case that the impact of these activities is negligible (especially given that they are currently practised on a relatively small scale). Although I do not have the space to address this issue fully here, there is undoubtedly a need for further investigation of the ecological impacts and concerns of working with clay.

One example that represents a potential solution is the work of ceramicist/sculptor Robert Lyon. Lyon mixes dextrine, a starch derivative adhesive, into his clay so that he does not have to fire his pieces (Joiner 31). His work addresses issues of recycling and natural processes, and he aims through his work "to foster an awareness" of ecological concerns (Joiner 32). Although this is just one example, it illustrates one method of reducing energy consumption that could be employed by other ceramicists working in a similar way.

It should also be pointed out that the advantages of working as a fine crafter in a developed region of the world are not shared by all craft producers. Artisans or crafters working in developing regions often do not find their labour valued in the same way as those who make work in a fine art/fine craft market. This is not to say that traditional handcrafts are not valued or respected, or that there are not people working in a fine

craft setting in these areas. When I interviewed a development worker who has spent time working with communities in Ecuador, she pointed out that often the prices of handcrafted objects sold there did not reflect the cost of the labour. Usually the price covered just the cost of raw materials with a slight mark-up (Lubell). As Ingrid Bachmann points out:

> We fetishize the product of excessive and often highly skilled labour from an individual in the developed world and disregard similar labour originating from the developing world. There is a great discrepancy between the economic and cultural value of a basket made by a craftsperson in the West functioning within an arts marketplace and a basket from an anonymous maker in the developing world (equally labour intensive) purchased for a few dollars at a dollar store or local market (46).

If fine crafters and ceramists are to interact truly with a global community of craft producers (and to consider their work as a socially conscious practice), they must find ways to address these discrepancies, valuing all crafts regardless of where they are made.

Consumers, in turn, need to examine thoroughly what they are purchasing, how those products are distributed and sold, and where the profits go, including handcrafted objects. There are a number of ceramic-based humanitarian groups addressing some of these concerns. Potters for Peace has been working since 1986 on a number of projects designed to assist potters in developing regions of the world. Their mission statement declares:

> Our goals are to offer support, solidarity and friendship to developing world potters; assist with appropriate technologies sustained using local skills and materials; help preserve cultural traditions. . . .The vast majority of potters in Central America are rural women and the core work for Potters for Peace has always been assisting these hard working people to earn a better living.

One of their main projects involves helping to set up production centres for making low-cost ceramic water purifiers (CWP) in parts of the world where clean drinking water is scarce, and teaching local craftspeople how to run these centres and make the filters themselves.

Another initiative is the Empty Bowls Project, originally started in 1990 by a high-school art teacher in Michigan (Empty Bowls "Home"). The Empty Bowls events can now be hosted by any interested group. The events are staged to raise awareness about hunger issues and to fundraise for organizations that fight hunger. For an Empty Bowl event, groups make ceramic bowls, and then use them to serve soup to guests. The guests in turn are encouraged to make a donation and to keep the bowl both as a reminder of their participation and the need for continued action on this front. All the money from these events goes to the group's chosen hunger-fighting organization. To date, the project has raised millions of dollars for these organizations (Empty Bowls).

Potters for Peace. Colloidal silver-enhanced ceramic water purifier (CWP). Terra cotta bucket 28 x 25 cm.

CRAFTING CHANGE

There are many ceramists who make work addressing specific political and social issues. Meaning arises not through *how* it is made, but through the ideas and content expressed by their work. These fine crafters use their work to express ideas about various political and social issues, much as similarly minded fine artists do. Although Matt Nolen uses traditional ceramic forms, the surfaces of these forms are covered with images addressing various political and social issues from credit card debt to depletion of the ozone layer (Dormer 198, 209). These pots offer satirical comments on issues, prompting viewers to look at them in a new light or to contemplate related issues such as over-consumption or alternative transportation.

A similar tactic is employed by Canadian First Nations artist Judy Chartrand, whose ceramic lard pails and spray cans reference stereotypes in advertising and labelling in order to critique the portrayal and treatment of Native Americans (see Chartrand's artist project in this volume). American sculptor Adelaide Paul's mixed-media ceramic works subtly question how we treat and view animals; her pieces promote animal rights

(Brown). Despite Paul's example, Glen Brown has expressed surprise at the relatively small number of ceramist-activists — given their "reputation for ardently-held beliefs" (41). I would suggest that the use of ceramics as a vehicle for analyzing, discussing, critiquing and subverting particular social issues by certain artists qualifies them as activists in the broad sense of the word. The emphasis in their work in terms of activism, however, is less on the materials of their craft and more on the messages they communicate. Art and craft objects of this type have always played a significant role in offering critique and commentary on social issues, and ceramic objects have the same expressive potential as objects made from any other medium used to this end.

While some fine crafters engage in craftivism through the content of their work, many activist crafters focus instead on how their work is deployed. Several activist initiatives use craft and art techniques for various purposes, ranging from projects like the AIDS quilt, to activist David Solnit's use of puppetry teach-ins to construct props for protests. These creative approaches can bring an element of fun and theatre into what often ends up being "quasi-militaristic marches culminating in placard waving outside locked government buildings" (Klein *Fences*, 125). They also provide a way for more people to get involved. One excellent example of this type of work is the Revolutionary Knitting Circle, an activist group based in Calgary. The RKC group meets once a month and holds knit-ins as a form of protest; one was staged outside of Banker's Hall in downtown Calgary during the G8 summit of 2002. Participants knit banners with revolutionary slogans and armbands with peace symbols, and they participate in skill-sharing at their meetings. Their manifesto explains their work as part of a "constructive revolution" (Neufeld Manifesto). They advocate crafting as a means for people to create useful items outside of a corporate model and to deploy an innovative and non-aggressive tool for protest. Grant Neufeld points out that when he is knitting, and people approach him to ask him what he is doing, he is able to initiate dialogue about activist issues outside of a protest context (Interview). The skill-

sharing and social interaction that takes place at their informal meetings is a critical part of what makes this group successful. Learning a new skill from a real person serves as an activist strike against the increased commodification of craft through the sale of trendy do-it-yourself kits (Flood 29).

Many other Do-it-Yourself, Stitch N' Bitch and hobby-crafting groups exist in other cities in North America and around the globe, with varying degrees of "revolutionary" activity.[2] Much of the DIY approach to craft (and the supposed strength of this kind of crafting) hinges on the make-it-instead-of-buy-it idea. Making something by hand means that it is easier to control how and where it is made, and it fosters appreciation for the true value of an object's production. This model emphasizes the value of making one's own goods (often clothing) outside of a corporate system, prizing the "unique" aesthetic of these goods. However, it also requires that the maker have the (leisure) time to make

The Revolutionary Knitting Circle in Global Knit-in at G8 protest, Calgary, AB, Canada, 26 June 2002. Photo: Grant Neufeld.

things by hand (Sabella). By emphasizing an aesthetically pleasing end product, it might neglect how the raw materials are produced or obtained.

Many of these textile-based craftivists rely on the suitability of their particular material or process to help promote their cause. Textile work seems to be one of the most easily transportable, affordable, teachable and accessible forms of craft to use for public protests, teach-ins and discussion groups. I have yet to encounter any examples of ceramics being used in a similar way, although I would not dismiss the possibility.

Clay has been used to subversive ends in the *Lost in the Supermarket* project, part of the *Shopdropping* exhibition curated by Marisa Jahn and Steve Shada. Artists Marijke Jorritsma, Marisa Aragona, Melissa Orzolek, and Tara Foley worked with the Boys & Girls Club of San Francisco to recreate in clay various standard supermarket items like bottles of dish soap and cans of dog food. The asymmetrical and distorted recreations were snuck back onto the shelves of the store (Jahn and Shada). While this

action provided the children with an opportunity to rethink the structure and rules of standard consumption models, the misshapen ceramic objects took on a life of their own once left behind for consumers to encounter. On the shelves, these imperfect objects contrast sharply with the slick surfaces and ideal forms that line the aisles. Possibly, they prompt a moment of shock or surprise or an increased awareness of the packaging, marketing and production of these commodities. Clay's malleability and its use by youth in this project make it a particularly appropriate medium in this case.

Even though there are no revolutionary ceramist groups yet, the potential for involvement with social activism suggests there is a place for contemporary ceramics practices in the craftivist movement. While there are still issues to be addressed around the effectiveness of certain craftivist approaches, questions raised in this discussion will, it is hoped, encourage further consideration and creative solutions. As these discussions gain momentum, they will generate new opportunities for collaboration, cross-pollination, innovation and growth. By looking at examples in which craft, activism and craftivism intersect, critical evaluation of the practices of each will advance, lending increased significance and credibility to all of these fields.

NOTES:
1. A list of organizations and causes can be found in "A Movement Yellow Pages" in *The Global Activist's Manual* (New York: Nation Books, 2002).
2. *craftivism.com* (www.craftivism.com) has links to many of these groups as well as historical background and information on the topic of knitting as a craftivist tool. Its founder, Betsy Greer, first coined the term "craftivism."

WORKS CITED:
Bachmann, Ingrid. "New Craft Paradigms." *Exploring Contemporary Craft.* Ed. Jean Johnson. Toronto: Coach House Books and Harbourfront Centre, 2002. 45–49.
Barry, Lisa. Personal Interview. 22 May 2004.
Bean, Susan S. "Gandhi and *Khadi*, the Fabric of Indian Independence." *Cloth and Human Experience.* Ed. Annette B. Weiner and Jane Schneider. Washington and London: Smithsonian Institution Press, 1989. 355–376

Brown, Glen R. "Adelaide Paul: A Recognizable Conviction." *Ceramics: Art and Perception* 56 (June 2004): 41–44.

Chartrand, Judy. Home page. 19 June 2004. www.nativeonline.com/judy.htm.

Dormer, Peter. *The New Ceramics: Trends and Traditions*. Rev. ed. London: Thames and Hudson, 1994.

Dormer, Peter, ed. *The Culture of Craft*. New York: Manchester University Press, 1997.

Empty Bowls. Home page. 6 October 2006. www.emptybowls.net.

Flood, Harry. "What Grandma Never Taught You. But then again did you ask her?" *Adbusters* 38 (November/December 2001): 29.

Greenhalgh, Paul. "The History of Craft." Dormer, ed. 20–52.

—. "The Progress of Captain Ludd." Dormer, ed. 104–115.

Greer, Betsy. *craftivism.com*. 6 October 2006. www.craftivism.com.

Heath, Joseph and Andrew Potter. *The Rebel Sell: Why the culture can't be jammed*. Toronto: HarperCollins, 2004.

Hickey, Gloria. "Craft within a Consuming Society." Dormer, ed. 83–100.

Jahn, Marisa and Steve Shada. "Curatorial Statement." *Shopdropping: Experiments in the aisle*. 6 October 2006. www.mucketymuck.org.

Joiner, Dorothy. "Robert Lyon: Melding Clay and Wood." *Ceramics: Art and Perception* 52 (2003): 31–32.

Klein, Naomi, *Fences and Windows: Dispatches from the Front Lines of the Globalization Debate*. New York: Picador, 2002.

—. "Introduction." Prokosch and Raymond. 1–10.

—. *No Logo: Taking Aim at the Brand Bullies*. Toronto: Alfred A. Knopf, 2000.

—. "Reclaiming the Commons." *A Movement of Movements*. Ed. Tom Mertes. New York: Verso, 2004. 219–229.

Lubell, Anne. Personal interview. 20 June 2004.

Metcalf, Bruce. "Contemporary Craft: A Brief Overview." *Exploring Contemporary Craft*. Ed Jean Johnson. Toronto: Coach House Books and Harbourfront Centre, 2002. 13–23.

Morris, William. "Art and Socialism." 1884. *The William Morris Internet Archive: Works*. 20 June 2004. www.marxists.org/archive/morris/index.htm.

—. "Useful Work versus Useless Toil." 1885. *The William Morris Internet Archive: Works*. 20 June 2004. www.marxists.org.uk/archive/morris/index.htm.

Neufeld, Grant. Personal interview. 8 June 2004.

—. "Revolutionary Knitting Circle Manifesto." 20 May 2004. www.knitting.activist.ca/manifesto.html.

Plested, Lee. "From Our Land: The Expo '67 Canadian Craft Collection." *From Our Land: The Expo '67 Canadian Craft Collection* (exhibition catalogue). Charlottetown: Confederation Centre Art Gallery, 2004. 8–17.

Potters for Peace. Mission Statement. 6 October 2006. www.pottersforpeace.org.

Prokosch, Mike and Laura Raymond, eds. *The Global Activist's Manual*. New York: Nation Books, 2002.

Rockel, Nick. "business solutions." *Adbusters* no. 52 (March/April 2004): 34–35.

Sabella, Jennifer. "Craftivism: Is crafting the new activism?" *The Columbia Chronicle*. 10 September 2006. www.columbiachronicle.com.

ARTIST PROJECTS

Strategic
Activism

The work of Rory MacDonald, Jeannie Mah, Sylvat Aziz and Jamelie Hassan exemplifies strategic activism. Drawing attention to the traditional relationship between ceramics and the built environment, Rory MacDonald makes casts of cracks and holes in cement street curbs and repairs the fissures with exquisitely decorated ceramic patches. Enacting a utopic gesture that is both a critique of abject civic space and a confirmation of daily life, MacDonald proposes a strategic role for public craft. Jeannie Mah, in *Hommage à Wascana Pool*, engages the utopic history of urban parks to remind the city of Regina of its responsibility to provide a healthy environment for its citizens. Sylvat Aziz's documentation of working conditions in brick factories in Pakistan and her proposed North American project address profoundly dystopic subject matter. At the same time, the endeavour is underpinned with a vision of social change. Jamelie Hassan's video *Olives for Peace* forms part of a larger series of artist projects that all envision peace and justice. In order to call for justice for children living in the Gaza strip, Hassan's project includes ceramic tiles with images based on paintings by these children.

1

Rory MacDonald

Curb Works

CURB WORKS ATTEMPTS TO develop and make tangible the idea of public craft. If it is possible to conceptualize a role for public art and intervention whose function is to create a space to critique and discuss the history and use of public space, so too is it possible to conceptualize a role for the crafts in a dialogue of public critique. The role of the crafts in this critique is grounded in the value of work and a concern for the material value of objects in space. *Curb Works* identifies areas of decay in the public works of a city. The critique is not, however, a question of identifying the responsibility of the public works department and the city to fix every crack in the sidewalk as much as it is an attempt to question the value of material and actions within abject public spaces. Repairing cavities of city curbs with a material such as ceramics draws attention to the value of materials (ceramics being more expensive than concrete), as well as the effort involved in the creation of these repairs.

These works call into question the abject in our city environments. The curb as an "object" is unremarkable, but, as a functional object of city planning, it determines much of the compartmentalization of the city landscape. It is a true borderline and thus ideal for the exploration of public craft.

IMAGES:
1, 2, 3 – *Curb Works*. 2003-in progress, Regina, Saskatchewan. Curb patch, glazed earthenware.

2

3

1

Jeannie Mah

Swimming en plein air: *Utopic Impulses and the Urban Park*

WHEN REGINA WAS FOUNDED, utopic impulses propelled our collective desire to create an ideal city that would be prosperous, liveable and beautiful. *Hommage à Wascana Pool: je nage; donc, je suis* is centred on Regina, but I extend the theme of swimming to speak of cultural, social and economic concerns that embrace the historical migration of peoples, ideas and objects.

Images of swimmers in Wascana Lake with the legislative buildings in the background firmly focus this piece on my specific geographical location: Regina. To link my home town conceptually with the world, I include Monet's *Les Nympheas* and the ocean-themed sidewalks of the once-mighty nautical nation of Portugal, whose explorations opened trade routes to China, importing to Europe a mania for Chinese porcelain and tea. The artful Portuguese mosaic sidewalks refer to water, but it was also in Portugal that I first swam in the ocean!

Reflective patterns of sun on water within tea-cup shapes incorporate the idea of the journey of porcelain and tea from Asia to Europe; the voracious desire for *bleu de Chine* ignited the European porcelain industry. The swimmer in the pool is paired with idealized maps of the 1912 Mawson Plan for Wascana Park, emphasizing a continuity of historical purpose within this city. Wascana Park was created as a public space for the enjoyment and betterment of its citizens. The active swimmer and the idealized plans for the park and the city remind us of the utopic dreams on which this city was built, incorporating urban planning, healthy living and aesthetically pleasing green spaces for the public good.

Views of the Luxembourg Gardens, Paris and Evian, France, are seen at both edges of this work. On the backs are found their respective

balustrades, where the "empty" spaces resemble pots on which one sees landscape (Luxembourg Gardens) and seascape (Lac Léman). For me, these two pieces represent cinema and refer to the act of looking. Evian is on Lac Léman and "just happens to" look across the lake to Rolle, Switzerland, the home of Jean-Luc Godard, comprising my oblique yet intensely personal cinematic reference.

With the Luxembourg Gardens and Evian, I conflate the lineage of European public gardens and spa towns with our own local and much-beloved Wascana Park in order to emphasize the historical precedents and continued need for water activity within the city. The social, caring face of early capitalism saw urban planning and social housing as duties for both government and industry to provide for the health of the people in promoting civilization and commerce. In 1995, Regina City Council's threat to close down Wascana Pool sparked outrage and protest. With this *hommage*, I remind the city of its responsibility. The social space of the public park activates the mind and body, enabling citizens to be healthy, industrious and happy.

IMAGES:
1, 2, 3, 4, 5, 6 – *Hommage à Wascana Pool (The Water Cups): je nage; donc, je suis (swimming + art + travel = swimming = comment (sur)vivre à Régina)*. 2003. Porcelain with underglazes and photocopy transfers, MDF shelf (Brian Gladwell) with gesso and acrylic, mirror and clips. 60 x 175 x 40 cm.

2

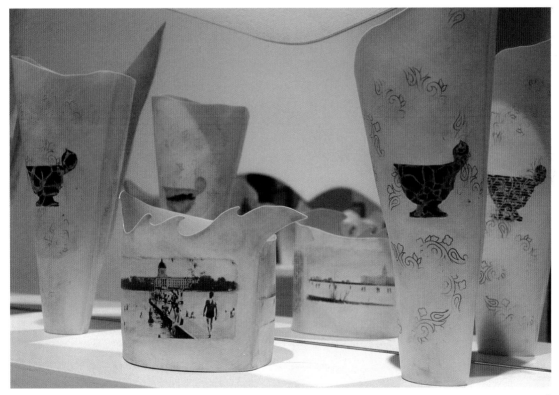

3

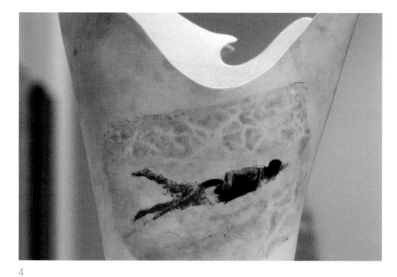

4

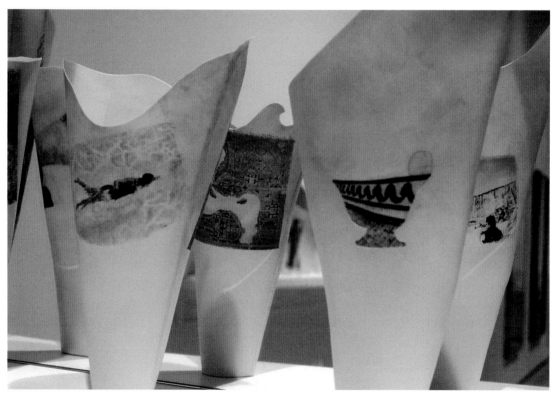

5

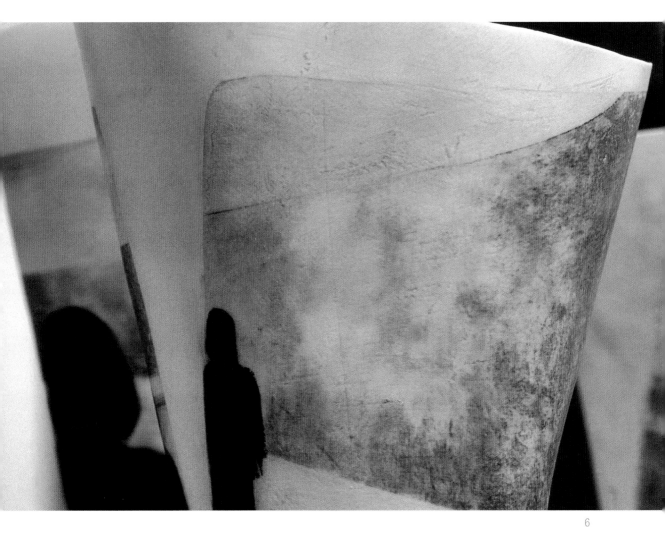

6

1

Sylvat Aziz

IN SOUTH ASIA, THE custom of balancing the needs of labour with indigenous building material is torn apart by the enormous demand for housing. This has created a slave market, investigated several times by agencies such as UNICEF and CIDA. Currently, in the guise of preserving the traditional and historical practices, the brick kiln industry is kept alive at enormous human and environmental cost through practices that emphasize the needs of the privileged.

This project will have two components:

- A visual essay of the brick kilns in Pakistan documenting the exploitation of labour and resources. This essay is included in part here.
- A studio component. This component will be completed in the future.

For the studio component, I plan eventually to hand-build bricks sufficient for a house for a family of five. Our own home in New Brunswick is built out of brick, taken from marsh mud in the area about 200 hundred years ago and fired on site. This seems to be the best place to complete the final project, as it provides obvious advantages in terms of supporting a project requiring such resources of time and physical endurance. I shall estimate the time taken by one labourer in South Asia, working 8–10 hours a day, to produce sufficient units for an average brick house. The product, relative costs for labour and production, and values generated in the "cheap" labour market "there" as opposed to the "fair" market here will be made *manifest*.

IMAGES:

1 – Kiln image. Due to the high rate of carbon poisoning, many workers, children and adults suffer from terminal lung and blood diseases. Most of this "industry" has been under a CIDA, UNICEF and other welfare agencies' watch. So far, nothing has been done.

2 – Top of the kiln. It is fed by pouring a mixture of petroleum-based fuel through these "vents," which also regulate kiln temperature.

3 – Families working, including underage children, who are bonded labour.

4 – Bricks laid out for drying before being loaded.

2

3

4

1

Jamelie Hassan

Olives for Peace and *Palestine's Children*

OLIVES FOR PEACE TAKES place in the artist's gravel laneway. A child anticipates the taste of olives. Sounds in the courtyard — footsteps on gravel, a car door slamming — distract the child. At each sound, the child turns her head. With each image of the turn of her head, the scene abruptly shifts to reveal a detail of a glazed tile — an interpretation of a child's painting of scenes in Gaza and a child's perspective of life under Israeli Occupation. The video, *Olives for Peace*, created in response to a call to artists for a two-minute video work, was selected as part of *The Olive Project: Two Minutes for Peace and Justice*, organized by the Hard Press Collective and Charles Street Video, Toronto, Canada. *The Olive Project* video includes the works of sixteen international video artists and is distributed by V-Tape in Toronto.

Olives for Peace presents images of ceramic tiles from earlier installations from 1990 and 1991. These works re-present in ceramic tile images from postcards of paintings by children living in Gaza, which were published by the Association of Artists in the Gaza Strip. These works initially were mixed-media, including ceramics, text and photography. The text from this earlier work and images of these ceramic tiles were presented in the artist book, *The Jamila/Jamelie Project*, published by Presentation House Gallery, North Vancouver, in 1993. An excerpt reads:

> I went to Gaza to see the work of a young artist from Rafah Refugee Camp whose paintings document every aspect of the Intifada. Salwa el Sawahly is a disarmingly happy teenager, her optimism a challenge to the reality she paints. Her desire to keep her paintings in Gaza despite offers of large sums of money from collectors, speaks to her belief that the painting she does is part of the community's history and that this work belongs to the residents of Gaza.

Re-presenting and re-cycling the ceramic images into another format, in this case, video, projected the work into a larger-than-life moving image, further extending their relationship and meaning to another context, for another audience one decade later.

4

5

Social
Idealism

A number of the artists included in this section engage the social idealism embodied in the writings of John Ruskin, William Morris and subsequent utopian projects such as the Arts and Crafts Movement, the Bauhaus and the Mingei revival. All these movements promoted the culturally redemptive value of craft objects either through partnerships with industry or the ideal of the self-sufficient studio potter. The Medalta International Artists-in-Residence project (MIAIR), located on a former industrial site, is one example of a productive partnership between industry and artists. As described by Artistic Director Les Manning, MIAIR looks to innovative apprenticeship models in its mandate to foster advanced research in ceramics. During her artist residency at MIAIR, Mireille Perron playfully turned the tables on top-down bureaucratic information-gathering. Designing a utopic census project of her own, she engaged the community in a participatory venture that highlighted the legacy of industrial ceramics in Medicine Hat. In the spirit of the Bauhaus, Angela Mellor's partnership with the lighting industry demonstrates that meaningful handcraft production can be wedded successfully to industry with benefits accruing to both partners. Representing the self-sufficient potter, Diane Sullivan explicitly echoes the Arts and Crafts movement's commitment to making thoughtfully designed and crafted handmade objects. These objects function as a reparative and critical response to the alienating effects of industrialization both in terms of meaningful work and aesthetic objects.

1

Les Manning

The Medalta International Artists-in-Residence Program

HISTORICALLY, CRAFT PRACTICE was passed on through apprentice-ship with a master artist. This learning process was direct and suited to mastering required technical skills. Individual aesthetic choices originated regionally but were fostered by the quality control inherent in the production of a professional workshop. The teaching of contemporary ceramics has made us aware of different educational needs. As new technologies transform world communication, we witness increased globalization that directly affects the character of art-making and artistic expression. International biennales, teaching and exhibition careers now mean that artists migrate from their original homelands and cultures, a situation that exerts a powerful influence on aesthetic territories and legacy ownership.

Residency programs represent one response to this situation. They offer an apprenticeship-like environment, but with a more personal aesthetic resolution for the individual. They provide an arena in which to examine questions that might not be explored as easily without such a forum. Residency programs bring professional groups of artists together on common ground for work experience, including self-directed and interactive exploration of each individual's work. This process of mutual exchange of ideas and philosophies between the participants increases awareness of the creative activity for the individual and for the group.

Interaction with peers on an international level is advantageous for evaluating one's own statement from a broader perspective. This arena of discourse offers an external position from which to assess one's ideas and desired changes. As the mission statement for an important international residency, the European Ceramic Work Centre in the Netherlands, states, "[This] is an international work space, which aims to develop the artistic

exploration into ceramics by providing a work place in a professional environment that stimulates a continuous exchange of action and reflection." In Canada, The Banff Centre for the Arts, another significant international residency program, explains that its resident facilities exist "for ceramic artists who elect to invest in their future by securing a block of time, free from outside pressures, to create a new body of work, an opportunity for the committed artist to challenge the creative process, constantly pushing toward a new cultural aesthetic."

For the most part, residencies are supported through the auspices of cultural and educational communities or through direct links with industry. The Medalta International Artists-in-Residence Program is housed within the Medicine Hat Clay Industries National Historic District in Medicine Hat, Alberta, Canada. The Sunburst Ceramics factory, a 10,000-square-foot plant located at the Medalta Potteries National Historic Site, is being refurbished to accommodate permanent year-round residency. Until its completion, the residency will operate each June at the Hycroft China Studios. The Medalta International Artists-in-Residence Program is seen as an integral program of the National Historic District, but one that is necessarily driven by its own objectives. Drawing on the resources of the Historic Clay District and the Industrial Museum, the Medalta Residency offers its own unique setting and experience. Although the historic potteries no longer produce crocks, hotel china and the like, visiting artists become aware that, through fostering different sorts of discussions unique to residencies, they continue to play an active role in the cultural, social and economic well being of their communities.

IMAGES:
1 – Beehive Kilns.
2 – The Medicine Hat Clay Industries National Historic District.
3 – MIAIR (Medalta International Artists-in Residence Program), Resident Trudy Golley.
4 – MIAIR, Residency woodfire.
5 – MIAIR, Resident Michael Moore.

2

3

4

5

1

Mireille Perron

2006 Census: MEDALTA WARE

EVERY FIVE YEARS, Statistics Canada conducts a census. The most recent one took place in May 2006. It was marred by controversy for a variety of reasons. Some raised issues relating to the legitimacy of questions about sexual orientation and mother tongue, while others expressed concerns about the contract being outsourced to a foreign defence firm, not to mention all the political consequences regarding the use of the data in the first place. In short, it left me and many other citizens with the uncomfortable feeling that this kind of census never asks any of us a question we would enjoy answering.

It is against this backdrop that I orchestrated my own census in the guise of an art project while I was an artist-in-residence at the *Medalta International Artists-in-Residence Program*, 29 May to 23 June 2006, in Medicine Hat, Alberta. My project consisted in first conducting an unusual census around Medicine Hat's unique industrial ceramics history. I tested and refined my idea with several members of the local Pottery Club. With their initial support and through word of mouth — an excellent strategy in a small and tightly knit community like Medicine Hat — I made a list of 100 residents who owned Medalta ware. I surveyed a wide range of residents who owned it, including those linked with the local farming history (including a few Franco-Albertans), workers still involved in the clay industry, collectors, curators and Friends of Medalta.

The second part of my project consisted of producing a material object to mark the extent and diversity of local ownership of Medalta wares. This component was carried out in the residency studios. Working under the general supervision of Annette Unger, who is in charge of the reproduction studio for Medalta ware, I asked master jigger-man Basil Leismeister,

now seventy-two years old, to train me at one of the few original remaining industrial jigger machines. Becoming my own factory production line, I endeavored to wedge clay, jig, trim, wax, glaze, design decals for and fire more than one hundred lids three times at different temperatures. I used molds reproduced from the original ware, selecting the lid for the half-gallon crock. Each lid was adorned with a logo and text. With permission, I reproduced the Historic Clay District logo, which represents a beautiful beehive kiln, adding a text that read:

2006 Census: MEDALTA WARE
This household is the proud owner of MEDALTA WARE.

I distributed the one hundred lids to participants in my census, asking each household to display it prominently on the front of their home, close to their street address, as a marker of the special historical relationship that Medicine Hat's residents have to their ceramic history. The project was very popular, and I could have distributed many more lids had I only the time to make them.

My proposed aim was to foster a new understanding of how ceramics history contributes to the social fabric and material culture of the region. My hope is that my humble contribution becomes a public/private conversation piece that nurtures community spirit and furthers the visionary project of the Medicine Hat Clay Industries National Historic District.

IMAGES:
1 – Basil Leismeister, Master Jiggerman, with Mireille Perron.
2 – 1/4- and 1/2-gallon Medalta crocks.
3 – Project in situ, 1105 Clay Avenue, Medicine Hat, Alberta.
4 – Detail, lids.

2

3

4

1

Angela Mellor

Ocean Light

OCEAN LIGHT DEVELOPED over eighteen months through an extensive study of artificial light sources used to enhance the translucency of bone china forms. This exploration was undertaken with lighting designer Urs Roth, of Ropa Lighting, and lighting design specialist, Mondo Lucé. The project was supported by an Australia Council Grant for New Work and culminated in an exhibition at Craftwest (now Form) in Perth. Its importance lies in the collaboration between individuals and industry, reflecting a research and development culture that is commercially rather than academically sponsored.

Light has always played an important role in my work. The contrast of the ultra-bright sunlight in Western Australia to the more subdued light in my British homeland impressed me strongly on my arrival in Australia in 1994. Fossils and shells found on the coast of Western Australia inspired *Cretaceous Light*, a column of bone china paperclay richly textured with shells and remnants of marine life. The cylindrical form became a table light, wall light and pendant light. A polyp of yellow spotted coral inspired the *Dendrophyllia* installation on a granite base. Roth's light fittings are minimal and discreet, consisting of tiny LED lights set beneath each spotted cone. This project allowed me to work on a larger scale by using multiples in large installations.

IMAGES:
1 – *Cretaceous Light*. 2003. Bone china textured paperslip, LED light. 17 x 6.5 cm diameter.
2 – *Coral Bud Chandelier*. 2003. Bone china (etched), steel and LED lights. 120 x 100 x 90 cm.
3 – *Dendrophyllia*. 2003. Installation view. Etched bone china on granite base, LED lights. 29 x 80 x 60 cm.

2

3

1

Diane Sullivan

In the Garden of Eden

THE IDEA OF THE potter as the gatekeeper of the "Garden of Eden," of a simpler more direct lifestyle, appeals to me. The first time I witnessed this storybook scenario was when I worked for Jim Smith, a potter in Chester, Nova Scotia, whose studio is set in a small hamlet, surrounded by an idyllic garden. Because Jim's storybook garden is a complete contrast to everything in my highly literate educational background, I found myself reaching into his garden for inspiration — not just as a lifestyle — but as a way of expressing myself that differed from my original context. My work at that time was directly informed by earth goddess imagery. The idea of a decorative language of communication based on the creativity of the earth entranced me.

It was a short step to look more closely for another garden to reference. The wildflowers of the Cascade and Rocky Mountain ranges provided me with that inspiration. The series *Mountain Flowers of the Pacific Northwest* directly referenced my experiences of hiking while attending graduate school in Seattle, Washington. The simplicity of the wildflower motif — cliché that it might be — offered me personal solace in a highly stressful time. The colour palette of reduced stoneware suggested the musky dark seduction of the West Coast rainforest. A shift in scale also represented conscious recognition on my part of the desire to step away from the academic lifestyle and into the garden of the full-time creator. The new work was smaller, suggesting domestic rather than public space, and it was more marketable.

When I emerged from the land of post-secondary institutions and began my own pottery business in the mid-1990s, I quickly recognized the fascination educators and the public had with the "happy craftsman."

This was partly shaped by a renewed interest in the Arts and Crafts movement of the late-nineteenth to early-twentieth centuries and William Morris' ideal that beauty in art should be the result of man's pleasure in his work, away from the "dull squalor of civilization." The historical reference my work makes to Persian, Oriental and Victorian ceramics further conjures lands and times that, in the West, are mythical places of a slower-paced world. The aggressive carving technique I developed as my signature look counterbalances the saccharine quality of the flower reference. This hand-carving technique flies in the face of modernity; the time spent seems excessive in this faster-faster world in which we live.

Although I find myself living in the city, the sanctity of the maker's garden of creativity is of tremendous appeal to the buying public. The largest part of my livelihood as a studio potter is made at craft fairs. The craft fair booth is a small garden transported to the urban centre, offering purchasers a glimpse into the creator's world. The connection with the maker at these fairs is as important as the work itself.

My experience suggests that the role of the modern studio potter is to reflect on the relationship of nature to civilization.

IMAGES:

1 – *Smilicina Racemosa Ewer*. 2006. Mid-fire porcelain, wheel-thrown, hand-carved. 53 x 20 cm.

2 – *Wild Rose Vase*. 2006. Mid-fire porcelain, wheel-thrown, hand-carved. 58 cm. high.

3 – *Passage*. 1993. Glazed earthenware, hand-built. 274 x 107 x 71 cm.

4 – *Saddle Tooling Platters*. 2006. Mid-fire porcelain, press moulded. Each 36 cm. long.

5 – *Aladdin's Teapot*. 2003. Mid-fire porcelain, wheel-thrown, hand-carved. 23 x 30.5 x 20 cm. Photo: Barbara Tipton.

2

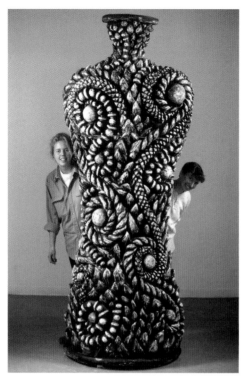

3

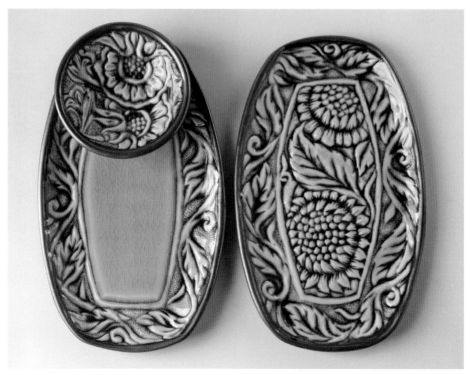

4

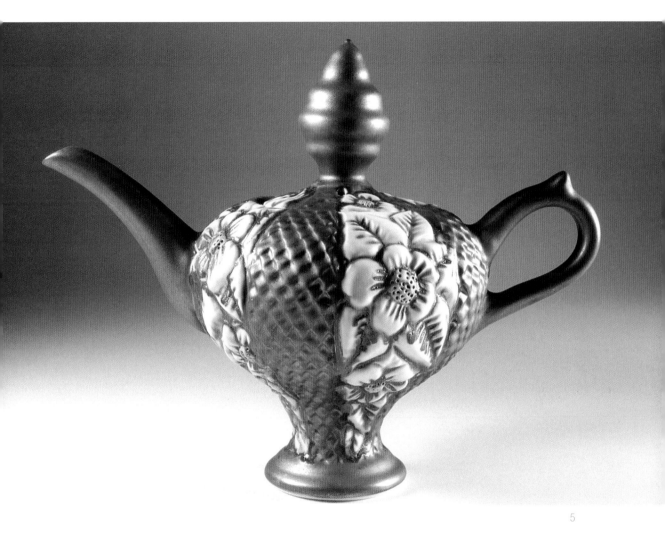

5

Critical
Domesticity

A number of ceramists exploit the familiarity of clay and its association with everyday and domestic environments in order to broach less comfortable observations on domestic and social conditions. First Nations artist Judy Chartrand's charged reminders of white privilege are simultaneously sharpened and made more amenable by the superficially domestic and vernacular qualities of her objects. Penelope Kokkinos proposes that everyday ceramic objects perform a profound psychological role through symbolic transference and reconciliation of collective and individual anxieties. Ceramic objects can facilitate the anchoring of the self in a shifting world because they are both prosaic and already packed with cultural meanings. Carole Epp presents a collection of children's lunch boxes and kitsch lawn ornaments in order to raise questions about ethical and moral obligations towards the next generation. *Best Before Date* addresses the commodification of the natural world and the impact of corporate industrial farming.

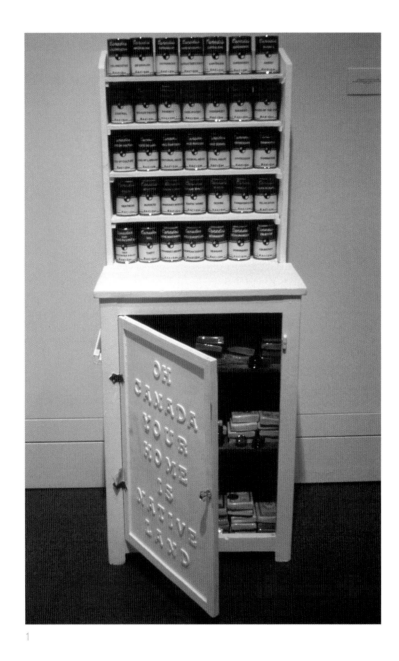

1

Judy Chartrand

MY CURRENT WORK DEALS with relations between First Nations and white people in Canada. My research focuses on the concept of whiteness as well as the ideology governing white racism so as to examine factors creating and maintaining grotesque distortions of First Nations' identity. Negative and stereotypical images have had a devastating effect on the identity and treatment of First Nations peoples, resulting in diminished feelings of self-confidence and self-worth. I use humour, which is grounded in anger and outrage, to promote a dialogue that contributes to social and cultural change.

I became interested in advertising on tins from the nineteenth and twentieth centuries. All of the images of Native people were romanticized versions of the noble and savage Indian used in advertising everyday products, including foodstuffs, medicines and tobacco. Other common household items such as salt and pepper shakers and ashtrays often featured grotesque and demeaning caricatures. These images were widely accepted because they appeared harmless, and they soothed white consciences. They referenced a nostalgic past while promoting white supremacy through their depictions of First Nations peoples.

I slip-cast numerous household objects, changing their labels to communicate the experiences I have everyday of ignorance and stereotyping. The replicated objects have multi-layered meanings. The lard pail holds many memories (both positive and negative) for those who used them as lunch boxes during their childhood. The use of lard addresses the desirability of being "Pure White." The labels challenge and deconstruct many romanticized images and stereotypical assumptions by revealing deeper truths, which convey realities experienced by First Nations peoples. They

show on-going defiance regarding contemporary issues while simultaneously revealing the experience of being Native.

The Cupboard of Contention (2002) consists of an antique handmade kitchen cupboard. On the shelves are thirty-five white and red ceramic soup cans representing First Nations and white cultures. At first glance, they appear to be Campbell's soup cans. On closer examination, the viewer becomes aware of the text "Canada's Racism," as well as the French and English translations for the contents of the cans. Inside the cupboard, stacks of ceramic bills and gold coins represent the gains white people have received from dominating, oppressing and cheating First Nations peoples out of their rightful possessions. Industry, business and corporate interests have made immense profits from natural resources through the displacement of many First Nations people. It is a reality that continues to position First Nations people in a constant struggle for survival.

The whole process of colonization was one of violence; the ideology of white superiority was achieved through brutal force. These attitudes re-emerge as white resentment of native treaty rights, culminating in violent reactions to these issues — including the Oka crisis — today.

IMAGES:

1 – *Cupboard of Contention*. 2001. Slip-cast low-fire clay, underglaze, glaze, lustre, antique cupboard, wooden letters, paint. 142.3 x 57.2 x 45.7 cm.

2 – *One Drop of Indian Blood Brand*. 2000. Slip-cast low-fire clay, underglaze, glaze, lustre, metal rod. 17.8 x 15.3 x 15.3 cm.

3 – *In Case of Emergency*. 2002. Slip-cast low-fire clay, underglaze, glaze, lustre, metal can opener, wood, plexi-glass, paint, glue. 22.86 x 29.85 cm.

4 – *Enlightenment Brand*. 2001. Slip-cast low-fire clay, underglaze, glaze, lustre, metal rod. 17.8 x 15.3 x 15.3 cm. Collection of Rennie Management. Photo Cameron Heryet courtesy of Surrey Art Gallery, Surrey, BC.

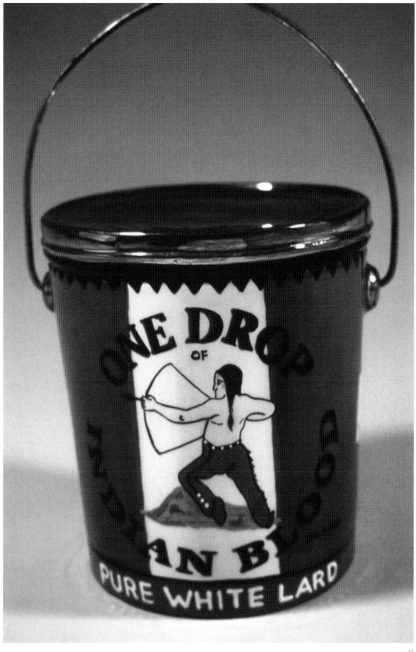

2

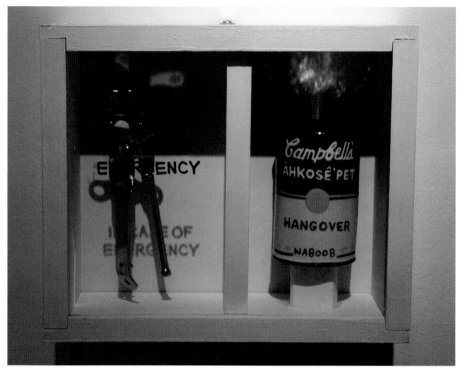

3

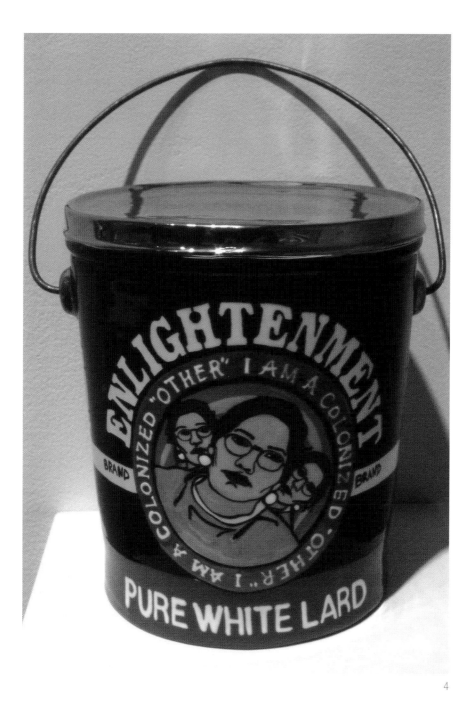

4

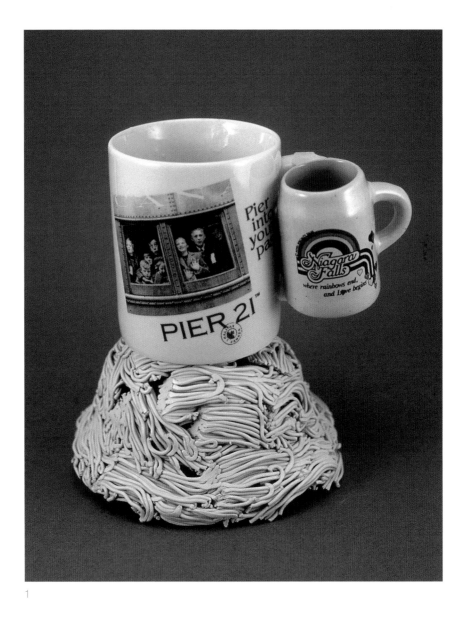

1

Penelope Kokkinos

Transient Potter

PAST AND PRESENT cultures have produced scores of useful — and not so useful — ceramic objects. Within the process of global or local commodity exchange, ceramics have directly or indirectly positioned and repositioned community attitudes, desires and biases towards ourselves and those around us. As items of exchange, ceramics are treasured as intimate, portable objects, which reside within and mirror the sphere of daily living.

In an age of air travel, cell phones and laptop computers, many people link domestic and professional sensibilities to a simulacrum of portability. Home, workplace and family are no longer tied to one location, as there are many. Such de-centred attitudes and positioning have prompted my inquiry into the notion of "transient potter," a professional ceramist whose contemporary practice is not fixed to one kiln, permanent studio or base. Such a nomadic ceramist relies on innate, transferable knowledge, interacting with handmade and found or manufactured materials at each locale.

As a way of recognizing contemporary ceramics as participants in transnational cultural exchange, defining myself as a "transient potter" allows me to explore the history and materiality of clay through venues promoting the fragile, temporal qualities of unfired clay and/or the assemblage of found, generic objects in the context of non-permanent local studio production. I use everyday items such as corporate logo cups, nostalgic saucers and pop culture knickknacks, which I amalgamate with handmade components. The resulting forms provide a de-centred, humorous look at shifting narratives and alternative relational organizations, revealing various socio-political subtexts hidden within the context of seemingly simple ceramic pieces.

In this way, I suggest that the non-permanent manufacture of "transient potter" demonstrates that ordinary ceramic objects can function as transitional objects, which fluctuate between touchstone mementos of collective histories, everyday rituals and material incidents that act out scenarios of place and space.

IMAGES:
All works are from *Trophies*, part of an on-going *cultural clutter* assemblage series.
1 – *Pier 21/Niagara Falls*. 2003. Found and hand-built ceramic. 17 x 17 x 14 cm.
2 – *White Matrix: Tea Party*. 2000. Found, thrown and hand-built ceramic.
 17 x 38 x 17 cm.
3 – *tom thomson meets blue mountain*. 2003. Found and hand-built ceramic.
 30 x 14 x 11 cm.
4 – *White Matrix: Picnic*. 2002. Found ceramic and unfired clay. 23 x 14 x 15 cm.

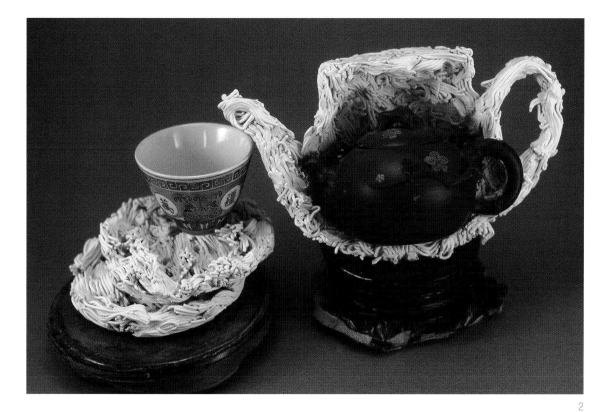

2

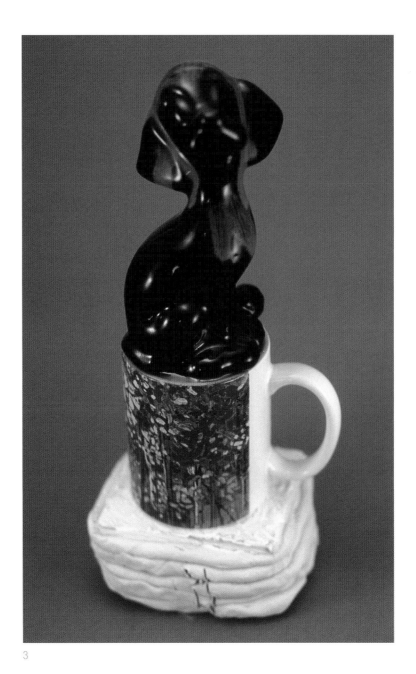

3

4

1

Carole Epp

Best Before Date

THE RESEARCH FOR MY work over the past few years has focused on the production of one of our basic necessities — food. I examine ways in which the market has changed to benefit industry rather than the consumer, and the impact this is having on our culture and the commodities we use. An intricate web of related ideas, narratives and conflicts impact the world over, beginning with the food we put on our breakfast table and continuing into environmental concerns. Related issues include first and third world poverty, the accessibility of goods, human rights in democratic societies, moral questions of genetic technology, the patenting of seeds and the commodification of the natural world.

My work *Best Before Date* addresses the impact of corporate industrial farming, seed patenting and genetic modification on farming communities in my home province of Saskatchewan. The subject is particularly relevant to the current fight against the introduction of genetically modified wheat in Canada, at a time when policy is being developed and debated in industry, government and society. The reality of the situation is that not only are family farms being bought out and traditional ways of life lost, the consumer is also further distanced from the production process of the commodity.

Best Before Date presents a collection of children's lunchboxes. Rather than depicting cartoons and superheroes, these depict agricultural scenes, machinery and landscapes. Through speaking about containment, collective memory and memorabilia, the lunchboxes also raise questions about our ethical and moral obligations towards the next generation and the ideas we are passing on to them. Presented inside a kitchen cabinet, the lunchboxes are juxtaposed with images of urban environments and cor-

porate signifiers to highlight the industrialization of agriculture. On the floor in front of the cabinet, there is a grouping of small, slip-cast ceramic rabbits. Normally seen as kitsch lawn ornaments, the rabbits in this instance represent the commodification of the natural world. Their colouring and surface treatment refer to the use of humans as test subjects in new genetic agriculture. Over the course of producing the rabbits, the mould from which they are cast breaks down, resulting in increasingly deformed or imperfect copies. The breakdown of the mould suggests the breakdown of modernist ideals of progress and industry.

Through my work, I argue for a greater complexity and subjectivity to the representation of human experience. My interest lies in developing new ways of approaching political subject matter. I view ceramics as a medium rich with potential in this area. Due to its predisposition towards familiarity, function, comfort and memory, ceramics can be used to present the harsh realities of politics and social concerns in ways that are subtle, beautiful and abstract. I am interested in manipulating elements such as beauty, fragility, desire and consumer culture to bridge the gap between content and audience. Through the use of everyday objects and installation, I engage the audience in a physical interactive space, where they are led through signs, images and familiar objects to re-evaluate their position vis à vis the objects, subject matter and context.

IMAGES:
1, 2, 3 – *Best Before Date*. 2002. Slip-cast, low-fire white ceramics and ceramic decals, wood, fluorescent lights, photo-transfers, plexi-glass. Installation approximately 300 x 300 cm. Cabinet: approximately 180 cm. Lunchboxes: actual scale. Rabbits: approximately 8 x 13 x 5 cm.

2

3

Remediation

Remediation characterizes the work of Marc Courtemanche, Sin-Ying Ho and Greg Payce. Remediation, or "the representation of one medium by another," is utopic in its ability to create alternative realities. Marc Courtemanche's perverse use of the medium, manipulating clay as if it were wood, questions the nature of objects and reality. Sin-Ying Ho's *Collision Course* reinterprets traditional Chinese ceramic vases into sites that stage the clash of corporate and traditional languages and cultures. Greg Payce explores the narrative possibilities of the realm between the virtual and the real. In *Harem*, a video captures the slow rotation of male and female forms; the shifting profiles enact erotic possibilities, which unfold as a series of cinematic images.

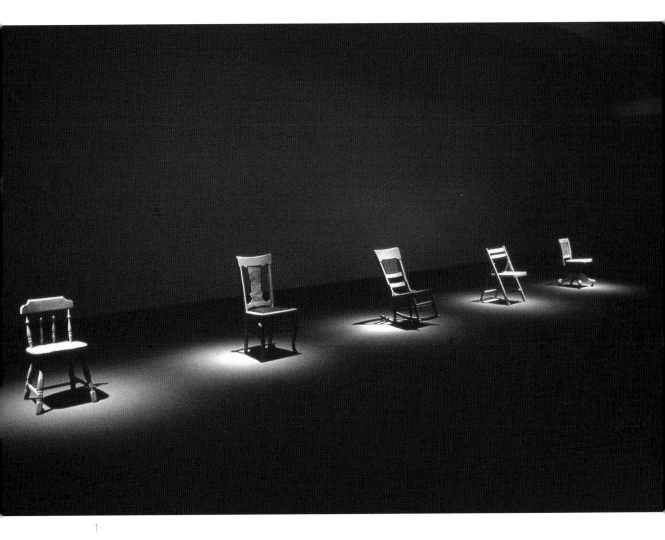

1

Marc Courtemanche

Not Quite

THOUGH ITS USE OF material, my current work questions how we define the everyday objects around us as art, craft or design. In my exhibition *Not Quite*, I chose five ordinary, industrially manufactured wooden chairs, dismantled them and copied each part in stoneware clay. However, in addition to traditional ceramic techniques, I treated the clay like wood. The chairs' parts are lathed, sawn and sanded. In addition, I used other woodworking techniques such as screwing, biscuiting, jointing, doweling and gluing.

The chairs at first might be interpreted as objects of trompe l'oeil. However, the intention was not to fool the eye but to confuse it by copying the form of the "real" object while allowing the stoneware to remain undisguised. I combine ceramic and woodworking techniques to produce hybrids that hover between these two traditions of object making and between two ontological categories: art and craft. This challenges the viewer's perception of utilitarian and non-utilitarian. Is a ceramic chair a real chair or only a copy? Is the chair more legitimate if you can sit in it?

The chairs are not displayed on pedestals but are placed directly on the floor in order to highlight tensions around their utility and status. You can sit on a utilitarian chair but not on a work of art. Because I prevent the audience from sitting on the chairs, they are prevented from being more than viewers, unable to use the object functionally. *Not Quite* exhibits five ceramic chairs that resemble and are made in the same manner as their prototypes. However, the material used calls into question their status as chairs, as clay is assumed to be fragile. Is a frail chair not a "chair," or is it just a weaker type of chair? Viewers have a difficult time deciding because they have not had previous experience with these types of chairs.

In combining traditions and techniques, my sculptures blur the boundary between art, craft and design; this positions the chairs in-between definitions. The close duplication of the forms of the wooden chairs highlights the significance of the material. The use of stoneware in *Not Quite* provokes questions as to how viewers interpret, define or perceive things. Therefore, the chairs become works of *visual* art and objects of contemplation rather than use. I enjoy objects that occupy this strange, ambiguous position, one that questions the nature of objects.

IMAGES:
1 – *Not Quite*. 2003. Installation view.
2 – *Not Quite: Mortise and Tenon*. 2003. Stoneware, leather, wood dowels. 101.5 x 43 x 43 cm.
3 – *Not Quite: Veneer*. 2003. Stoneware, metal screws, wood dowels. 94 x 76 x 40.5 cm.
4 – *Not Quite: Step Dovetail and Dado*. 2003. Stoneware, metal hardware and wooden biscuits. 86.5 x 61 x 61 cm.

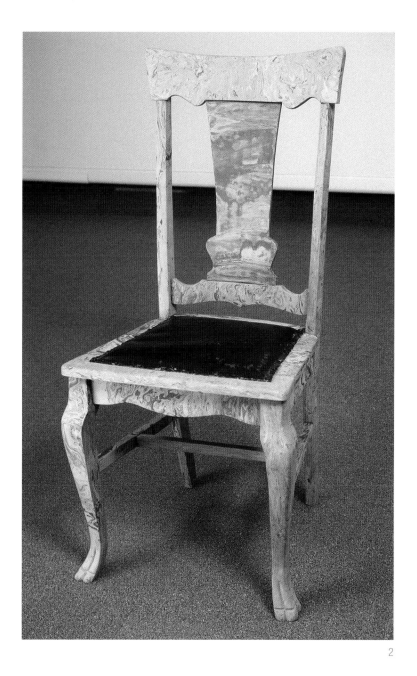

2

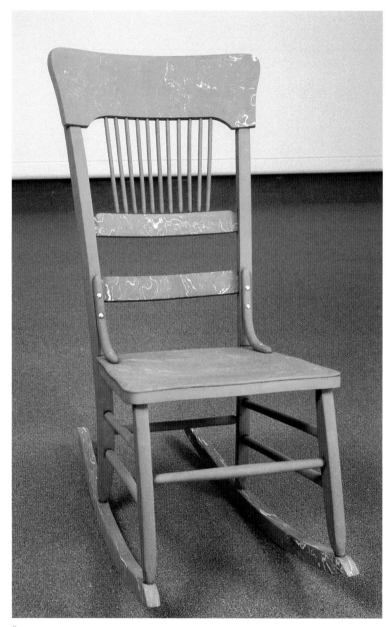

3

4

1

Sin-Ying Ho (Cassandra)

Collision Course

IN THE TWENTY-FIRST century, politics, technology and economic globalization result in the merging of people from many nationalities and cultures. My work *Collision Course* describes the path of such an encounter between two or more cultures that collide. To make this work, I replicate classical Chinese pot forms, decorating them with hand-painted images and computer decal transfers of contemporary commercial logos. I develop new objects by cutting and reattaching porcelain vessels to create hybrid forms, transforming a familiar porcelain vessel into an unfamiliar and unidentified sculptural form. I decorate these forms using ornaments from ancient peoples such as Celts, Egyptians, Greeks and Romans, as well as Chinese symbols and computer text in its binary form.

My work is influenced by contemporary postcolonial theory, which critiques Imperial Europe through examining such issues as slavery, migration, race, gender and place. My own postcolonial examination is based on growing up in Hong Kong, migrating to Canada, living in the United States and maintaining ties with communities in three countries. In my family and social environment, we spoke Cantonese. Before 1997, however, Hong Kong was a British colony and citizens in Hong Kong assumed English names based on British phonetics. Under British rule, students learned Chinese and English, providing a first-hand example of how an imperial power can force the colonized country to use a foreign language. The popularity of English can be attributed to this cultural and economic hegemony. Economic globalization has mandated the use of a second language in order to communicate. The required use of English is now imposed through economic rather than political colonialism. The cultural dynamics intensify tensions, confusions and complexity in globalized communication.

At the beginning of the twenty-first century, many configurations of words, letters or distinctive patterns are known throughout the world from advertising. Today, we share meanings attached to certain forms of public display with people across the globe. Widely diffused images in the public realm derive from social life and religious rituals, or they are created by modern corporations to sell goods and services. Corporations spend thousands of dollars to advertise products symbolized by their commercial logos. Logos dot the highway, blanket the city and come into our homes through television. Corporate branding dominates our visual experience, clothing, food, appliances and transportation. In China, the signs of McDonalds™, Coca-Cola™, KFC™, Nike™, Marlboro™ and Disney™ are equally as visible as the dragon motif. In my work, I freely mix motifs from corporate and traditional Chinese culture in order to indicate the degree to which commercial imagery has penetrated our innermost psyche.

As corporate globalization attempts to dominate large parts of the world, cultural identity becomes important for self-identification. The impact of globalization on the development of culture is still an unknown. Although my experience in East-meets-West cannot speak for other cultural collisions, I believe that critical questions of politics, communication, language, aesthetics, cultural identity, economy and power are contentious in all cultures. In this body of work, I reference my personal experience to speak about my on-going observations of this collision course.

IMAGES:
All works high-fire porcelain, hand-painted cobalt blue, computer decal transfer, terra sigillata.
1 – *Binary code — the link* (detail). 2004. 12.5 x 53 x 10 cm.
2 – *Histogram*. 2004. 20 x 40 x 20 cm.
3 – *Music*. 2004. 40 x 20 x 20 cm.
4, 5 – *Past and Present* (full view/detail). 2002. 37.5 x 22.5 cm.

2

3

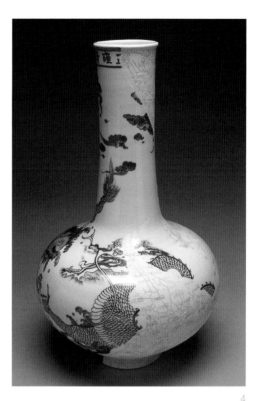

4

5

1

Greg Payce

Possible Worlds

WHEN EYES ARE FOOLED, imaginations are thrown wide open. Realms between the virtual and the real contain unique narrative possibilities. The negative spaces between ceramic albarelli become strange, non-dimensional — yet, oddly, three-dimensional — images. Archetypal relationships between forms of human and vessel cannot help filtering in. In domestic contexts, pottery introduces understated tactile, useful, visual and intellectual experience into people's lives, often with subtle and profound effect. Approaches from within the discourse of ceramics are paramount in the work. The initial strategy involved actively viewing static, domestic-scaled ceramic objects in real time and three-dimensional space. Virtual re-mediation of these ceramic forms provided additional unique possibilities for the works' dissemination and scale.

Concepts grow as a pantheon of images, forms, experiences, information, ideas, emotion and memory converge. The albarelli develop as chance players in a universe where the odd but interesting connections between ideas and objects become tangible. A "leap of faith" or a-logical approach to developing concepts allows for personal, multi-dimensional rendering of moments between objects, ideas and images. Works that pull viewers in for multiple readings are very interesting; didactic projects less so.

Dualities of figure/ground, positive/negative, form/surface and object/idea inform and develop vocabulary and grammar in the works. Point of view, syntax and rotational speed provide a structural framework. Language evolves as ideas become more complex. Narratives construct themselves from viewers' experiences. Expansion of the discourse of ceramics in current video projects such as *Harem* offers time-based consideration of the dichotomy between virtual and real.

IMAGES:

All works in *Possible Worlds* are wheel-thrown using earthenware and porcelain clays. The surfaces are terra sigillata slips and some glazes, which are banded or sprayed onto the forms while they are spinning.

1 – *Harem*. 2004. Earthenware. Still from video of moving ceramic albarelli. In this work, a turntable slowly rotates a stage filled with female and male profiles. The video image shifts seamlessly as the albarelli grouping moves past the camera. Human profiles wax and wane as images of figure and face ebb and flow. Line, form and colour converge simultaneously as shapes and images endlessly transform. Photo: M.N. Hutchinson.

2, 3 – *Pantheon* (full view/detail). 2004. Earthenware. Each element 21 cm high/ configuration variable. This work consists of various congregations of up to fifty individual elements. The groupings are photographed using video and still processes. Photo: M. N. Hutchinson.

4, 5 – *More Buildings About Song and Food* (full view/detail). 2005. Porcelain. Installation view/configuration variable. 36 x 185 x 28 cm. Photo: M.N. Hutchinson.

2

3

4

5

Dynamics
of Process

In distinctive ways, Thérèse Chabot, Seema Goel and Lia Tajcnar meditate on the dynamics of desire, beauty and the creative process. For these three artists, elements of time and process garner significant aesthetic consideration. Thérèse Chabot explores issues of identity, gender and nature through large-scale installations and performances that incorporate ceramic components and materials from her garden. Seema Goel's desire to be simultaneously close to two opposing worlds, which she characterizes as "vertigo," is rendered through the proximity of objects that come from different universes, mediated by the ephemeral beauty of the work. As a way to document and make visible her creative process, Lia Tajcnar incorporates ceramic decals depicting her work at different stages within the work itself. The emphasis on process "encourages an active experience of a static object."

1

Thérèse Chabot

Odyssée

AFTER MANY YEARS OF art practice, I still work with the medium of time. My work concerns cycles, rituals and renewal on both a physical and metaphorical level. It is rooted in issues of identity, gender and nature as explored through the creative process. Instinctively, I chose to initiate my research in ceramics, a material with which I am still very involved through my teaching. However, my practice now extends to the exploration of space through large-scale installation and performance. My main medium is flowers, the petals of which I use as if forming mosaics.

The processes I use with flowers parallel those I use to make ceramics. I create my materials from seeds, growing the plants until they flower. I collect the flowers and use them as if they were pigments, textures and forms. My ways of seeing, thinking and making have been influenced by ceramics and textiles. For example, when I was twelve, I researched Bernard Palissy and Emile Gallé. Moravian tiles and Mexican clay figures from the *Dia de Muertos* inspired me to shift my work from object to installation as I explored the role of rituals in the cycle of life and death. Persian carpets and Gobelins tapestries informed my expression of themes from daily life and my relationship to the world. I referenced these mediums to reinterpret the universal through the cultural. I repeatedly used ceramic objects such as teacups and other ceremonial vessels as central symbols in my performances.

My research examines the theme of sacred gardens. Recently, I began to engage myself physically in these installations, adding a theatrical element by performing actions based on archetypes related to motherhood, queens and the idea of empowerment. I also sing and tell stories in the manner of *chansons de geste*, inspired by the spirit of medieval trouba-

dours. I often invite other women of different ages to collaborate in my plays.

My current body of work is *Odyssée*, an on-going project started in 2003. The project speaks about passion, the quest for harmony and acquisition of a new power. In this performance, I present myself in a sumptuous dress with a circular skirt of thirteen metres. Using clothing, props and artefacts as vehicles, I assume the character of, successively, a woman-boat, a woman-table and a woman-feast. Songs and incantations accompany those archetypes. Through this work, I reconnect with my past as a maker and collector of ornaments. Using symbols such as a broken teacup, a doll head and other objects made or collected over the years, I subvert these anthropomorphic representations to speak about our individual "odyssey" on earth, our discoveries and our losses, through the different stages of a lifetime.

This performative act embodies structures aimed at creating tension between two systems of representation that do not quite fit or relate to each other. At the opening reception of *Odyssée*, a performance is presented and offered as a gift to the audience. What remains after is the installation: the dress, the objects and props used during the play — a comical hat in the shape of a snail decorated with red peppers, two pairs of satin gloves, a box on wheels with a plastic doll inside and the broken teacup, a snake skin scarf and so forth. Memory of what has happened remains, documented in video, as the only surviving trace.

I view *Odyssée* as an on-going project. I am still working on the content and opportunity to present the piece in different sites to various audiences and to engage with the viewers in the play. During a recent visit to Mexico, I became intrigued by paintings of adorned nuns from Columbia, Peru, Spain and Mexico in the sixteenth and seventeenth centuries. This genre of painting is referred to as *Monjas Coronadas* (crowned nuns).[1] Depicting young women just as they enter the convent or aging ones on their death beds, these images represent a last bit of vanity that must be renounced along with the rest of the material world. This tension between

vanity, eroticism and renunciation resonates with my current research into eco-feminism.

NOTES:
1. For example, see the exhibition *Monjas Coronadas. Vida Conventual Femenina en Hispanoamérica,* presented March 2004 by Institute Nacional de Antropologia y Historia and el Museo Nacional de Virreinato.

IMAGES:
Odyssée. Performance and Installation, 22 November 2003 to 4 January 2004. Estevan Gallery, Estevan, Saskatchewan.
1 – Installation detail. Table, box with doll figure, bleeding heart circle and pansies. Photo: Dennis J. Evans.
2 – Performance detail, 22 November 2003. Woman Feast Singing. Photo: Dennis J. Evans.
3 – Performance props: broken porcelain teacup, doll and doll heads, snake skin and red peppers. Photo: Thérèse Chabot.
4 – Installation detail. Mandala with viewers. Photo: Dennis J. Evans.

2

3

4

1

Seema Goel

Altared Images

PERHAPS ALL WORK aspires to inspire vertigo. Vertigo — a feeling of dizziness induced by the simultaneous attraction to and repulsion from an object/idea/experience. The novelist Milan Kundera describes vertigo as "the desire to fall" rather than the fear of falling.[1] It is the subsequent internal conflict — I want to fall, I do not want to fall — that results in giddy light-headedness. What does it mean to be concurrently drawn to and repelled by the same thing? *Altared Images* exists for me in such a space. It examines the desire to be as close as possible to two opposing forces, each of which simultaneously elicits this particular vertiginous unease.

The piece includes two digital photographic prints, each 45 x 68 cm. One print is of a male figure and the other of a female figure. A dusting of *sindoor* powder (1.2 x 1.8 metres) is spread directly onto the floor,[2] as are 600 to 700 small, empty ceramic vessels. The photographic images are intentionally blurry. They allude to the influence of perspective on understanding as well as to the body's limitations in portraying anything more than the outside of things. Although the prints are hung on opposite walls, there is no direct line of sight between them because of an obstructing column integral to the structure of the room.

An offering lies on the floor before each image. In front of the male figure, the blanket of *sindoor* powder is a fragile, undisturbed desire. Intensely red-orange, it glows of its own accord. It looks both overwhelming and inviting, its perfect surface a temptation. Although entirely organic in its origins, the material here is marshalled into geometric order. It covers enough space for two people to lie within it. This is desire with knowledge, with future, with intent.

On the other side of the room, beneath the unfocussed image of the woman, sit the hundreds of hand-thrown, stoneware cups. In contrast to the *sindoor*, they reference the constant, the enduring and inseparable attachment between the present and the past. Like so many mouths open to kiss, they offer silent promises and childhood litanies. The clay vessels are arranged haphazardly, unlike the structure of their counterpart on the other side of the room. The arrangement suggests the unchecked growth that happens through the accumulated experiences of life. It speaks of abundance and intimacy. Each cup is the size of the closed fist, the size of the human heart.

In general terms, *Altared Images* describes a struggle common to many people — in my case, between the world I choose to inhabit and the world of my upbringing. This is not a culturally specific experience; rather, it is simply a rift between the values that are selected in adulthood versus those ingrained in childhood. More specifically, it speaks of the personal relationships I value most and my attempts both to maintain those relationships and to unite those people. The content, unusually personal, emerged without premeditation or analysis. Despite its autobiographical elements, it translates almost without trace of an accent. Although I am suspicious of sentimental work, in this case, the earnest quality of the piece lends it a sadness and intensity that is palpable. It is an intersection between the sublime and the ridiculous, the heartfelt and the melodramatic. It is vertigo through proximity.[3]

NOTES:
1. Milan Kundera, *The Unbearable Lightness of Being* (New York: Harper Perennial, 1984).
2. A vermillion-coloured powder used by Hindu women as a marker to indicate marriage.
3. Kundera, *The Unbearable Lightness of Being*.

IMAGES:
1, 2, 3, 4 – *Altared Images*. Installation space 7.5 x 6 m; photographs 45 x 68 cm; sindoor on floor 1.2 x 1.8 m; arrangement of approximately 700 cups (high-fire stoneware with iron oxide and ash): 4 x 3 m.

2 3

4

1

Lia Tajcnar

MY WORK PAYS HOMAGE to the strange beauty of the natural world. I reference natural forms such as pods, shells and organic matter, which I combine with more stylized elements to suggest the surreal and meta-physical. I take into account chance, accidents and the physical properties of the material, allowing them to disrupt my preconceived ideas and to influence the outcome of the work. Wanting to record this creative process visually, I photograph parts of the work as it evolves, make the photos into decals and apply them to the work. By having pictures of the work on the work, I reference the process of the creative act by playing with forms of representation. This also adds to the strangeness of the work, stopping it from being only a representation of organic form. By including these images, I also suggest issues of time and fragmentation. The two-dimensional decals of the work depict aspects of the piece from specific vantage points in time and space. These are incorporated in the final piece, which archives all the variables inherent in experiencing something in three-dimensional space.

The physical presence of the work is important. The colours, tactile na-ture of the forms and variations within the glaze and surface invite closer inspection, initiating a sensual reading of the work. Not all the information is available in a single glance. The viewer must move around and interact with the work to form an idea of the "whole." Such movement encourages active engagement with a static object, highlighting the complex and con-tradictory nature of perception.

IMAGES:
1, 2, 3, 4, 5 – *Untitled*. 2004. Multi-fired glazed porcelain and stoneware clay, laser decal. 18 x 26 cm; 19 x 25 cm; 10 x 7 cm.

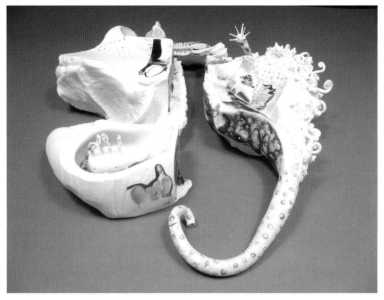

2

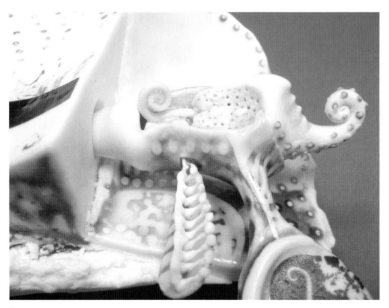

3

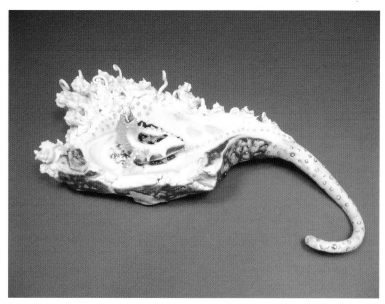

4

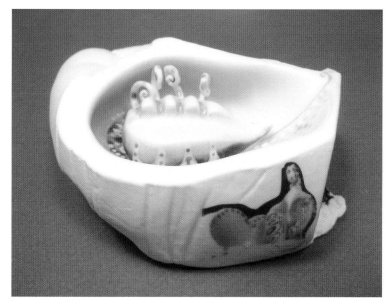

5

Systems of
Knowledge

Ruth Chambers, Dagmar Dahle and Anne Ramsden all reference systems of knowledge deriving from science and the often poor fit between such systems and the experiential world of nature, the psyche and the construction of historical memory. Dagmar Dahle investigates relationships among natural history museums, forms of hobby craft and decorative art. The digital images included here remediate an earlier project, *Rare, Common, Extinct*, in order to relocate it in relationship to historical documentation of the natural world. Ruth Chambers reflects on historical amnesia, ambivalence and the construction of geographical place in *Either/Or (in consideration of what is now known as Saskatchewan)*. Acknowledging Saskatchewan's progressive ideals, as reflected in its ambitious legacy of health care and social welfare, Chambers simultaneously notes dystopic aspects of cultural genocide and the profound alteration of the natural world as a result of intensive farming. In her ongoing series of projects, *Anastylosis*, Anne Ramsden, whose project is discussed here by Melanie O'Brian, breaks and repairs commercial ceramic dishes in order to subvert archaeology's construction of history through its system of classification and preservation of objects. Rejecting the ideologically manufactured coherence of museum display, Ramsden's unmistakably broken and "conspicuously repaired" china calls attention to psychological wounds, shattered memories and lost ideals.

1

Dagmar Dahle

Birdmaps

BIRDMAPS IS SERIES OF digital images made by scanning ceramics and pairing them with scanned watercolours. The ceramics were selected from one of my previous pieces entitled *Rare/Common/Extinct* in which I used commercial slip-casting moulds and altered the cast pieces by cutting holes in them to produce lacy, bone-like objects. Shown as part of the Alberta Biennial of Contemporary Art in 2002, this work was part of a larger investigation of relationships between natural history and decorative art that referenced taxonomies of science, museum display and collection. The watercolours derive from a daily drawing practice in which I draw without predetermination, allowing images, forms and shapes to emerge on their own.

The combination of the drawings with ceramic pieces relates to my awareness during the process of cutting holes through the wet clay that I was engaged in the act of drawing. I am interested in how the two types of images resonate together as though one might be a blueprint for the other, each speaking a different language.

IMAGES:
1, 2, 3 – *Bird maps: Jayloops, Cardinal Atoms, Duck Dots*. 2004. Digital images.

2

3

1

Ruth Chambers

*Either/Or (in consideration of what
is now known as Saskatchewan)*

EITHER/OR (IN CONSIDERATION *of what is now known as Saskatchewan*) is
about the subjective and ambivalent relationship I have with my adopted
place, the province of Saskatchewan. It is a place that in my imagination
embodies both utopic and dystopic elements. The province has a tradition
of social idealism and innovation, with, for example, the first universal
health care, arts-board creation and co-operative movement in North
America. Conversely, we have — like much of the rest of the world — a
history of colonial atrocities. This dystopic legacy has impacted Saskatch-
ewan's aboriginal population with particular force. And although we have
a magnificent landscape that is, for the most part, free of urban sprawl or
ugly industrial scars, it is a landscape in which an unusually high percent-
age of the topography has been altered. Because so much of the province
is arable prairie, it has been extensively worked.

Either/Or comprises an elliptical table into which are set back-lit por-
celain forms. Images imprinted into the porcelain include names and de-
pictions of a number of endangered species of flora and fauna. The names
are selected from a longer list of species-at-risk in the province, in part for
their poetic and resonant qualities: sage grouse, hairy prairie clover and
black-footed ferret. Also inscribed is the Cree word for the place of the
"swift flowing river" in Cree syllabic. This is the aboriginal word from
which the name "Saskatchewan" is derived. In part, its use is intended to
draw attention to the transient and constructed nature of the place now
known as Saskatchewan. Finally, interlaced throughout the images are
both direct imprints and abstractions of foliage. Some of the imprints are
of indigenous plants I grow in my own garden. The abstractions are pat-

terns that further refer to the culture of nature and the construction of the garden in cultural imagination.

Tommy Douglas, the visionary politician and premier of Saskatchewan for many years, profoundly influenced the development and implementation of socialist thinking in Canada. His roots were in the social gospel movement of the thirties, and his utopian projects resulted in enlightened social policies such as universal health care. In my work, I quote the epitaph on Douglas' grave, which reads, in part, "it is not too late to build a better world." I find this phrase to be profoundly moving and utopic. At the same time, when I read it, I immediately — and, from a dystopic perspective — think "but it is too late!" Both the irony and the hopefulness of this text are employed in *Either/Or.*

IMAGES:
1, 2, 3 – *Either/Or (in consideration of what is now known as Saskatchewan).* 2005.
 Porcelain, fluorescent light, birch veneer plywood, found branches.
 78 x 150 x 94 cm. Photo: Don Hall.

2

3

1

Anne Ramsden

Melanie O'Brian on "The Anastylosis Project"

THE DISPLAY OF OBJECTS and their representations feature in much of Anne Ramsden's work. Intrigued by the social life of things, the artist constructs her own displays of cultural signs and the politics of cultural property. Her preoccupation with the critique of presentation systems has extended to the conventions of interior decoration (Pakasaar 14).

In the *Anastylosis* project, Ramsden portrays and displays faux artefacts, reproducing processes of archaeology, preservation, the creation of history and the classification of things. "Anastylosis" is an architectural term that refers to the practice of leaving apparent traces of repairs made in the restoration of artefacts. *Anastylosis: Inventory* comprises a collection of over 300 repaired ceramic dishes arranged according to colour and function on twenty units of metal shelving. Ramsden bought the plates and bowls over the course of a year, selecting only a fraction of what was available on the current market. She methodically broke them by throwing them on the floor. Photographing the resulting shards in various groupings, she repaired them with gold-hued glue, emphasizing the creative process of reconstruction. Ramsden comments:

> In this process, one that is simultaneously destructive and restorative, one kind of value — commercial — is transformed into another — aesthetic. Because anastylosis refers to the activity of restoration, I am able to insist upon the presence of reconstruction and coherence in the project, and thereby counteract the powerful presence of breakage and fragmentation in the work (Ramsden 7).

Anastylosis: Childhood, the second component of this project, presents children's dishes. These are shown as photographic representations (fragments and reconstructions) as well as in three-dimensional form. The use

of children's china reveals both the commodification of childhood and Ramsden's subjectification of commodities. Directed toward the bourgeois child, the plates are utilitarian collector items. These dishes perpetuate a certain association of consumerism and desire informed by nostalgia. They feature Becassine, Bunnykins, Tintin and Le Petit Prince, all characters from stories read to generations of children, each with ideals imbued with a strong morality. The dishware slips these ideals into the everyday under soup and mashed potatoes, to be revealed only when the plate is cleaned.

The constrained and formal installation of photographs and dishes within the gallery belies the emotive quality of the work. While the restorative process balances destruction, the implications of the breaking act cannot be ignored. Like the scars of memory, the gold veins running through the plates draw attention to the wounded or abused state of the dishware. The dishes are not only conspicuously repaired; there are also places where chips are missing and spaces that have not been entirely filled in. Just as we all have histories marked by painful events, the broken china becomes a symbol of shattered memory, broken childhoods and imperfect ideals. The metaphor and activity of archaeology call into question the entire process of display and artistic production, and the plates themselves function as mirrors to be held up to our own ideals.

WORKS CITED:
Pakasaar, Helga. *Anne Ramsden: Residence*. Oakville: Oakville Galleries, 1994.
Ramsden, Anne. *Anastylosis: Inventory*. Sherbrooke: Galerie d'art du Centre Culturel de l'Université de Sherbrooke, 2000.

IMAGES:
Anastylosis: Inventory. 1999–2002. Twenty grey metal shelving units, 308 ceramic objects, epoxy glue, acrylic paint. 244 cm. x 190 cm. x 10.36 m. Laminated C-print, wall-mounted with push pins. 114 cm. x 13.7 m. *Anastylosis: Childhood*. 1999. Colour photographs, each 122 x 152.5 cm.
1 – *Anastylosis: Inventory*. Installation view. Photo: Paul Litherland.
2, 3 – *Anastylosis: Inventory*. Installation view. Photo: Don Gill.
4 – *Anastylosis: Childhood (flying)*. Left panel. Photo: Anne Ramsden.
5 – *Anastylosis: Childhood (falling)*. Right panel. Photo: Anne Ramsden.

2

3

4

5

Contributors

SYLVAT AZIZ is Associate Professor, Department of Art, at Queen's University, Kingston, Ontario. She works across disciplines in painting, printmaking and sculpture. Her research focuses on industrial materials and technical methods in the studio, issues of representation in medieval Islamic traditions and material culture. Major exhibitions include the Venice Biennale (1997) and *Modernities and Memories* at the Dolmabache Art Centre, Istanbul (1998). She is represented in the permanent collections at the Royal Ontario Museum, the Canada Council Art Bank, the Nickle Arts Museum, among others, nationally and internationally.

NICOLE BURISCH is an Alberta-based artist, writer, and cultural worker. A graduate of the Alberta College of Art & Design, Burisch investigates intersections of art, craft and activist practices. Her writing on contemporary craft and art has been published by local galleries and journals and internationally by *Ceramics: Art and Perception* (Australia).

THÉRÈSE CHABOT has been teaching in the Studio Arts Department at Concordia University in Montréal, Québec, since 1983. She has researched formal Renaissance gardens in France, sacred rites around the Day of the Dead celebration in Mexico and fiestas throughout the religious calendar. Her installations and performances have been shown in solo exhibitions in Québec, Canada, the United States and abroad in France, Scotland, Italy, Germany and Mexico. In May 2003, she was selected as one of the new members of the Royal Canadian Academy of Arts. The recipient of several grants from the Conseil des Arts et des Lettres du Québec (CALQ), she lives and works in Saint-Jean-Baptiste, Québec.

RUTH CHAMBERS is a visual artist whose work incorporates a range of media, often including ceramics, in an installation format. Recent projects explore various cultural, medical and metaphysical endeavours that have aimed to transcend and reconcile concepts of the material and immaterial and the internal and the external. She also gives papers, participates in symposia, and chairs academic panels on such topics as contemporary ceramics and craft, art and science and collaborative art practice. She has taught at the University of Regina since 1994 and is currently Associate Professor of Visual Arts/Ceramics and Associate Dean of Fine Arts. She is one of the co-editors of this volume.

JUDY CHARTRAND is a self-employed ceramic/mixed media artist who is based in Coquitlam, British Columbia. Her art practice focuses on First Nations and white relations in Canada. Her recent exhibitions include *Lost & Found* (2006) at Access Gallery in Vancouver, and *Changing Hands: Art Without Reservation 2* (2005–2007), a travelling group exhibition organized by the Museum of Art & Design, New York.

NAOMI CLEMENT graduated in 2002 from the Nova Scotia College of Art and Design, where she studied ceramics and craft history. Since graduating, she has interned with several studio potters, among them Joan Bruneau, and she returned to the college in 2003 as the summer ceramics studio technician. She currently lives in Toronto, exploring her love of all things hand-made through two very different avenues: working for a small wine importing company and continuing to pursue her studio and scholarly interest in ceramics.

DAGMAR DAHLE has a wide-ranging practice that includes sculpture, painting, drawing, collecting and walking. The intersections of museology, natural history, art history, craft and the everyday inform her work. She teaches painting at the University of Lethbridge, Alberta.

CAROLE EPP is a ceramic studio artist, writer and teacher based in Saskatoon, Saskatchewan. Her practice incorporates functional objects and politically based sculpture. Epp obtained her masters degree from the Australian National University, and she has exhibited in Canada, Australia and the United States. Her most current series is a figurative project entitled *A Collection of Small Miseries*. She is represented by Dashwood Galleries in Calgary, Alberta.

LÉOPOLD L. FOULEM is a ceramic artist living in Montréal. He teaches visual arts at Cégep de Saint-Laurent. He has exhibited extensively in Canada and abroad. Foulem has given numerous lectures on various aspects of ceramics as an autonomous art form. Many of these were published. He is a renowned specialist on the ceramics of Picasso.

SEEMA GOEL is a Regina sculptor, writer, curator and educator. Her work has been exhibited in Canada and the United States and encompasses an eclectic range of materials and contexts from projection onto buildings to taxidermied animals. Her current preoccupations include the subversion of domestic objects, commensal animals, and urban/rural relationships as considered through landscape. Her work strives towards developing metaphor and considering context. She holds a BSc in Biology from McGill, an Associate Arts diploma from the Ontario College of Art and Design in Fine Art, and an MFA in Sculpture from the Rhode Island School of Design.

AMY GOGARTY is an artist, writer and educator who recently relocated from Alberta to Vancouver, British Columbia, where she works full-time as an artist and researcher. She has presented her research focusing on contemporary issues in art and craft practice nationally and internationally in the form of numerous catalogue essays, reviews and conference presentations. She is one of the co-editors of this volume.

JAMELIE HASSAN is a visual artist based in London, Ontario. Her interdisciplinary works incorporate ceramics, painting, video, photography, text and other media and explore personal and public histories. She has exhibited widely in Canada and internationally since the 1970s. Commissioned ceramic works include those for the London Regional Cancer Clinic, Victoria Hospital, London, Ontario, and the Ottawa Courthouse and Land Registry. She received the "Canada 125 Medal" in recognition of her outstanding service to the community in 1993, the Governor General's Award in Visual Arts in 2001 and the Chalmers Art Fellowship in 2006.

SIN-YING HO is Assistant Professor of Ceramics at the City University of New York, Queens College, Queens. Ho was born in Hong Kong, immigrated to Canada and currently teaches in New York City. Her work focuses on the collision course of cross-cultural experience under globalization, technology advancement and consumerism. Her work has been collected by museums in Yixing, Guangdong, Taipei and Calgary.

PENELOPE KOKKINOS is a ceramic artist, curator, writer and instructor. Her clay work has been exhibited in Canada and internationally. She views contemporary ceramics as an exploratory mirror for socio-political identities. Some of her recent publications include "Pot: As Movable Memory" (2004), "Joni Moriyama: Echo" (2004), "Evidence of Everyday" (2003) and "Crafts: transient/transitional/transgressive bodies" (1999).

RORY MACDONALD is currently Assistant Professor of ceramics at the University of Regina and Department Head of Visual Arts. MacDonald's work in ceramics explores the history of industrial ceramic production techniques. He is interested in the role of ceramics within the practice of design and art, concentrating on the development of new public audiences and spaces for ceramics. Central to his current research is the exploration of the concept of public craft. He received the 2007 Winifred Shantz Award for ceramics.

JEANNIE MAH is a ceramic artist living in Regina. Her interests in ceramic history, cinema and local history infuse her work, which is exhibited and collected

nationally and internationally by private, corporate and civic institutions. Recently, she was one of three editors of *Regina's Secret Spaces: Love and Lore of Local Geography*, in which she proclaims her love for Wascana Pool.

LES MANNING is a studio artist and volunteer Artistic Director of the Medalta International Artist-In-Residence Program. His ceramic forms are influenced by the sculptural presence of the Canadian Rockies, with an expression similar to that of the Group of Seven. He has held recent solo exhibitions in Amsterdam and Seoul and was a recipient of an Alberta Centennial Metal for contribution to the arts. He is a former vice president of the International Academy of Ceramics.

PAUL MATHIEU is a potter now living in Vancouver where he teaches ceramics in the School of Visual Arts at the Emily Carr Institute of Art + Design. His numerous essays on various artists and conceptual aspects of ceramics have been widely published and anthologized. He is the author of *Sexpots: Eroticism in Ceramics*, published in England by A&C Black, in the United States by Rutgers University Press and in Switzerland, in a German translation, by Haupt. He is presently at work on a new book, *On Ceramics*, which will examine historical and contemporary aspects of ceramics in the context of various aesthetics and themes. He is the 2007 recipient of the Saidye Bronfman Award for excellence in the fine crafts, one of the Governor General's Awards in Visual and Media Arts.

JUDY MCNAUGHTON is currently Northern Artistic Coordinator for Common Weal Community Art Inc., based in Prince Albert, Saskatchewan. Her practice as a ceramic artist includes gallery installations as well as site-specific and community-based ceramic murals. Her curatorial practice is focused on multi-disciplinary community-based events.

ANGELA MELLOR recently returned from Australia to the UK to open a gallery for contemporary art and craft in Ely, Cambridgeshire. A studio ceramist, Mellor worked and lived in Western Australia, where she was inspired by the bright sunlight and the ocean. She was awarded an Australian Council grant for new work, collaborating with a lighting designer for a year. Her work has been shown at SOFA Chicago and COLLECT at the Victoria and Albert Museum. She is a member of the International Academy of Ceramics.

MICHAEL MOORE is an artist and a Reader in Fine and Applied Art at the University of Ulster, Belfast School of Art and Design, in Northern Ireland. He has exhibited internationally, and his ceramic works can be found in the permanent collections of the National Museum of Ireland; the Australian National University, Canberra; the World Ceramic Exposition Foundation, Icheon, Korea; and

the Keramion Museum, Frechen, Germany, among others. He has presented his research in numerous international journals and at conferences in Canada, Britain, Ireland and Hungary.

MELANIE O'BRIAN is the Director/Curator at Artspeak, Vancouver, Canada. She has organized exhibitions in Vancouver and internationally, and written for numerous journals, catalogues and magazines. She lives in Vancouver.

GREG PAYCE teaches at the Alberta College of Art & Design in Calgary. Works from Greg's thirty-five-year studio practice have been included in over 150 national and international exhibitions. His current research and practice focus on collaborative projects involving ceramics, photography, video and music.

MIREILLE PERRON was born in Montréal, Québec. Since 1982, her installations have appeared in solo and group exhibitions in Canada, the United States, France, Italy and the United Kingdom. Her work explores connections between gender, culture, visual arts, science and medicine. She has written and published critical essays on a variety of subjects related to representation. Recent examples of the range of her work include *The Feminist Laboratory of Pataphysics* (The New Gallery, 2007), an installation at the crossroads of medical, sensual and critical imagery, and an essay titled "Feminists, Colporteu(r)ses and Pataphysicien(n)es," published in the anthology *Culture of Community* (MAWA, 2004). Perron lives and works in Calgary, Alberta, where she teaches at the Alberta College of Art & Design. She is one of the co-editors of this volume.

ANNE RAMSDEN works in sculpture, installation, photography and video. She has exhibited across Canada as well as in the United States, Europe and Japan. She teaches in the École des arts visuels et médiatiques at the Université du Québec à Montréal and is a researcher at Hexagram, Institute for Research/Creation in Media Arts.

DIANE SULLIVAN has an MFA from the University of Washington in Seattle and a BFA from the Nova Scotia College of Art and Design in Halifax. Her one-of-a-kind work has been exhibited internationally, and her studio pottery line, Arabesque Pottery, is represented across Canada and the United States. Sullivan has published numerous articles on the ceramic arts in journals and books on contemporary craft and has received many awards. She has taught at several post-secondary institutions and continues to conduct workshops nationally. For the past ten years she has been self-employed, marketing her work across North America through trade shows, retail shows and one-of-a-kind exhibitions.

SUSAN SURETTE is a professional ceramic artist working from Studio Surette in the Eastern Townships of Québec. She has exhibited her ceramic murals and objects in craft shows, gallery exhibitions and museums. Her publications on landscape and ceramics are included in *Craft: Perception and Practice*, Vol. II (2005), *Re-Crafting Tradition* (2006) and the George R. Gardiner Museum of Ceramic Art exhibition catalogue, *On the Table* (2007).

LIA TAJCNAR makes ceramic sculpture in Canberra, Australia. Originally from Alberta, where she studied at the University of Calgary and the Alberta College of Art & Design, she received one of the inaugural C.D Howe Royal Canadian Academy of the Arts Scholarships for Art and Design to assist in undertaking her masters degree at the Australian National University, where she now teaches part time. She recently had an article published in *The Journal of Australian Ceramics* and exhibited in *Convergence: A North/South Discourse* at NECEA 2007.

Index